Acknowledgements

I should like to acknowledge the assistance and advice obtained from the following individuals and institutions, without which the exhibition would have been impossible to arrange: the Trustees of the British Museum, and the Department of Oriental Antiquities, for the loan of prints, and for photographs of them; Mr B. W. Robinson, for the loan of prints and books, and for advice and assistance; Mr J. Hillier, for the loan of books, and for advice; the Japan Information Centre and Mr Shigeru Wakaki, Associate Professor, Department of Architecture, Nippon Daigaku, for advice on special features in the exhibition design; the Museum's Photographic Studio, and in particular Miss S. Chappell and Mr P. Murphy and the Museum's Conservation Department, in particular Miss G. Wood.

R. A. C.

The Floating World

VICTORIA AND ALBERT MUSEUM

Japanese popular prints 1700–1900

世絵展

R A Crighton

LONDON: HER MAJESTY'S STATIONERY OFFICE 1973

Exhibition at the Victoria and Albert Museum
September – November 1973
Exhibition designed by I. D. Heal,
Design Section, Victoria & Albert Museum

© Crown copyright 1973

SBN * 11 290190 5

Preface

The exhibition is largely drawn from the Museum's own collection of prints, which is strongest in nineteenth century material, although by no means deficient in works of the earlier period. Its intention is to illuminate the range of subjects and styles of ukiyo-e woodcuts over a period of two centuries. Consequently an attempt has been made, not to spotlight isolated great men, but to place them in their broader contexts.

Supplementary material, largely from the British Museum and of eighteenth century date, has therefore tended rather to be chosen with a view to completing the contexts than to including omitted individuals. The chief omissions are the Kaigetsudō artist, or artists, and Ippitsusai Bunchō, the first because of unavailability, and the second because his influence is adequately conveyed by Harunobu on the one side, and by the Katsukawa school on the other.

The approach has been to make five basic divisions of the material by subject matter:

I Kabuki, the popular theatre
II Beautiful women with a few intrusions
III Landscapes and views
IV Birds and flowers, including animals and water life
V Heroes and heroines, battles and warriors, myths and legends, poetry and fiction

Each section has its own introduction. Particular comparisons should be made between II and III and between I and V, where there is overlap of subject matter.

The main sections have been further broken down into contextual groups, the members of which are related either formally (I and II) or by subject matter (III, IV and V). The order of the prints within each group is loosely chronological. There is an associated display of illustrated books for each main section. These are listed at the end of the section, but are not reproduced.

Each catalogue entry for the prints takes the following form:

1. Catalogue number (roman numeral for section, arabic for order in section).
2. Artist's name (bold type).
3. Date of print.
4. Title or description of print. Any peculiarities of printing or format are noted here.
5. Signature and seals, if any.
6. Dimensions, height before width, centimetres before inches, and Museum number, if any.
7. Name of lender or donor, if any.
8. Commentary, where relevant.

There are five Japanese terms occasionally included under 4 above:

Aizuri-e: Blue print. These are printed entirely in blue tones.
Hashira-e: Pillar print. Tall narrow format, designed to be displayed on the pillars of a house.
Ishizuri-e: Stone print. Printed with the line in white, imitating Chinese stone-rubbings. Not usually printed from stone.
Kakemono-e: Hanging scroll print. Imitating the proportions of a hanging scroll.
Surimono: Printed thing. High quality small edition print. Often a private commission for the New Year celebrations.

Biographical details of artists, when known, are given in alphabetical order as an Appendix, together with the catalogue numbers of works by each man in the exhibition. Signatures of many of the artists are reproduced.

A list of books for further reading is also appended. For the serious student a comprehensive bibliography of books on the subject in the Museum's National Art Library has been prepared, and will be available upon application to the library.

Particular thanks are due to Mr B. W. Robinson, Keeper Emeritus in the Far Eastern Section, both for his foundation work on the Kabuki section, and for his advice and assistance throughout the writing of this catalogue. Any remaining errors are of course my own.

General introduction

Ukiyo, the floating world, is originally a Buddhist term, where floating has connotations of transience and lack of substance. It was used to refer to the illusory and undesirable state of affairs in this world of ceaseless reincarnation which could be transcended through faith in the saving power of the Buddha. In seventeenth century Edo it came to be applied with more positive feelings to the changing fashions and amusements of the life devoted to pleasure. Ukiyo-e, pictures of the floating world, is the name given to the distinct style of painting, and of the book illustrations and prints derived from the paintings, which grew up to record and give visual identity to this new urban culture.

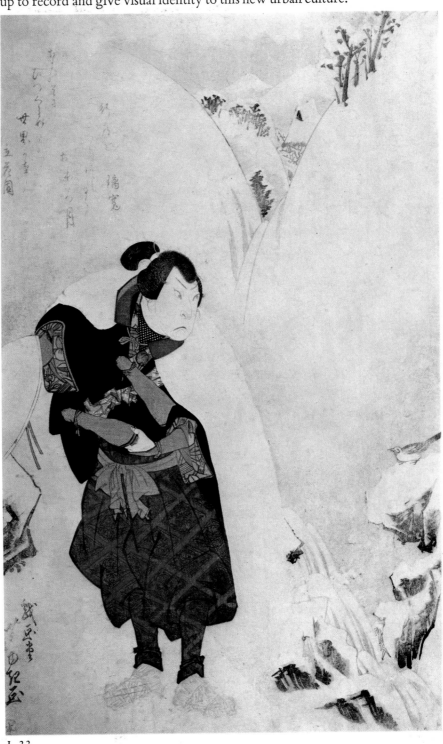

I 33

Historical background

Edo, the old name for modern Tokyo, was known as a small fishing village from the fifteenth century. It was founded as a city at the beginning of the seventeenth century by Ieyasu (1542–1616), the first of the Tokugawa line of shōguns who were to lead Japan until the restoration of the Meiji emperor in 1868. Edo was to be the centre of the military government, safely distant from the enfeebling intrigues of the Imperial Court in Kyoto, which had worked the downfall of earlier military dictators. The emperor was stripped of all but the most ceremonial of functions and the meagrest of revenues.

Japanese society at this time may be simplified into a three-stage hierarchy: at the top were the feudal lords, the daimyō, with their retainers, the samurai. At the bottom were the peasants, whose labour in the fields provided the rentier lords with their rice revenues. The middle was filled by the craftsmen, artists and merchants, who supplied the needs of the upper classes.

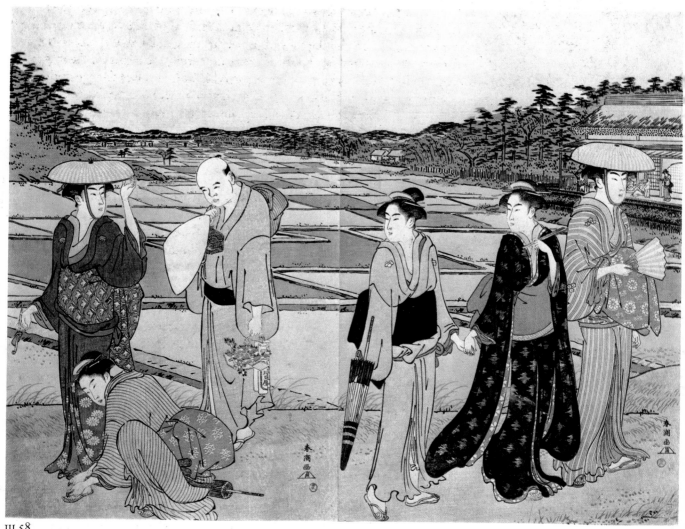

III 58

It had been the rivalry between the lords, secure in their own domains, which had generated the centuries of civil strife, effectively terminated by Ieyasu after his victory at the battle of Sekigahara in 1600, and the elimination of his last major rival in 1615 with the reduction of the great fortress at Osaka. In furthering his desire to prevent recurrence of the sort of disorder which had allowed him to gain supreme power Ieyasu had all the daimyō sign a pledge of loyalty to him. Part of the terms of the pledge was that they should set up a residence in the new city, where their families would live, hostages, the year round, and themselves for at least half the year. The support population, the mercantile class, was largely drawn from the cities of Kyoto and Osaka, to form

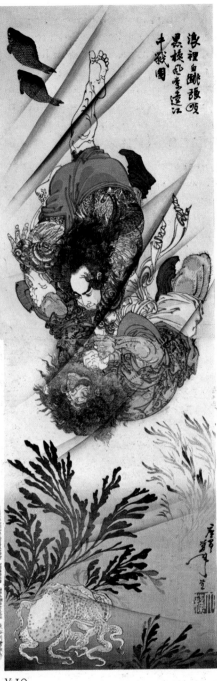

浪裡白跳張順
黒楝船童遼江
千戟圖

V 10

the basis of a rapidly expanding community. From near zero in 1600, excluding the samurai, who were not subject to the census, the population of Edo had grown to 500,000 by 1723 and by 1800 exceeded 1,000,000.

It was around 1600 that a cash economy began to play an important part in life, particularly in the cities, where the sheer volume of business, and the associated long-distance transport problems, precluded the bulky barter system based on rice. The result was that the nobles were forced to convert their rice into coin to pay the merchants. Inflation caused the price of rice to vary wildly, encouraging wealthy merchants to speculate in it. The end result of this confusion was that the peasants were more and more crushed by demands for rice from the lords, who in turn got deeper and deeper into debt with the merchants.

This new wealth could not regularly be used, as was the case in the West, to improve the social position of the merchants outside their own class because of the rigidly formulated social structure, although by the nineteenth century it was not unheard of for samurai rank to be purchased from impoverished members of the class. Consequently the diversions of the city, the theatre, the pleasure quarters and the courtesans therein, the tea and wine shops, elaborate clothing, paintings, lacquer, food, were the natural recipients for the money. Repeated efforts by the government to curb the luxurious life-style of these lower orders by means of sumptuary edicts were without durable effect, at best encouraging a subtler sort of extravagance.

The culture which resulted from this massive spending was distinct from the China-orientated preferences of the ruling classes, and emphasized its Japanese qualities.

The social stalemate was complicated by the ban on foreign trade and travel which Ieyasu imposed in stages, and which was virtually complete by 1640. The reason was his perhaps justifiable fears about the expansionist intentions of the Portuguese and Spanish, and the possible role in this of their Catholic missionaries. The only exceptions to the rule were a few Dutch and Chinese who were permitted an enclave in the port of Nagasaki.

The economic difficulties of the government, exacerbated by floods, famines and the concomitant flight from the land by overburdened peasants, continued to grow throughout the period. The consequent discontent at all levels of society found its chief emotional outlet in religious revival. Numerous quasi-Buddhist sects based on inspiration grew up, and the native Shinto was rehabilitated in the late eighteenth and early nineteenth centuries. This accompanied increased support for the traditional cult of the emperor, who had always remained the titular leader of Japan.

The end of the shōgunal system was heralded by the forced treaty imposed by America in the guise of Commodore Perry and his tiny squadron in 1853 and 1854, although it managed to linger until 1867–68, when after some conflict a new order of things was established under the Meiji emperor.

By the end of the century Japan was strong enough to defeat China and Russia, and it is the prints which record this which have been taken as the end point of this exhibition.

Prior to the fall from real power of the Ashikaga line of shōguns in the sixteenth century, Japanese secular painting was dominated by two schools, which continued to function with somewhat diminished vitality until the end of the nineteenth century. On the one hand, largely patronized by the warrior elite, was the Kano school. This took as its landscape models the academic paintings of Sung China, and later Ming dynasty derivatives of it, and for its figures the bold line of Zen painting. On the other was the more distinctively Japanese Tosa school, its chief patrons the by now impoverished imperial court. Its subject matter was dominated by the romances and personages of the imperial zenith before the twelfth century, its treatment of the subjects minute and detailed, with jewel-like colour enhanced with gold.

The conquests of Nobunaga, Hideyoshi and Ieyasu, who overthrew the Ashikaga, and then one another, were accompanied by the building of great castles. The artists of both schools were called upon to provide the lavish decorations for these castles on a grand scale. The results, now largely lost, combined the linear vigour of Kano with the chromatic vitality of Tosa in a new synthesis. Great numbers of screen paintings were produced, amongst which a few were devoted to scenes from life, chiefly rustic picnics and dancers. Screens, hanging scrolls and handscrolls derived from these castle products were the characteristic paintings of seventeenth century Edo, whose streets and inhabitants provided further subjects. Ukiyo-e proper seems to begin around 1660, reaching its first full flowering in the Genroku period (1688–1703).

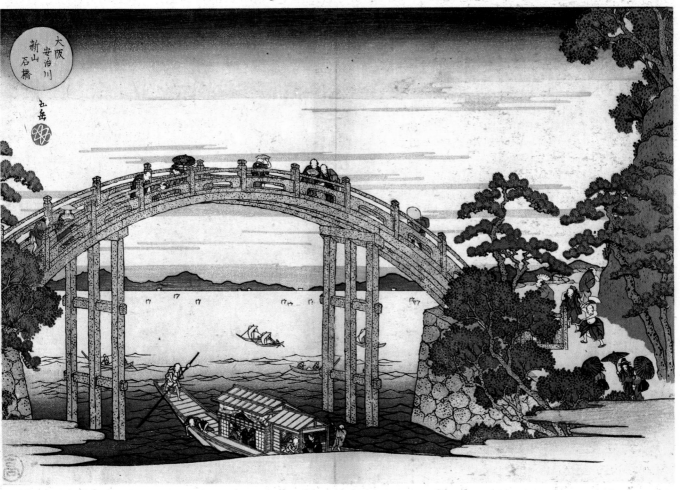

III 55

The enhanced standard of living of the urban mercantile class had been accompanied by an increase in literacy. It is in the illustrations to the popular novels and guides to the brothels, volumes of poetry and sex-manuals which were produced to satisfy this market that the Ukiyo-e print has its origins. The paintings of the Ukiyo-e school, for all that they were by aristocratic standards plebeian, were available only to the wealthier plebeians. The isolated print was a means of extending the social range of the art, by providing it in large quantities at low prices.

The use of the print medium widened the influences on Ukiyo-e to take in both the folk paintings and prints of Otsu, Otsu-e, crude in colouring and bold in outline, which were produced in large quantities for sale to Buddhist pilgrims, and the subtler repertoire of forms of Buddhist iconographical prints.

An appreciation of the development of the Ukiyo-e print, from the bold black lines of Moronobu at the end of the seventeenth century, through the perfection of polychrome printing and its first full exploitation by Harunobu in the mid-eighteenth, to the quasi-Western delicacy of colour and ferocity of feeling in the late nineteenth century Yoshitoshi, is provided by the main body of the catalogue.

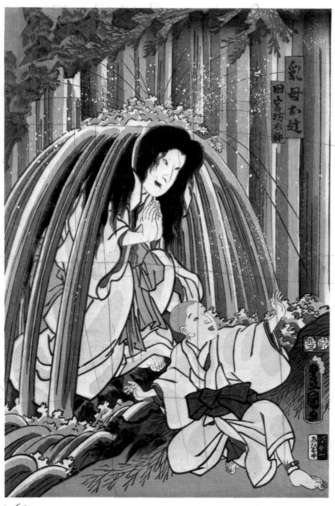

1 65

Technical background

Knowledge of the woodcut medium reached Japan with Buddhism from China, probably in the eighth century. It was extensively used to reproduce charms and images of the gods. In the printing of texts, especially versions of the Chinese classics and the Buddhist scriptures, the usual method was to engrave the whole page of text on one block, despite the fact that the use of movable type (also cut in wood) was known.

The Ukiyo-e woodcut picture was a cooperative endeavour, with the publisher usually the prime mover. The artist produced a line drawing on a very thin paper. This was pasted face down on a block, usually of cherry or pearwood cut with the grain. A team of engravers were engaged in the block cutting. The most skilled would cut round the lines of the drawing, destroying it in the process. The resulting line-block was passed to the printer, who struck off a few proofs: these were returned to the artist, who indicated the areas to be printed in colour. Further blocks, sometimes up to ten in number, were then prepared, one for each colour. Register was ensured by cutting a raised patch on the corner and halfway down the side of the key block. These were printed on to the trial prints, and transferred on to the colour blocks. Thus the only causes of poor register were warped or worn blocks, and dimensional instability in the paper. The blocks were then passed to the printers, also a team. The line image was printed with sumi, an ink made from soot and glue, the colours from a mixture of pigments and rice paste.

The printing was done without a press: the block was covered with pigment brushed on, the paper, lined up carefully on the registration marks, placed on top, and the image transferred by means of a special tool, the baren. The baren is a circular pad, made up of a coil of twisted bamboo sheath cord, and covered with a sheath also made from the outer skin of the bamboo.

The paper chiefly used was a variety called hoshō. This, made from the fibres of the bark of the paper mulberry, was soft in texture, allowing good penetration of the pigment, and yet was strong enough to resist the rubbing of the baren. It also had very good qualities of dimensional stability, essential for good registration.

A variety of specialized techniques were available both in printing and in block cutting, to achieve such finishes as mica or metal dust areas, fades in printing and blind printing, or gauffrage. These were particularly used in the variety of print known as surimono. These were elaborately printed small editions, usually on private commission, and particularly common as New Year cards, with poems complementing the image.

There was no fixed size to an edition, blocks changed hands from publisher to publisher, and colour schemes vary considerably. Damaged blocks would often be recut, involving small changes in the image which it is usually impossible to place in chronological sequence.

For a thorough treatment of the technical side of the Ukiyo-e print, and its modern successors, with a wealth of detail about tools, materials and methods of working, see Yoshida, T., and Yuki, R. *Japanese Print-making*, Rutland, Vermont and Tokyo, 1967.

歌

舞

伎

I *Kabuki: The popular Theatre*

Kabuki was the prime inspiration, and indeed the progenitor, of the Japanese print. Among the ruling class its origins and atmosphere were considered to be far from respectable, and throughout the Tokugawa period it had to fight an almost unceasing battle with official disapproval and harassment. But it was firmly rooted in popular affection, and triumphantly survived all the government's efforts at suppression and censorship on both moral and political grounds.

It is traditionally said to owe its origin to a certain O-Kuni, a beautiful and talented girl, who in 1596 began to stage dances of a religious nature in the dry bed of the Kamo river in Kyoto. As they gained in popularity the performance became more secular, elaborate, and dramatic under the influence of O-Kuni's *samurai* husband, Nagoya Sanzaburō; companies were formed to include a number of ladies of undoubted charm but perhaps dubious morals, and this provoked the first blast of official opposition. In 1629 female performers and dancers were banned outright.

But the tradition of popular drama was established, and was carried on by companies of young men (*wakashu kabuki*). In a very short time, however, there was more scandal, this time of a kind to offer even more violent outrage to the keepers of the public conscience, and in 1644 the *wakashu kabuki* went the way of O-Kuni's young ladies. But a third phase of development proved more fortunate, and by the middle of the seventeenth century the foundations of Kabuki, as we know it, were firmly laid. These foundations may be said to consist in a succession of great acting families, of which the Ichikawa, Nakamura, Onoe, Iwai, Sawamura, and Bandō are the most important in the period with which we are concerned. Each had its own jealously guarded traditions and honoured names, passed down for as many as a dozen generations. The best actors would circulate between Edo, Osaka, and Kyoto, each of which boasted several theatres, besides acting on tour in the provinces. There were, of course, no actresses, all female parts being taken by *onnagata*, actors who specialized in this work, and certain families, such as the Iwai and the Segawa, consisted entirely of *onnagata*.

The main plays were either historical pieces (*jidaimono*) or plays of ordinary life (*sewamono*), leavened with musical performances, dancing, and various 'specialities'. Programmes were long, lasting most of the day, and fresh productions were staged every two months or so at the various theatres. So there was no lack of material for the *ukiyoe* artists who specialized in theatrical subjects, and the public enthusiasm for the drama and adulation of the principal actors ensured a constant demand for their work. Block-printed illustrations to books were known in Japan from the late sixteenth century, and from the earliest years of the true Kabuki this medium was eagerly seized upon to supply the theatre-going public with representations of their favourites.

But official harassment of the popular theatre and all associated activities, such as print-making, was almost continuous, reaching its peak in 1842 with the so-called Reforms of Tempō. Two of the Edo theatres had been destroyed by fire, and Kabuki was in imminent danger of complete suppression, but eventually they were allowed to be rebuilt in a sort of theatrical ghetto, Young Monkey Street (Saruwaka-chō), as far as possible from Edo castle, the Shōgun's residence. At the same time Ichikawa Danjurō VII, the greatest actor of his time, and a vivid and flamboyant personality, was expelled from Edo for nearly ten years on account of his over-lavish stage productions, his extravagant private life, and his infringement of *samurai* privilege in wearing real armour on the stage. As part of the same 'reforms', *ukiyoe* artists were forbidden, amongst other things, to make prints of theatrical subjects, a ban which they soon contrived to circumvent in a variety of ingenious ways. Nevertheless from 1842 to 1862 we no longer find

the actors' names on the prints, so must rely for identification on our ability to recognize the features of the star performers.

Throughout the history of Kabuki detailed and accurate records were kept of all productions staged; these have been edited and published from time to time by Japanese scholars, and are invaluable for identifying and dating theatrical prints. But we must remember that favourite plays were staged on numerous occasions, sometimes even simultaneously at two different theatres, that over the years an actor often played the same role in different productions of the same play, that certain characters occur in a number of different plays, and that a prominent actor might take as many as seven different parts in the same play. So the positive identification of the production represented in a given print is not always so simple a matter as might be imagined. In addition to all this, actors frequently changed their names. But once the production has been identified, it may safely be assumed that the print was published within a month of the beginning of the 'run'.

There is no space available here to discuss the aesthetics of Kabuki, to describe the Japanese acting conventions, or to tell the stories of the plays. The prints must speak for themselves.

B. W. Robinson

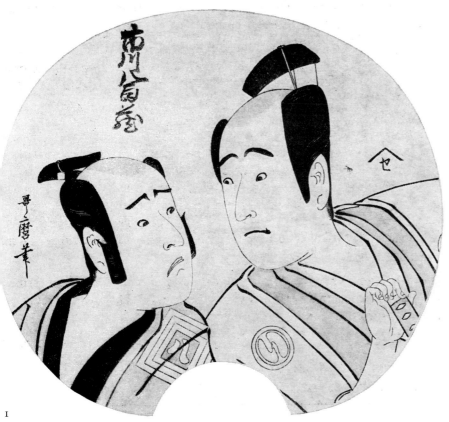

I

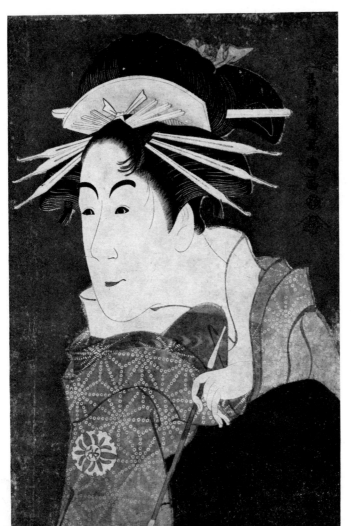

1 1–1 8 Edo Prints

1 1
Utamaro
c.1780

Portraits of the actors Ichikawa Yaozō III (left)
and Sawamura Sōjurō III (right). Publisher
unidentified. Fan print.
Signed: *Utamaro fude* Publisher's seal: *Se.*
22·9 × 26·7 (9 × 10½) E.2378–1912

Both the subject-matter and the format are
unusual ones for Utamaro, as is the use of a
dominant sulphurous yellow.

The two actors were brothers, being sons of
Sawamura Sōjurō II. The theatre, like much
of the rest of Japanese culture, was in theory
rigidly hereditary, but the possible bad con-
sequences of this system were mitigated by
the device of adoption. Here a Sawamura
became an Ichikawa.

Yaozō's name has been added to the print in
manuscript.

1 2
Sharaku
1794

Portrait of the actor Matsumoto Yonesaburō
as Shinobu, posing as Kewaizaka no Shōshō in
the production of Kataki-uchi Noriai-
banashi at the Kiri-za in the fifth month of
Kansei 6 (June 1794). Published by Tsuta-ya
Jūsaburō, (Kōshodō).
Signed: *Tōshūsai Sharaku ga* Publisher's
mark. Censor seal: *kiwame.*
36·2 × 24·4 (14¼ × 9⅞) 1909–06–18–52

Lent by permission of the Trustees of the
British Museum

Shinobu was one of two sisters whose father
had been murdered. She posed as a courtesan
in order to avenge his death.

An atmosphere of veiled menace is conveyed
by the thin smile on the lips contrasted with
the staring eyes, and is enhanced by the dark
background of mica dust, a device of which
Sharaku was particularly fond.

I 3

Toyokuni

1800

Portrait of the actor Onoe Matsusuke as the
villain Kudō Suketsune in the production of
Saihai Soga in the first month of Kansei 12
(February 1800). Published by Tsuru-ya
Kiemon.
Signed: *Toyokuni ga* Publisher's mark.
37·2 × 24·6 (14⅝ × 9⅝) E.994–1914

Kudō was the villain responsible for the
murder of Kawazu no Saburō, the avenging
of which is the principal plot in the Soga
Monogatari (see V9, V43).

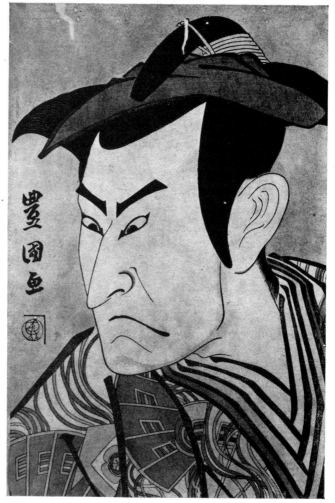

I 3

I 4

Toyokuni

c.1800

Portrait of the actor Sawamura Gennosuke as
(?) Kōtoya Rijirō, from a series of portraits
against patterned grounds.
Signed: *Toyokuni ga*.
37·5 × 24·1 (14¾ × 9½) E.3241–1953

Bequeathed by Sidney Lee, RA, RE, RWS, and
Mrs Edith Mary Lee

This actor later became Sōjurō IV, the family
resemblance between him and the brothers in
I I being easily detectable.

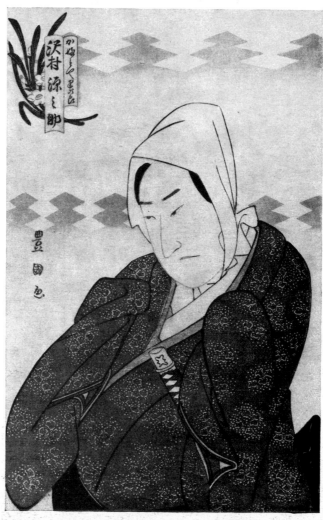

I 4

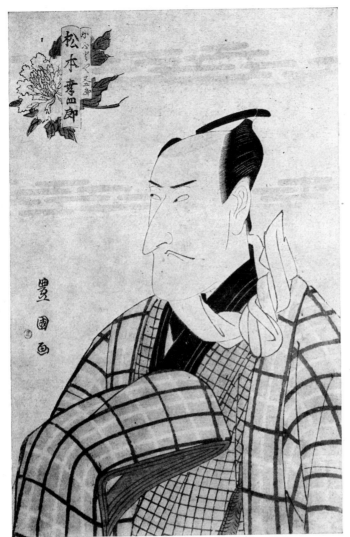

15

Toyokuni
c.1800

Portrait of the actor Matsumoto Kōshirō vas
Kōtoya Bungorō. From the same series as the
previous entry.
Signed: *Toyokuni ga.*

37·5 × 24·8 (14¾ × 9¾) E.4838–1886

15

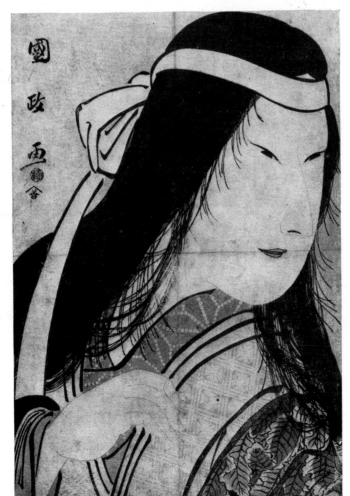

16

Kunimasa
c.1800

Portrait of an actor, probably Onoe
Matsusuke, as Yama-uba in the production of
Modori-bashi at the Kawarazaki-za in the
eleventh month of Kansei 12 (December
1800). Publisher unidentified.
Signed: *Kunimasa ga* Publisher's seal: *Zen*
Censor seal: *kiwame.*

34·5 × 24·2 (13⅝ × 10½) 1910–04–18–187

Lent by permission of the Trustees of the
British Museum

For Yama-uba, the foster mother of the strong
boy Kintoki, see v 34. Compare with 13, a
portrait of the same actor in a male role.

Kunimasa's large heads have a power equiv-
alent to that of the Sharaku's, but lack the
acidic undertones.

6

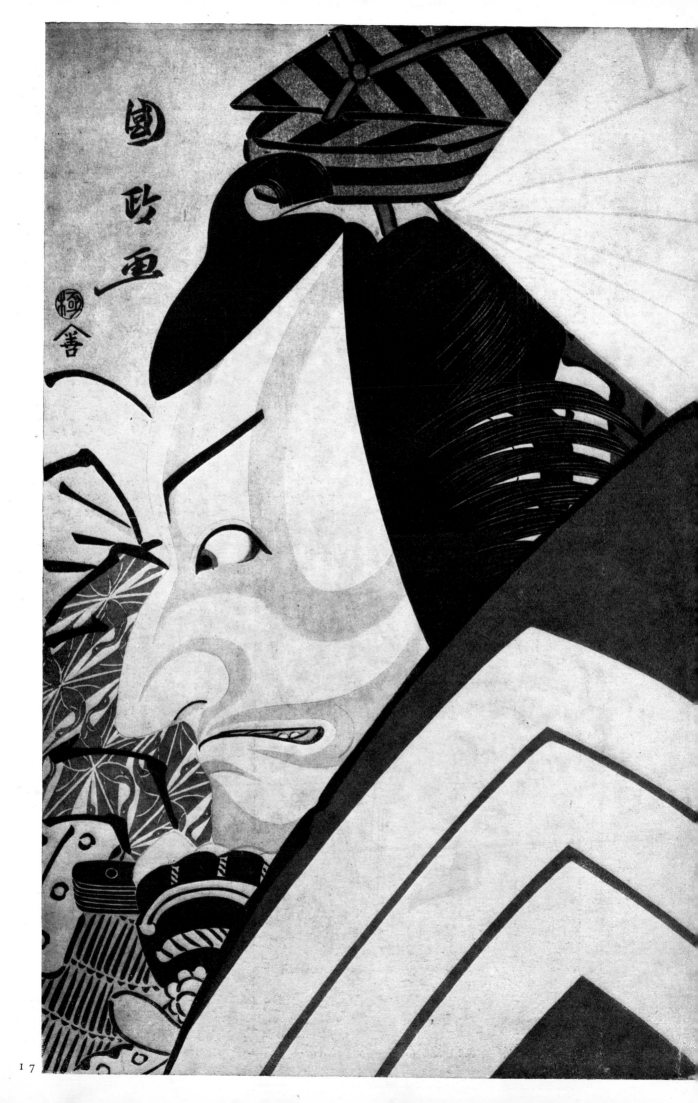

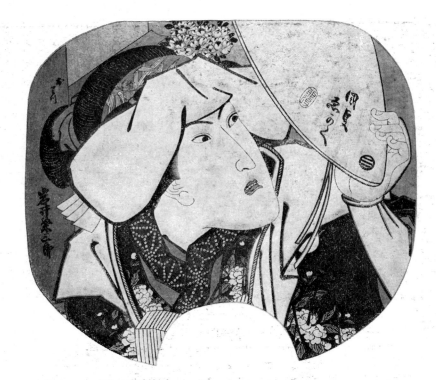

I 7

Kunimasa

c.1796

Portrait of the actor Ichikawa Danjurō v in a shibaraku role, probably Usui no Sadamitsu in the production of Ō-atari Genji at the Miyako-za in the eleventh month of Kansei 8 (December 1796). Publisher unidentified.
Signed: *Kunimasa ga* Publisher's seal: *Zen*
Censor seal: *kiwame.*
38·9 × 25·8 (15¼ × 10⅛) 1906–12–20–462

Lent by permission of the Trustees of the British Museum

This sort of role, called shibaraku, 'wait a minute', after the cry of the actor before setting to the scene is the epitome of the aragoto, rough stuff, which appealed to Edo audiences. It is characterized by the ferocious make-up, and by grotesquely exaggerated costume and swords (see I 29, I 30). The action consisted in a lot of swaggering, foot-stamping and cutting-off of heads.

I 8

Kunisada

1831

Portrait of the actor Iwai Kumesaburō (later Hanshirō vi) as O-Ritsu, wife of the robber Ishikawa Goemon, in the production of Masago no shiranami at the Nakamura-za in the third month of Tempō 2 (May 1831). Published by Iba-ya Sensaburō (Dansendō). Fan print.
Signed: *Kunisada egaku* Publisher's mark.
Censor seal: *Hare* combined with *aratame.*
22·9 × 27·0 (9 × 10⅝) E.2938–1913

Given by Mr R. Leicester Harmsworth, MP

I 9–I 18 Osaka prints

I 9

Ashihiro

c.1815

Portrait of the actor Ichikawa Morinosuke as Hayano Kampei in the Chūshingura drama. Published by Honsei.
Signed: *Harukawa Ashihiro ga* Publisher's mark. Engraver's mark: *Ono.*
37·6 × 25·4 (14¾ × 10) E.2836–1886

For the story of the Chūshingura see v48. Kampei was one of the loyal retainers. The Osaka school, while always under the influence of Edo artists such as Toyokuni, Hokusai and Kunisada, nevertheless achieved a distinct feeling of its own, partly characterized by an interest in representation of texture, and a consequent wide use of such techniques as metallic colouring, which were restricted to the surimono in Edo. This distinctness gradually lessens during the course of the century until such productions as I 18, which perhaps reflects the unification of previously different Kabuki traditions.

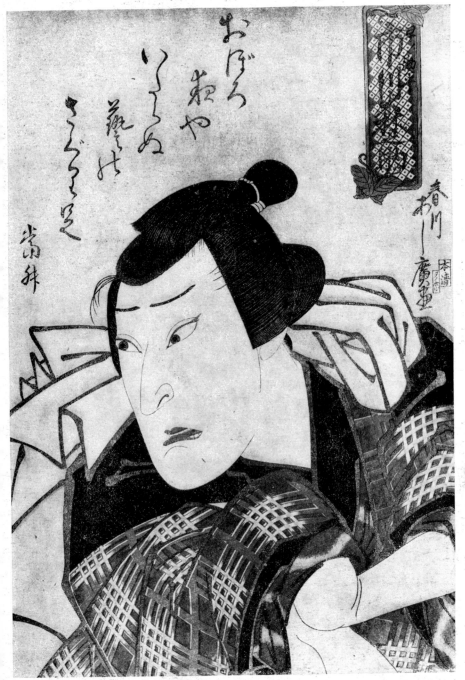

I 8

I 9

Hokuei

c.1834–1835

Ryukō kagami no kasumi, Mist on the mirror of fashion. Portraits of the actors (left to right) Arashi Rikan II as O-Hagi (really Mukan-no-tayu Atsumori), Nakamura Shikan, later Utaemon IV, as Tawara Tōda Hidesato, Arashi Rikan II, again, as Washio Saburō, Seki Sanjurō as Gorota (really Hayano Kampei) and Nakamura Tomijurō II as the serving girl O-Taka.
Published by Tenki (Kinkadō). Pentaptych.
Signed: *Shumbaisai Hokuei ga* Artist's seals: *Sekkaro* (two versions) and *Hokuei* Engraver's seal: *Kumazō* Printer's seal: *Hide*.
37·6 × 127·0 (14¾ × 50) E.5060–1886

The fleeting qualities of floating world life are admirably contained in the title of this set, and by the use of the mirror surface as the ground for the heads.

This is a good example of a polyptych which works well as single images, but is reinforced by the interplay between the different faces.

The roles are from different plays, and are probably the pick of the season's best productions.

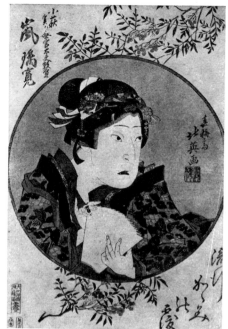
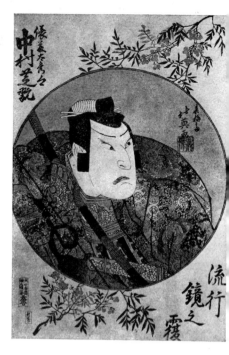

I 10

Hokushū

1825

Portrait of the actor Nakamura Utaemon III as the villain Kyōgoku Takumi, represented on a fan. This was his special performance (isse-ichidai) in the production of the play Hikosan at the Kadono-za, Osaka, in the third month of Bunsei 8 (March-April 1825). Publisher unidentified.
Signed: *Shunkōsai Hokushū ga* Artist's seal: *Hokushū* Publisher's mark and seal: *Chū* Engraver's (?) seal: *Goichi*.
36·8 × 25·4 (14½ × 10) E.1321–1922

T. H. Lee Bequest

The effect of the mirror disks in the last entry and the fan in this is to detach the image from the pictorial space, with the implication of existence in a separate reality. This same device was used in Buddhist painting from which it may derive.

The ribs on the fan are indicated by blind printing.

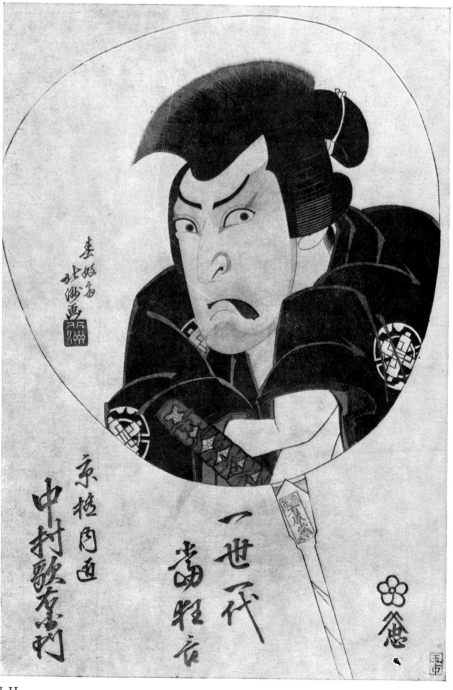

I 11

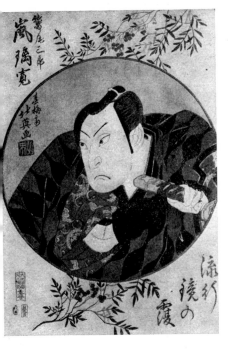

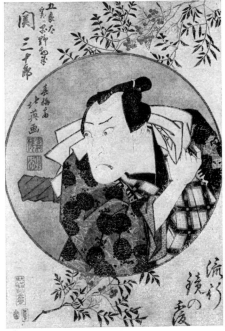

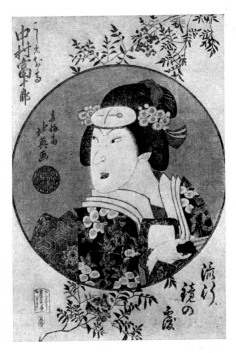

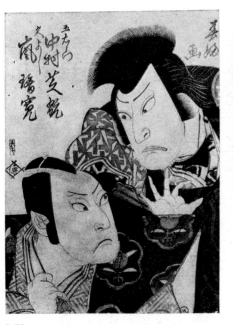

I 12

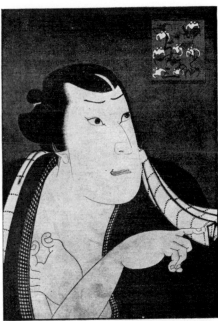

I 13

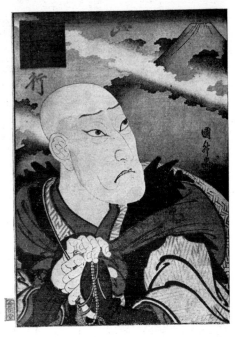

14

I 12
Hokushū
c.1830

Portraits of the actors Arashi Rikan II (left) as
Hisayoshi and Nakamura Shikan, later
Utaemon IV, as the robber Ishikawa Goemon.
Published by Tenki (Kinkadō).
Signed: *Shunkō ga* Publisher's seal.
17·8 × 12·1 (6⅝ × 4¾) E.212–1898

Both of these actors are also depicted in the
Hokuei pentaptych, I 10. The shock of hair in
this and the previous prints is indicative of
villainous characters. Respectable people
decently shaved the hair from the top of their
heads.

I 13
Tomiyuki
? 1836

Portrait of an actor, possibly Nakamura
Utaemon IV, as Yosō in the production of
Haru no tori at the Kadono-za, Osaka, in the
first month of Tempō 7 (February 1836).
Signed: *Tomiyuki ga.*
24·5 × 17·5 (9⅝ × 6⅞) E.12624–1886

I 14
Kunimasu
c.1840

Actor as the priest Saigyō Hōshi in front of
Mt Fuji: an illustration of the Kakegawa stage
of the Tōkaidō. Published by Tenki
(Kinkadō).
Signed: *Kunimasu ga* Undeciphered artist's
seal. Publisher's seal.
25·1 × 18·1 (9⅞ × 7⅛) E.5517–1886

For the Tōkaidō see III 2.

Saigyō Hōshi (1115–1190) was a nobleman
who turned monk. He is particularly associ-
ated with Mt Fuji, which he praised in his
poetry. He is always shown wearing a large
pilgrim's hat, here seen only as a brief patch of
woven straw above his shoulder, and carrying
a staff.

This is a particularly fine example of the
Osaka penchant for elaborate printing tech-
niques used to describe rich textures.

I 15
Hirosada
c.1840

Portrait of an actor as ? Sarunango, from a long series of actor portraits.
Signed: *Hirosada*.
$23 \cdot 2 \times 16 \cdot 2 \left(9\frac{1}{8} \times 6\frac{3}{8}\right)$ E.3120–1886

I 16
Hirosada
c.1840

Portrait of an actor as Ōte no O-Roku, from the same series as the previous entry. Publisher unidentified.
Signed: *Hirosada* Artist's seal: ? *Hiro*
Undeciphered publisher's seal.
$23 \cdot 2 \times 16 \cdot 2 \left(9\frac{1}{8} \times 6\frac{3}{8}\right)$ E.3136–1886

These two prints are unusual in that they provide supports for the figures, and thereby violate the indefinite space which is the customary background for close-up portraits.

I 17
Kuniaki
1861

Portrait of the actor Nakamura Shikan as Toneri Matsuōmaru in the play Sugawara. Published by Hori Takichi.
Signed: *Kuniaki ga* Publisher's seal. Censor seal: *aratame* combined with *Cock 11*.
$36 \cdot 8 \times 25 \cdot 4 \left(14\frac{1}{2} \times 10\right)$ E.5234–1886

For the story of Sugawara no Michizane, upon whose tragic career this play was based, see V 31. The play involves three episodes of triplets parting from their children. Matsuōmaru, a henchman of the villain of the piece, is forced to sacrifice the life of his son to protect that of Sugawara's.

I 18
Kunichika
1865

One of the series Mitate etehon. Selected illustrated specimens: portrait of the actor Bandō Hikosaburō IV as Kanshōjō (Sugawara no Michizane). Published by Shima-Tetsu.
Signed: *Kunichika ga* Artist's seal: toshidama seal of the Utagawa school. Publisher's seal.
Engraver's seal: *Hori Ushi*.
$36 \cdot 8 \times 24 \cdot 1 \left(14\frac{1}{2} \times 9\frac{1}{2}\right)$ E.5371–1886

The plum tree is particularly associated with Sugawara.

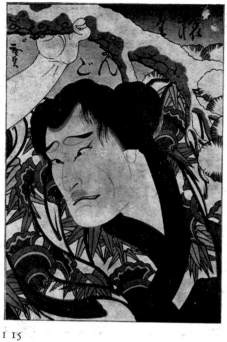
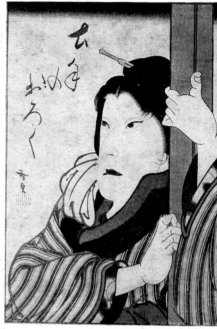

I 15 I 16

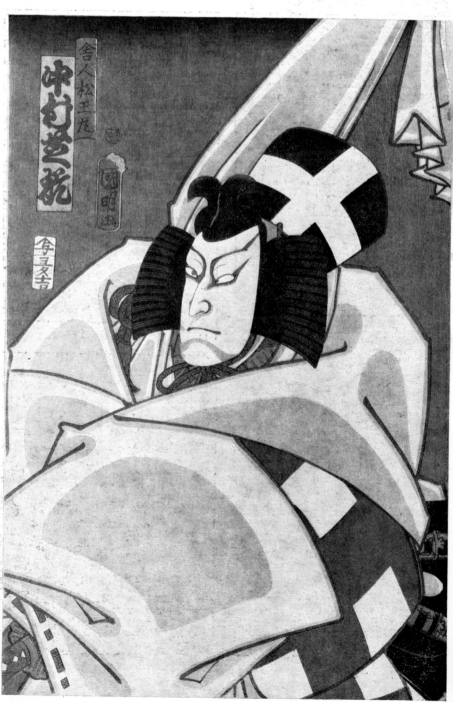

I 17

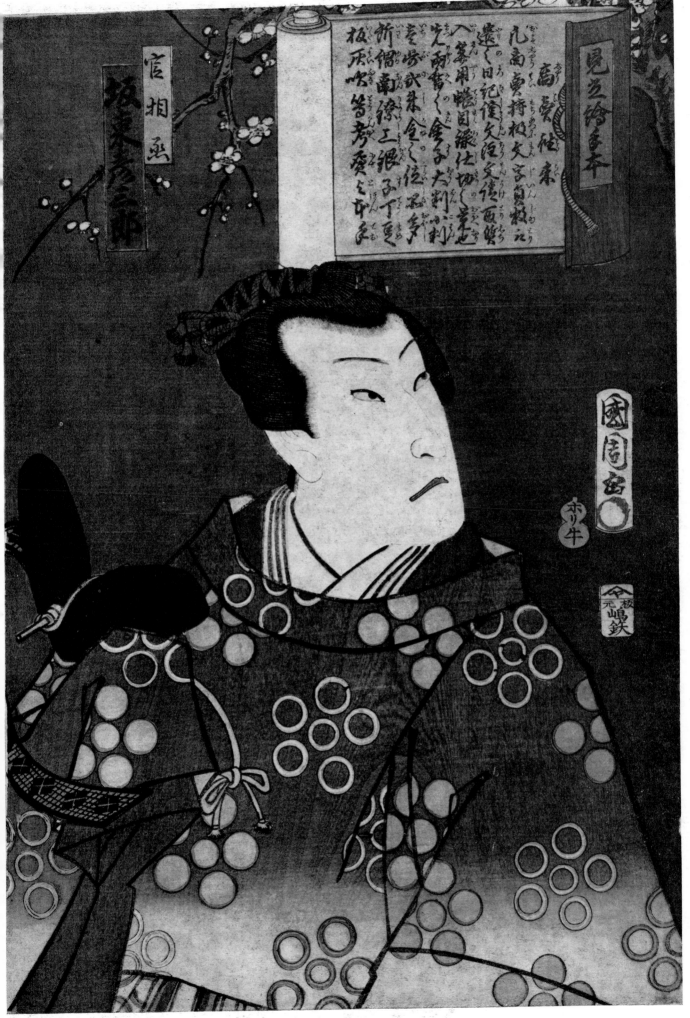

I 19
Kiyomitsu
c.1760

Portrait of the actor Sakata Hangorō I as Yamada Saburō. Published by Nishimura-ya Hibino (Eijudō).
Signed: *Torii Kiyomitsu ga* Publisher's mark and seal.
31·1 × 14·6 (12¼ × 5¾) E.289–1952

Bequeathed by Miss Rose Shipman

The Torii family were the authorized publicists for the theatre from the inception of the print tradition. Kiyomitsu was of the third generation to carry out this role. Their rather stiff iconic approach to actor portraits was superseded by the more lively full colour realistic treatment given to the subject by the Katsukawa school (see I 22–I 28 among others), and the Torii school sank into an obscurity enlivened only by Kiyonaga, who is better known for his non-theatrical work (see II 44, III 59).

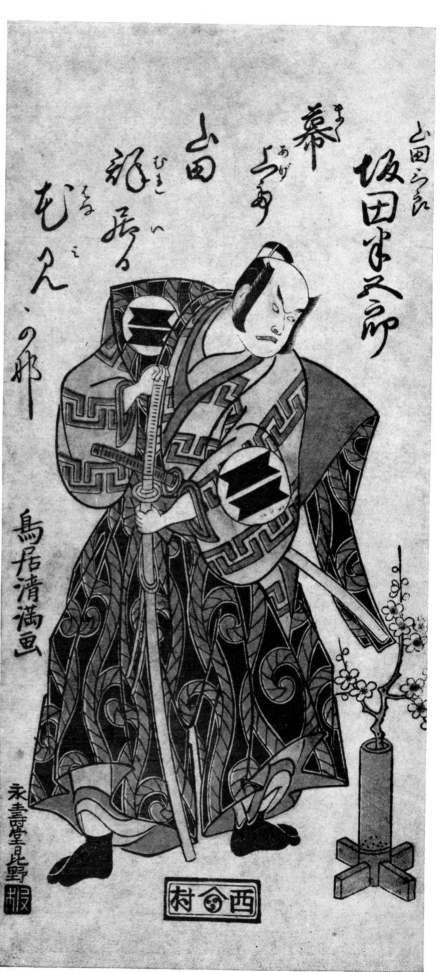

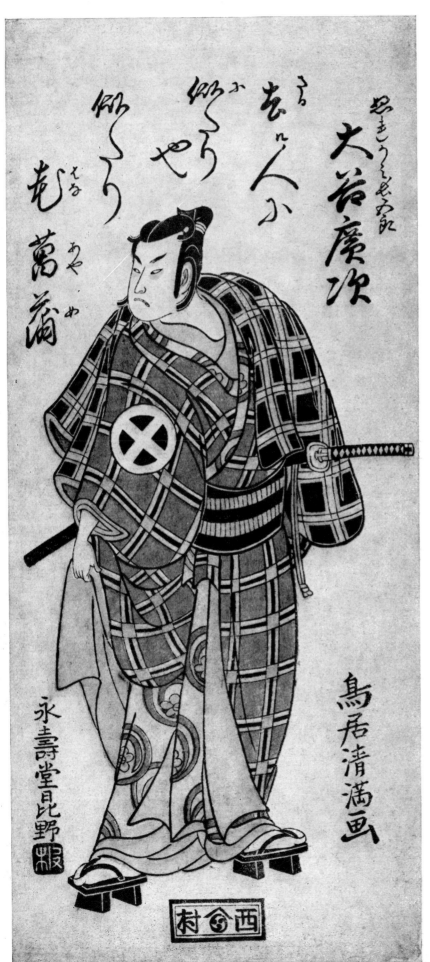

I 20
Kiyomitsu
c.1750–1760

Portrait of the actor Ōtani Hiroji II as the wrestler Nuregami Chōgorō. Published by Nishimura-ya Hibino (Eijudō).
Signed: *Torii Kiyomitsu ga* Publisher's mark and seal.
30·7 × 13·9 (12⅛ × 5½) 1954–04–10–07

Lent by permission of the Trustees of the British Museum

I 21

Kiyomitsu

c.1750–1760

Portrait of the actor Onoe Kikugorō I (Baikō) as Katsuta no Jirō Narinobu in the play Mume momiji Date no Ōkido, holding a mirror. Published by Urokogata-ya Magobei. Signed: *Torii Kiyomitsu fude* Publisher's mark.

30·7 × 14·1 (12⅛ × 5⅝) 1906–12–20–22

Lent by permission of the Trustees of the British Museum

The poem on this print indicates that it celebrates the début of this actor.

I 22

Shunshō

c.1770

Portrait of an actor, probably Nakajima Mioemon II, as a samurai. Signed: *Shunshō ga*. 30·8 × 14·6 (12⅛ × 5¾) E.53–1969

Bequeathed by Mr Paul Shelving

Many, if not all, the prints of this size form one of a triptych, but function equally well as isolated compositions.

The actor is holding a closed fan in his right hand.

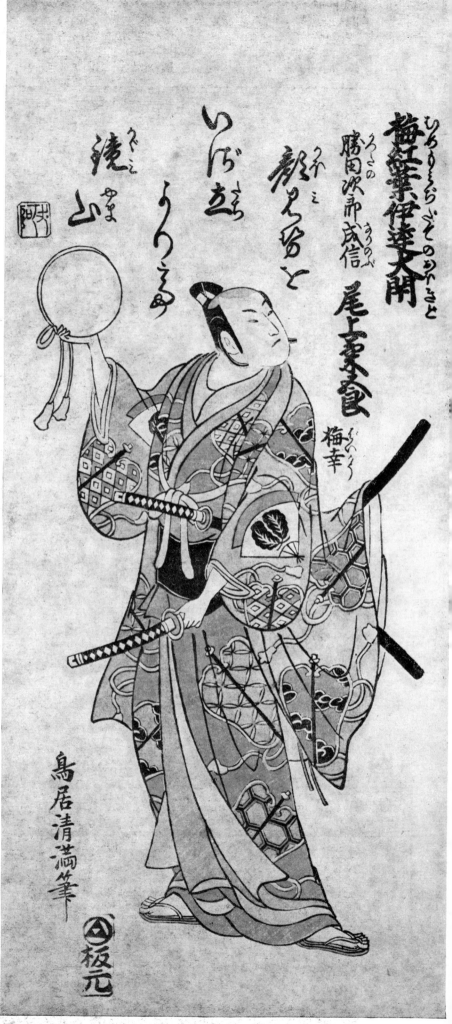

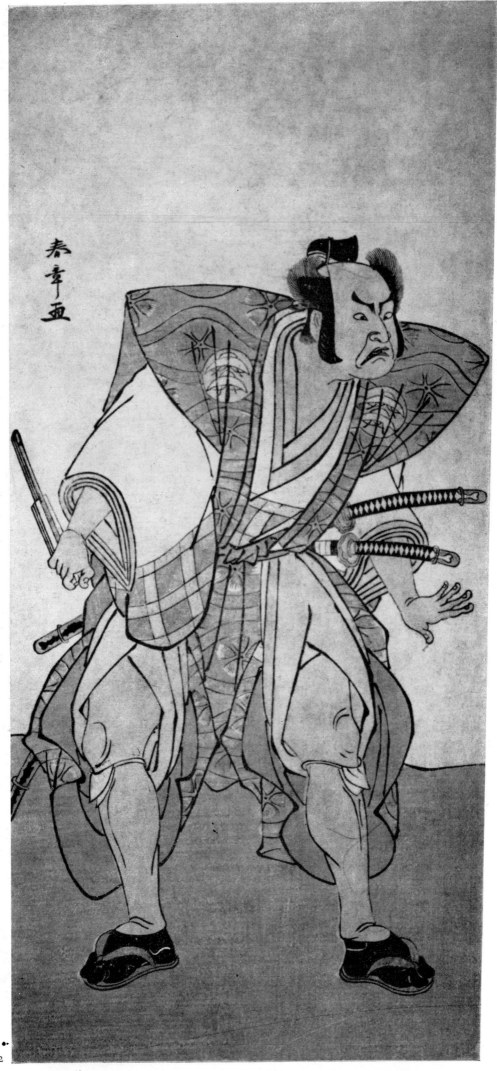

Shunshō

c.1770

Portrait of the actor Nakamura Denkurō II
as a retainer holding a tied-up banner.
Signed: *Shunshō ga* Collector's seal:
Deurasu.
32·1 × 14·6 (12⅜ × 5¾) E.47–1969

Bequeathed by Mr Paul Shelving

The background scenery, a Katsukawa school
novelty, is a halfway compromise between
stage scenery and natural landscape.

I 24

Shunshō

c.1770

Portrait of the actor Nakamura Denkurō II
as Watanabe no Tsuna in court dress.
Signed: *Shunshō ga* Collector's seal: *Deurasu.*
31·4 × 14·6 (12⅜ × 5¾) E.48–1969

Bequeathed by Mr Paul Shelving

The name of the actor Nakamura Nakazō has
been added to the print in manuscript. This is
erroneous. The mon, badges, of the two actors
are quite different.

Watanabe no Tsuna was the henchman of the
hero Raikō. For a note on them see V 58 and
V 59.

I 25

Shunshō

c.1780

Portrait of the actor Iwai Hanshirō IV in a
female role.
Signed: *Shunshō ga.*
33·0 × 15·2 (13 × 6) E.4985–1916

Given by the Misses Alexander

I 26

Shunkō

c.1780

Portrait of the actor Ichikawa Danjurō V in a
samurai role.
Signed: *Shunkō ga.*
30·5 × 13·7 (12 × 5⅜) E.57–1969

Bequeathed by Mr Paul Shelving

Shunkō's work is distinguished from his
master Shunshō's largely by an increase in the
internal tension within the figures.

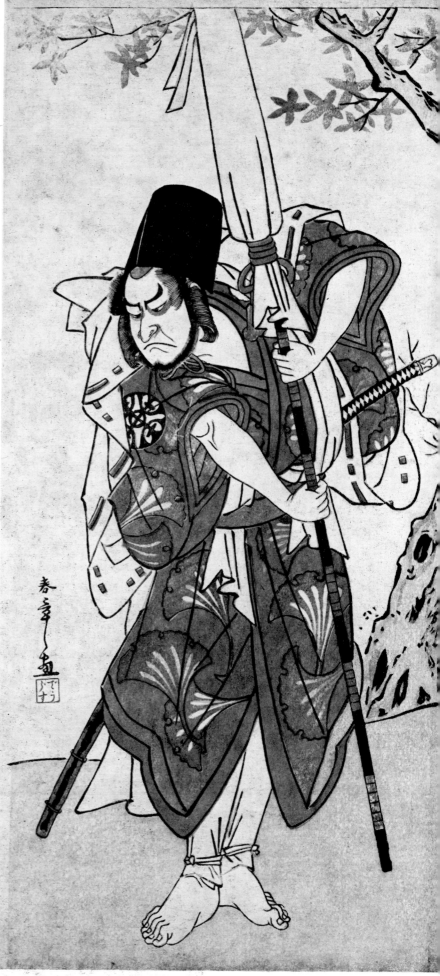

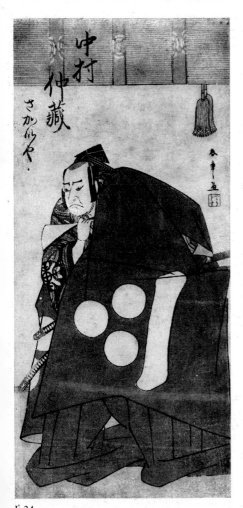

I 24

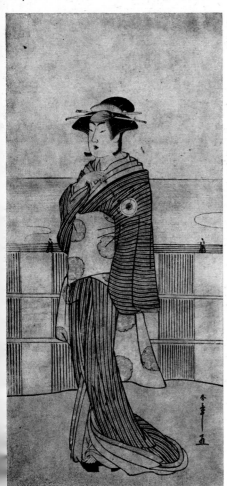

I 25

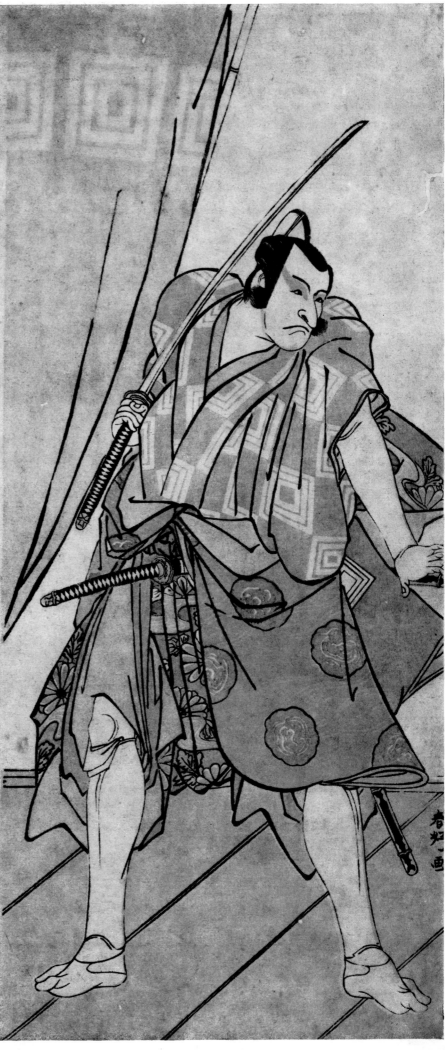

I 26

I 27
Shunkō
c.1780

Portrait of the actor Segawa Kikunojō III in a
female role dancing with a hand-drum
(tsuzumi).
Signed: *Shunkō ga.*
30·5 × 14·3 (12 × 5⅝) E.1296–1886

The lack of background and the swirling of
the kimono give this dance a floating
ethereal feeling.

I 28
Shunkō
c.1780

Portrait of an actor in a female role.
Signed: *Shunkō ga.*
32·4 × 15·6 (12¾ × 6⅛) E.58–1969

Bequeathed by Mr Paul Shelving

The actor, who may be of the Onoe line, is
wearing a kimono with a hare and wave
pattern. This pattern is a metaphor for moon-
light on the sea, the hare that lives in the moon
sending little images of himself as moonbeams.

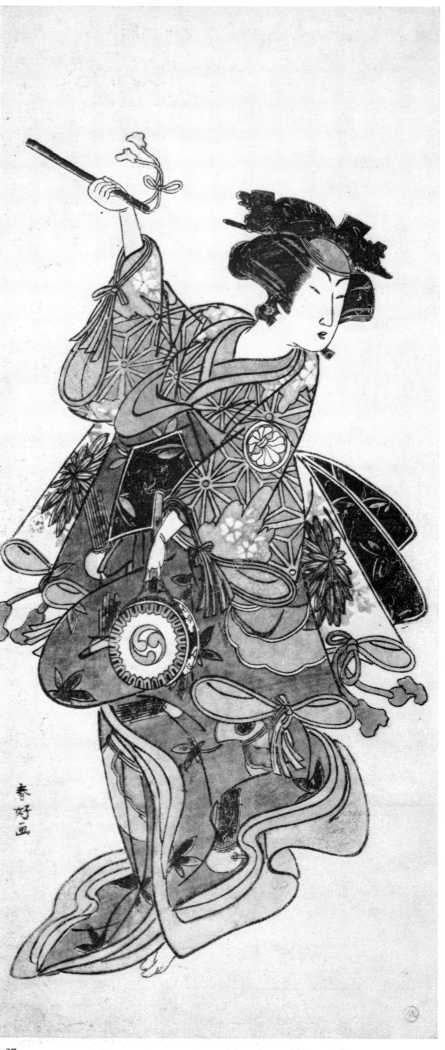

I 27

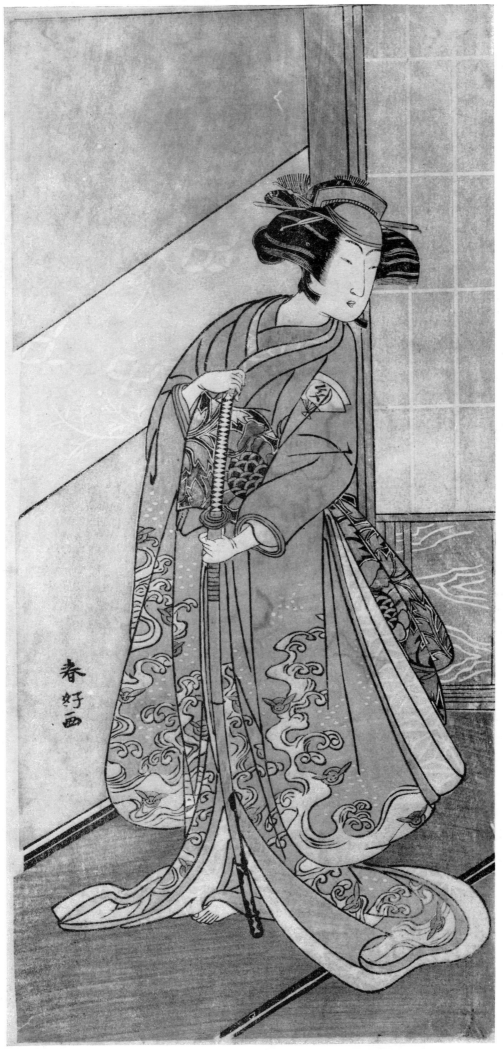

I 28

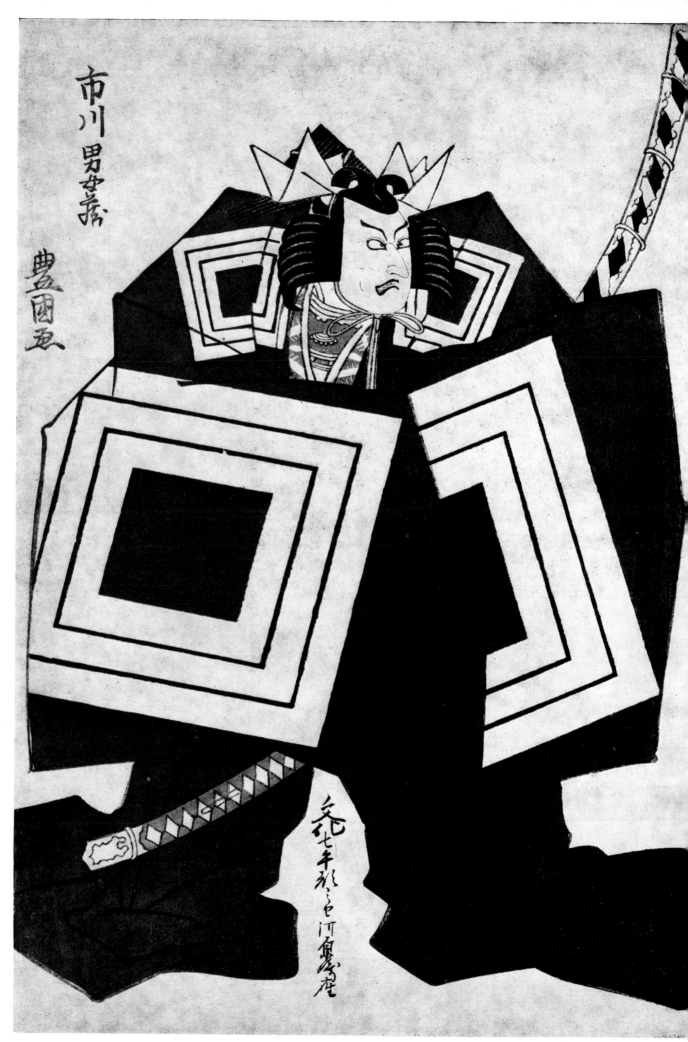

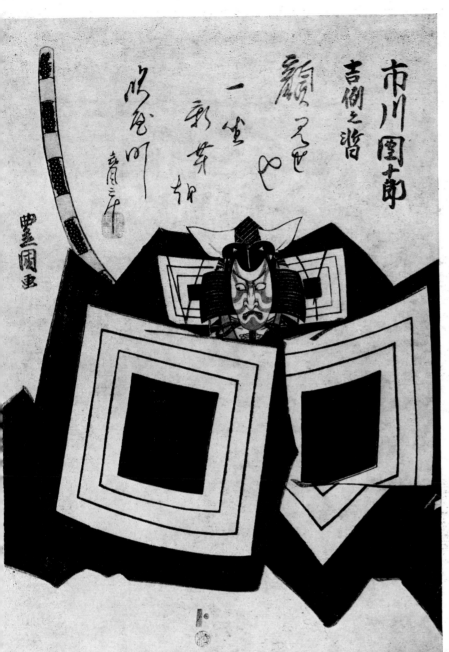

I 29
Toyokuni
1810

Portrait of the actor Ichikawa Omezō in the aragoto piece Shibaraku.
Signed: *Toyokuni ga.*
38·7 × 26·0 (15¼ × 10¼) E.4829–1886

For aragoto and Shibaraku see I 7.

A hand-written note at the bottom of this print states that the performance took place at the Kawarazaki theatre in Bunka 7 (1810).

I 30
Toyokuni
1807

Portrait of the actor Ichikawa Danjurō VII in the shibaraku part of Kumai Tarō in a production of Yashima Gaijin at the Ichimura-za.
Published by Yamaguchi-ya Tōbei.
Signed: *Toyokuni ga* Publisher's mark
Censor seal: *kiwame.*
38·7 × 40·0 (15¼ × 10¾) E.12646–1886

This print commemorates the kaomise, début, of Danjurō VII as a full-grown actor.

I 31
Hokuchō
c.1820–1830

Portrait of the actor Nakamura Matsue as the young girl O-Mitsu. Published by Honsei. Sheet from a pentaptych.
Signed: *Shunshōsai Hokuchō ga* Publisher's seal. Engraver's seal: *Osaka, Kasuke horu*
Inscribed: *Go-mai tsuzuki* (Set of five sheets).
38·1 × 25·4 (15 × 10) E.4751–1886

For a complete polyptych in similar style see I 54.

Note the depiction of moiré patterns on the striped silk.

I 32
Hokuei
c.1830

Portrait of the actor Arashi Rikan II as Sasaki Saburō Moritsuna in court dress. Published by Honsei.
Signed: *Shunkōsai Hokuei ga* Artist's seal: *Hokuei* Publisher's seal.
36·5 × 20·0 (14⅜ × 9⅞) E.5130–1886

For other portraits of Rikan II see I 10, I 12, I 33, I 49, I 50 and I 53. A busy actor.

I 31

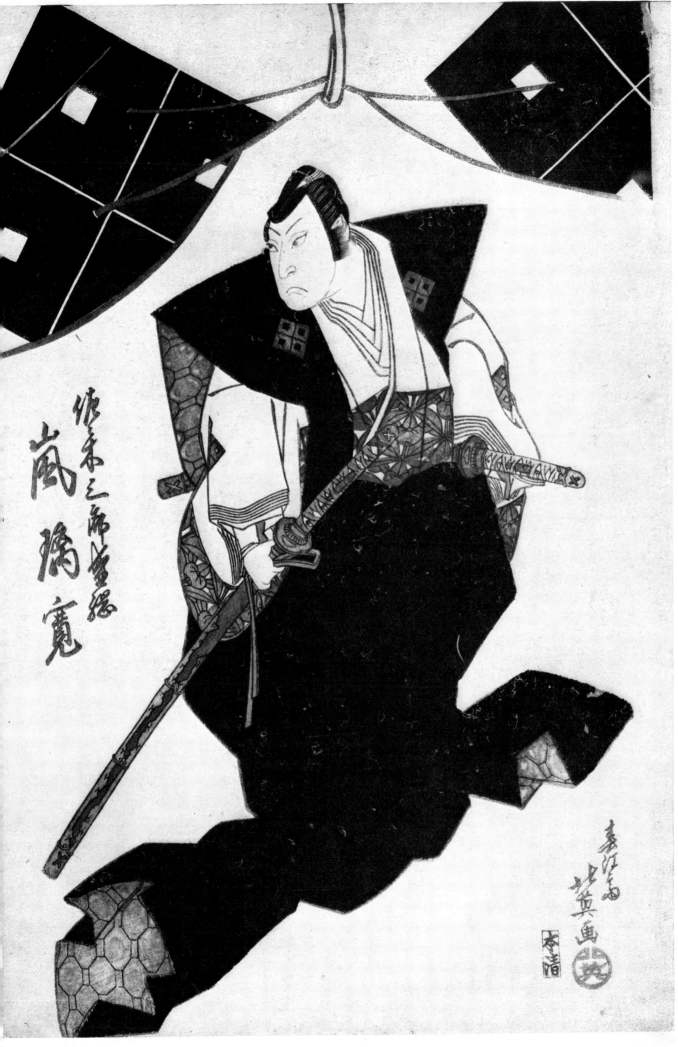

作者三府豊穂
嵐璃寛

嘉永三年
英画
李清

I 33
Ashiyuki
c.1820

Portrait of the actor Arashi Rikan II as a
samurai. Published by Honsei.
Signed: *Gigadō Ashiyuki ga* Publisher's mark.
37·2 × 23·5 (14⅝ × 9¼) E.2843–1886

Once again the textural contrasts are brilliant.
The rich dark colours of the samurai's clothes
are overprinted with metallic lines. The white
cloak causes his silhouette to merge with the
snowscape. The resulting dark mass gives a
feeling of human agitation contrasted with
winter quiet.

I 34
Sadanobu
1838

Portrait of the actor Nakamura Utaemon IV
as Shōki the demon-queller, one of seven
specialities he performed at the Nakamura-za,
Osaka, in the first month of Tempō 9
(February 1838). Published by Honsei.
Signed: *Hasegawa Sadanobu ga* Unde-
ciphered artist's seal. Publisher's seal.
37·5 × 25·4 (14¾ × 10) E.12308–1886

For Shōki see v26–v28.

The figure of Shōki is executed in shades of
red. Red was the colour in which magic
charms and talismans were painted, and Shōki
was one of the favourite talismans.

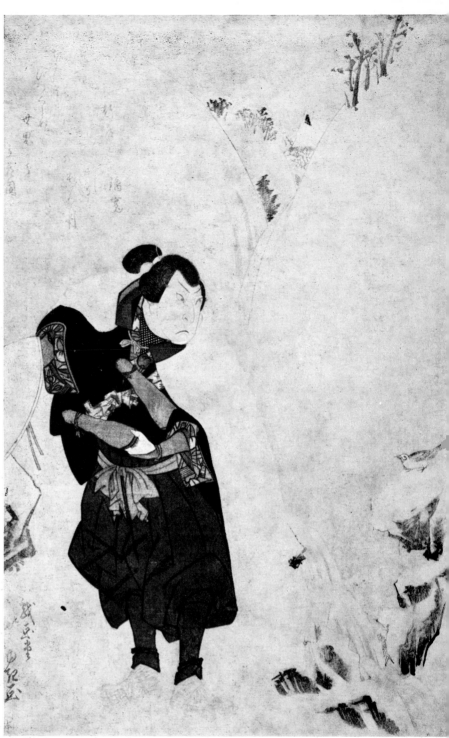

I 33

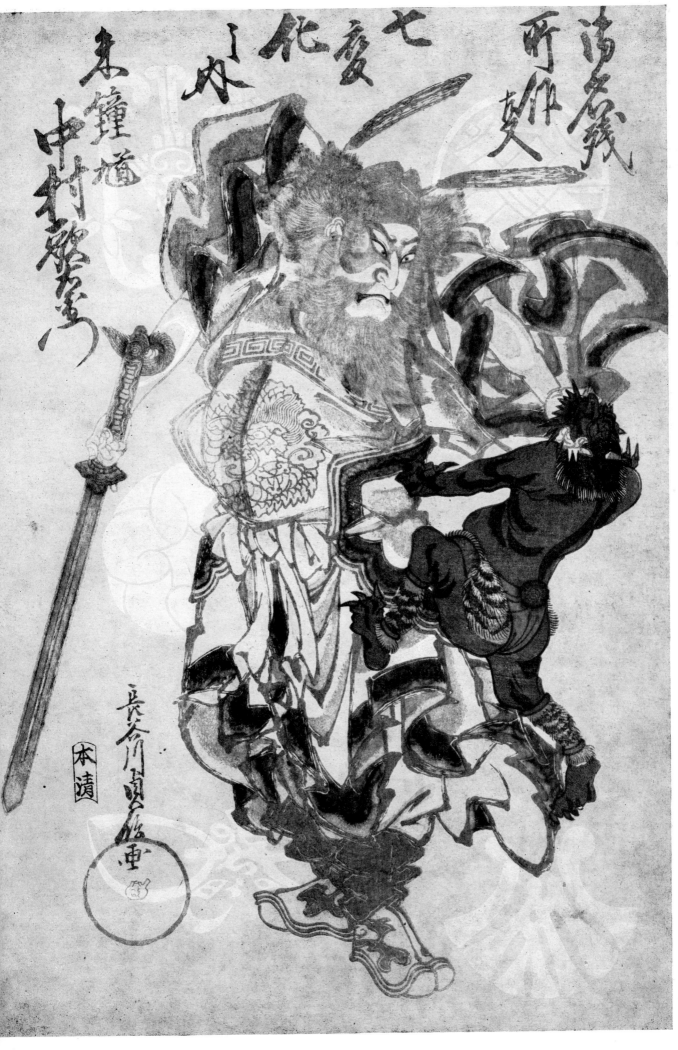

I 35
Kiyomasu
c.1715

Scene from the play Soga no Sukeroku, with
an actor of the Ichikawa line, either Danjurō
II or Yaozō II, as Sukeroku. Published by Iga-
ya of Motohama-chō.
Signed: *Torii Kiyomasu* Artist's seal:
Kiyomasu Publisher's seal.
29·2 × 42·2 (11½ × 16⅝) 1906–12–20–17

Lent by permission of the Trustees of the
British Museum

The character of Sukeroku is really an alias of
one of the Soga brothers (see v 8, v 9, and v 43),
Soga no Gorō, who in the guise of a witty
dandy searches Edo for a sword belonging to
the Genji family. He haunts the pleasure
quarters, picking quarrels to make people
draw their swords for examination.
Here he glances over his shoulder at two
courtesans sitting outside their house, the
Matsuba-ya. The name of the brothel is
displayed as a rebus.

1 36
Kiyonobu
c.1725

Portraits of the actors Sodezaki Iseno as a girl
embraced by Ogino Isaburō as a samurai.
Published by Ise-ya. Coloured by hand.
Signed: *Torii Kiyonobu fude* Publisher's mark
and seal.
31·8 × 15·2 (12½ × 6) E.53–1895

A good example of careful hand-colouring,
with brass dust sprinkled on to glue as an
additional attraction.

I 37
Kiyomitsu
c.1760–1765

Portraits of the actors Bandō Hikozō (left) and
Arashi Hinaji. Published by Nishimura-ya
Hibino (Eijudō).
Signed: *Torii Kiyomitsu ga* Artist's seal:
Kiyomitsu Publisher's mark and seal.
30·7 × 15·3 (12⅛ × 6) 1935-12-14-02

Lent by permission of the Trustees of the
British Museum

The circular cartouches above the heads of the
figures are the actors' mon, badges.

I 37

I 38
Kiyomitsu
c.1760–1765

Portraits of the actors Segawa Kikunojō II
(left) as O-Hana and Nakamura Matsue as
Hanshichi. Published by Nishimura-ya Hibino
(Eijudō).
Signed: *Torii Kiyomitsu ga* Artist's seal:
Kiyomitsu Publisher's mark and seal.
43·9 × 30·8 (17¼ × 12⅛) 1907-05-31-01

Lent by permission of the Trustees of the
British Museum

See I 59

I 39
Kiyohiro
c.1765

Portraits of an actor of the Nakamura line as a
girl performing the tea ceremony, and of
another, perhaps Sakata Tōjurō, as a man
pausing from arranging flowers. Published by
Maru-ya Kohei (Hōsendō).
Signed: *Torii Kiyohiro ga* Artist's seal:
Kiyohiro Publisher's seal.

Lent by permission of the Trustees of the
British Museum

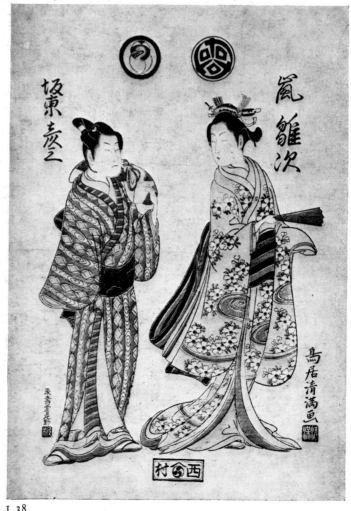

I 38

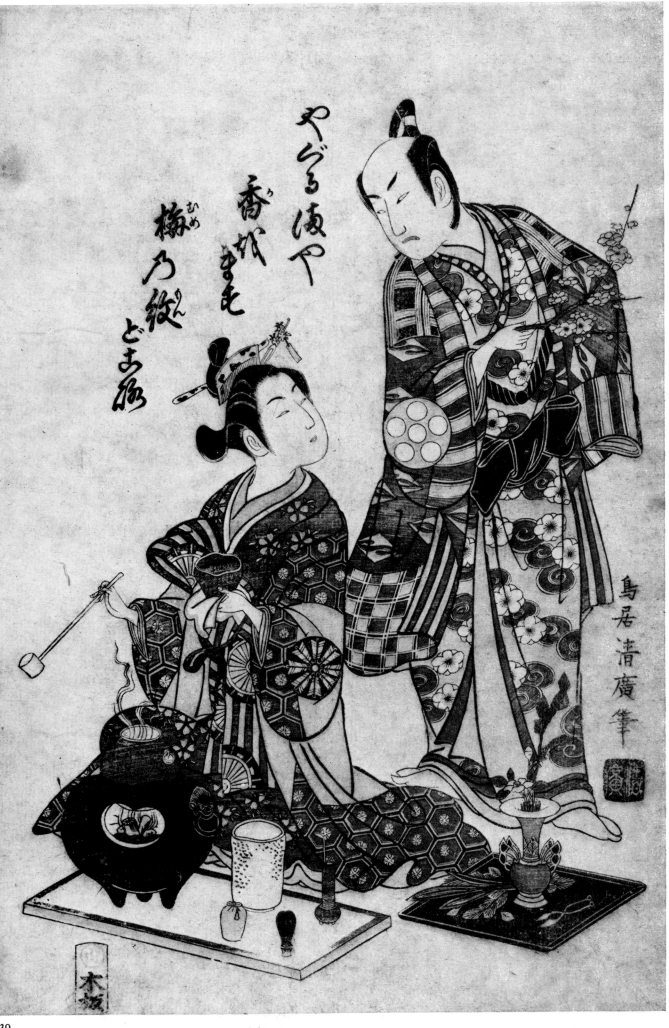

I 40
Shunkō
1785

Portrait of the actor Onoe Matsusuke in his dressing room, assisted by his dresser, preparing for the part of Asahina Saburō the strong man.
Signed: *Shunkō ga.*
30·5 × 14·0 (12 × 5½) E.55–1969

Bequeathed by Mr Paul Shelving

The actor's name is integrated into the picture, being attached to a piece of paper on the back wall, rather than simply superimposed in the usual way.

I 41
Sharaku
1794

Portraits of the actors Ichikawa Komazō II as Kameya Chūbei (right), and Nakayama Tomisaburō as the courtesan Umegawa, in the last scene of a production of Katsuragawa tsuki no omoide at the Kawarazaki-za in the seventh month of Kansei 6 (August 1794). Published by Tsuta-ya Jūsaburō (Kōshodō). Signed: *Tōshūsai Sharaku ga* Publisher's mark. Censor seal: *kiwame.*
36·0 × 24·0 (14⅛ × 9⅜) 1909–06–18–55

Lent by permission of the Trustees of the British Museum

For a note on Umegawa and Chūbei see 1167.

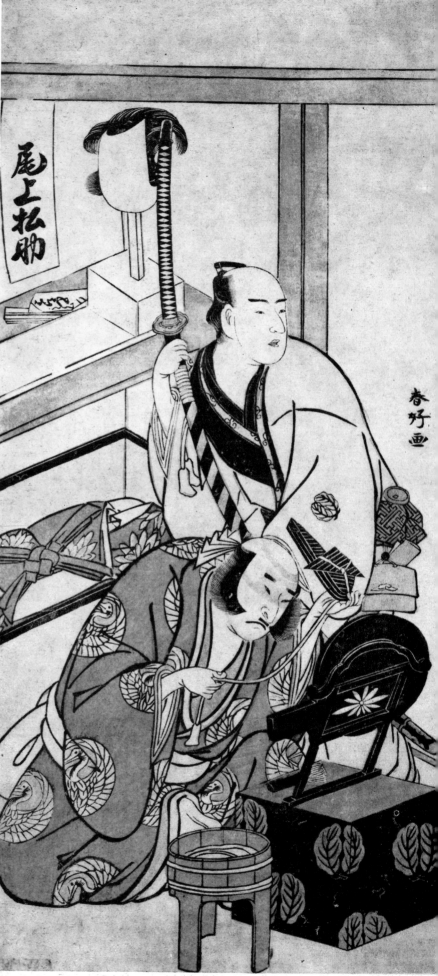

I 40

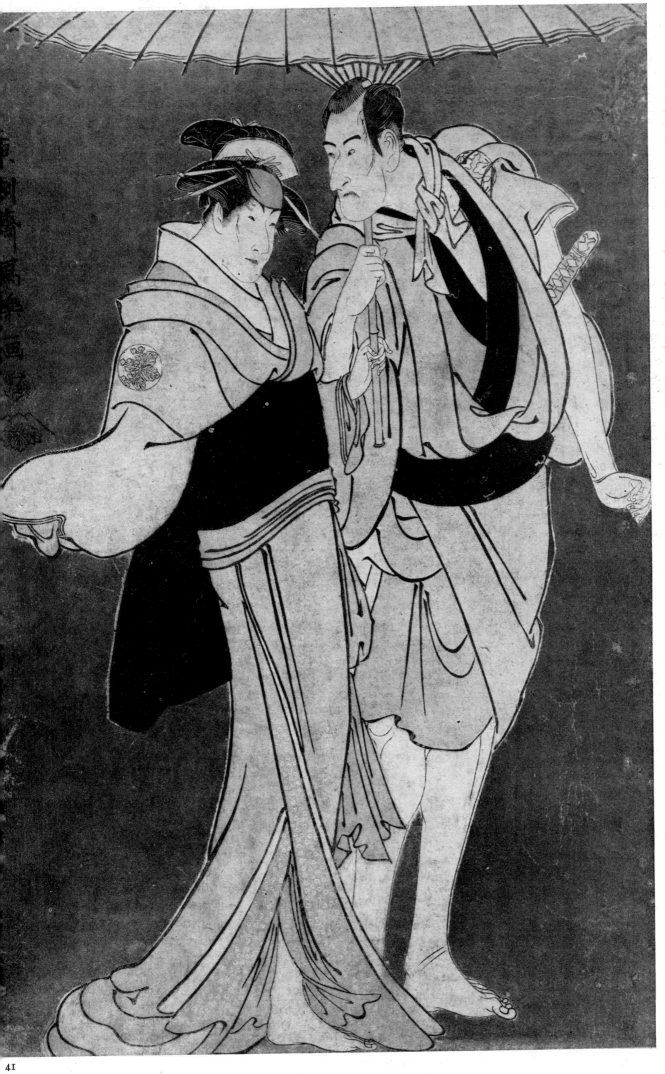

41

I 42
Toyokuni
1798

Portraits of the actors Ichikawa Komazō, later
Matsumoto Kōshirō IV, as Kame-ō (left), and
Iwai Kumesaburō, later Hanshirō V, as his
wife O-Yasu, in the production of Shunkan in
the third month of Kansei 10 (April–May
1798). Published by Nishimura-ya Yohachi
(Eijudō).
Signed: *Toyokuni ga* Publisher's mark and
seal Censor seal: *kiwame*.
37·5 × 24·8 (14¾ × 9¾) E.4825–1886

I 43
Kunimasa
1798

Portraits of the actors Sawamura Sōjurō III as
Sonobe no Hyōe (right) and Segawa
Kikusaburō as Usuyuki Hime in the play
Usuyuki produced in the ninth month of
Kansei 10 (October 1798). Published by
Tsuru-ya Kinsuke (Senkakudō).
Signed: *Kunimasa ga* Publisher's mark.
37·5 × 23·4 (14¾ × 9¼) E.337–1895

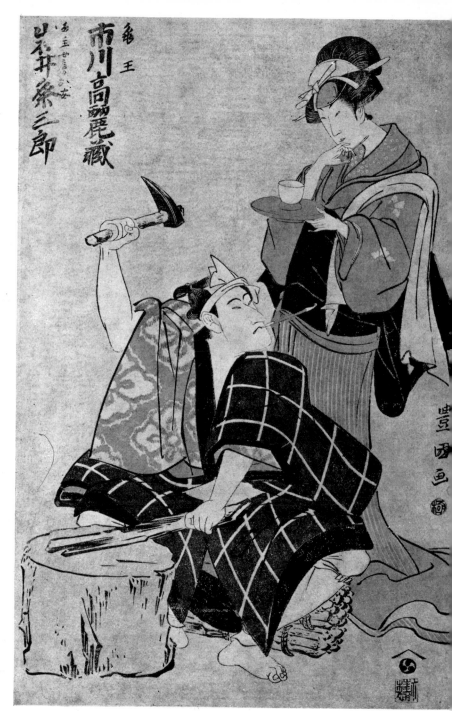

I 42

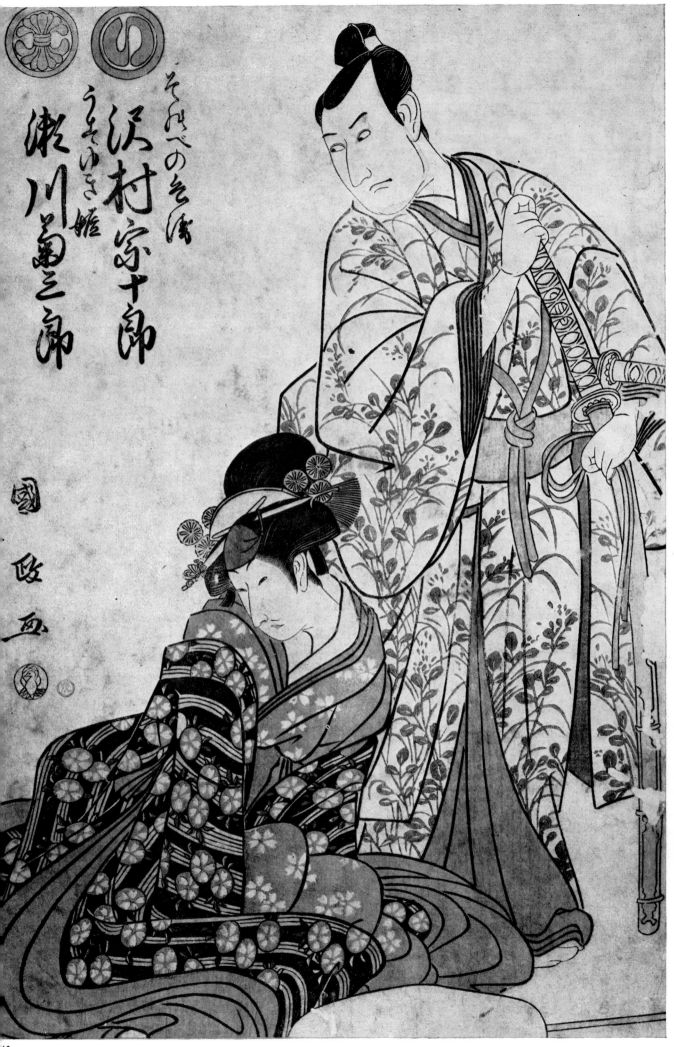

そんべの云弥
沢村宗十郎
うそゆき姫
瀧川菊三郎

國政画

43

I 44
Shunchō
c.1800

Scene from a jōruri performance, with the
actors (left to right) Segawa Kikunojō III,
Sawamura Sōjurō III and Iwai Hanshirō IV.
Published by Fushimi-ya Zenroku.
Signed: *Shunchō ga* Artist's seal:
Nakabayashi Publisher's seal.
37·5 × 24·8 (14¾ × 9¾) E.424–1895

The jōruri was a sort of ballad-drama with
musical accompaniment. This sort of com-
position, with the musicians and chanters in
the background is partially stereotyped, only
the foreground figures varying.
It is possible that this forms part of a
polyptych.

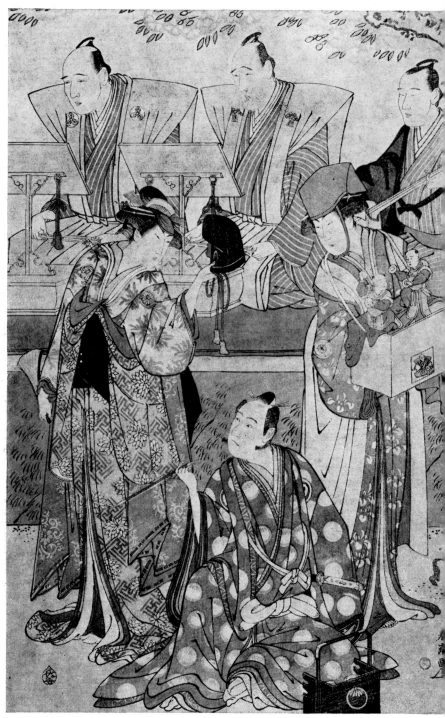

I 44

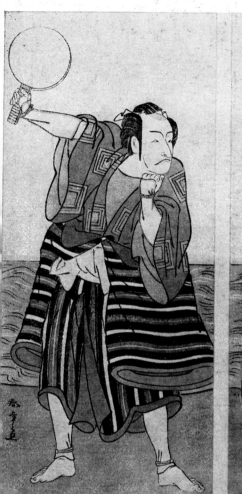
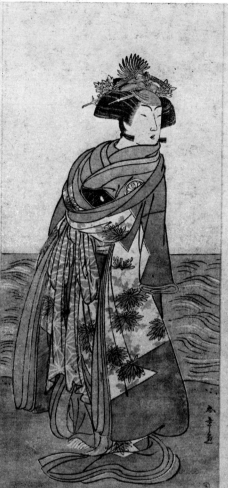
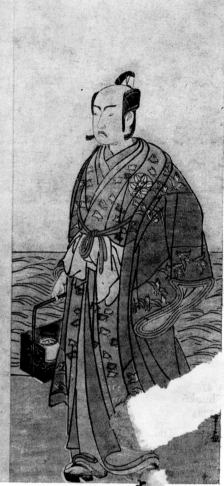

I 45
Shunshō
c.1780

Scene from a play with (left to ri[...] [...]awa
Danjurō v holding a mirror, Sega[...] [...]nojō
III, and Ichimura Uzaemon holdin[...] [...]
smoker's requisites. Triptych.
Signed: *Shunshō ga*.
30·5 × 42·9 (12 × 16$\frac{7}{8}$) E.1[...]

The female role is that of a courtesan, and the
males are probably rival suitors for her
affections.

The figures are given slight recession by the
flattened triangle formed by the positions of
their feet. Note the way in which, as so often,
the trailing robe stabilizes the female figure.

1 46
Shunshō
c.1780

Portraits of the actors Ichikawa Monnosuke II
as a samurai and Nakamura Noshio II as a girl
with a doll. Triptych, missing the centre
sheet.
Signed: *Shunshō ga.*
30·5 × 14·3 (12 × 5⅝) E.1276–1896

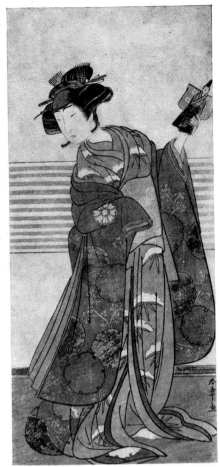

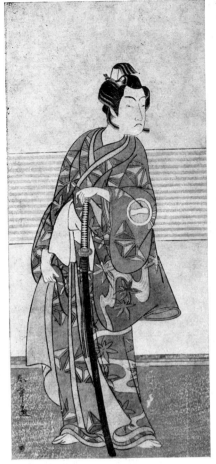

1 46

1 47
Shunkō
c.1785

Portraits of the actors Iwai Hanshirō IV as a
girl with an arrow, and an actor of the
Nakamura line as a girl with a notice board.
Triptych, missing the centre sheet.
Signed: *Shunkō ga.*
30·5 × 28·6 (12 × 11¼) E.1293–1896

The notice-board is inscribed Jūsan no
tsurigane, Temple bell of Jūsan. The scene
probably involves a temple ceremony.

1 48
Shunkō
c.1785

Portraits of the actor Iwai Hanshirō IV as
Shizuka and of an actor of the Ogino family
as Kitsune, fox, Tadanobu. Diptych.
Signed: *Shunkō ga.*
30·5 × 28·6 (12 × 11¼) E.1292–1886

Shizuka was the concubine of Yoshitsune
(see V 18–V 22). After his defeat he parted from
her, leaving her as a keepsake a hand-drum
made from a fox skin, and putting her under
the care of his faithful retainer Tadanobu.

The fox in Japanese mythology is credited
with much the same powers of metamorpho-
sis as the werewolf in the West. Particularly
powerful foxes had multiple tails. The son of
the fox from whose skin the drum was made
changed himself into the form of Tadanobu
and schemed to obtain the drum. He is here
shown, the sausage shapes representing the
tails, the only part to remain unchanged,
holding the drum in his teeth and performing
a grotesque dance.

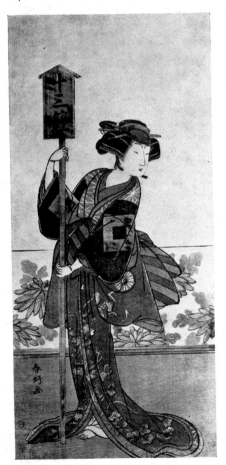

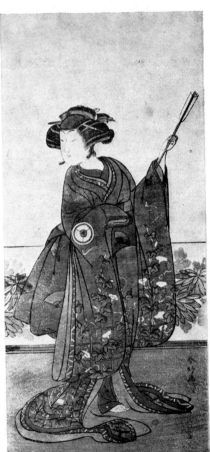

1 47

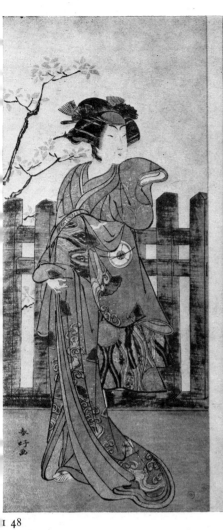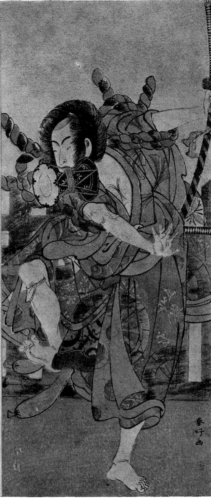

I 48

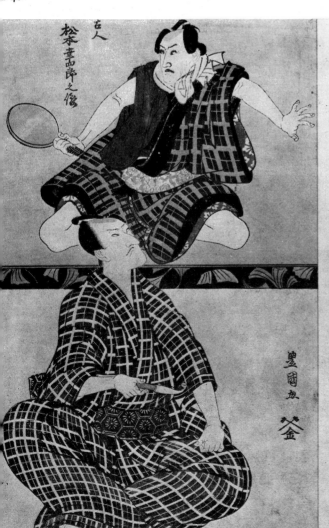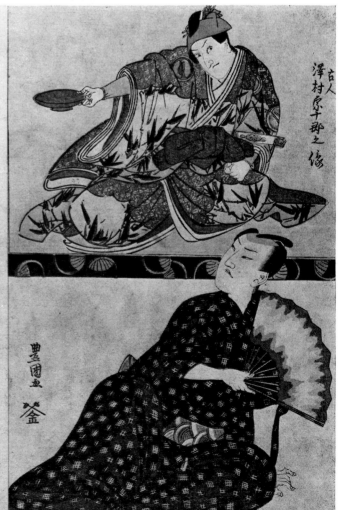

I 49
Toyokuni
1802

The name goes on: left, above, the recently deceased actor Matsumoto Kōshirō IV and, below, his successor Kōshirō V. Right, above, the late Sawamura Sōjurō III and, below, his successor Sōjurō IV. Published by Yamazaki-ya Kimbei. Diptych.
Signed: *Toyokuni ga* Publisher's mark.
35·9 × 49·5 (14⅛ × 19½)
E.4856, 4857–1886

See I 1 for a young Sawamura Sōjurō III.

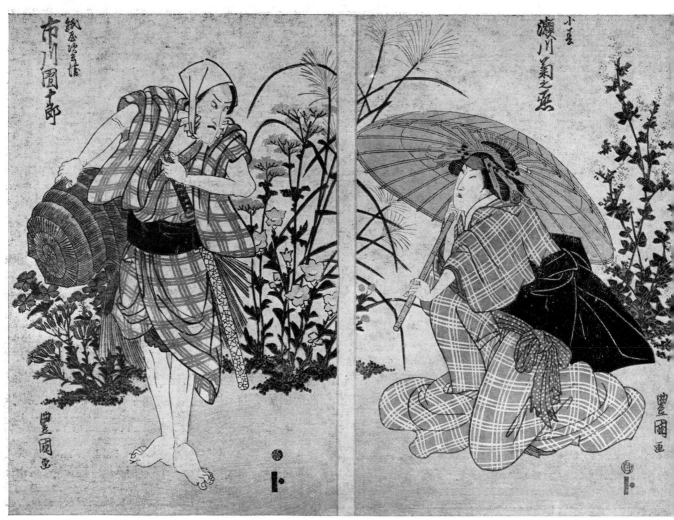

I 50

I 50
Toyokuni
c.1810

Portraits of the actors Ichikawa Danjurō VII,
left, as Kamiya Jihei and Segawa Kikunojō IV
as O-Shun. Published by Yamaguchi-ya
Tōbei (Kinkyōdō). Diptych.
Signed: *Toyokuni ga* Publisher's mark
Censor seal: *kiwame*.
38·1 × 52·1 (15 × 20½) E.12643–1886

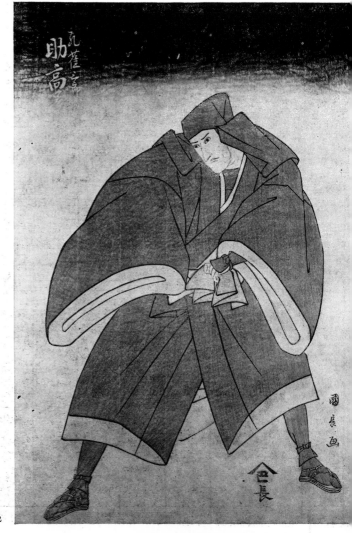

I 52
Kuninaga
1804

Portraits of the actors Matsumoto Kōshirō V
as Hada no Daizen (right) and Suketake-ya
Takasuke as Kujaku Saburō in the production
of Yuki no furusato in the eleventh month of
Bunka 1 (December 1804). Published by
?Iwai-ya.
Signed: *Kuninaga ga* Publisher's mark.
37·4 × 50·8 (14¾ × 20) E.294, 294A–1952

Bequeathed by Miss Rose Shipman

The grey clothing indicates that the scene is
one of night scouting.

I 52

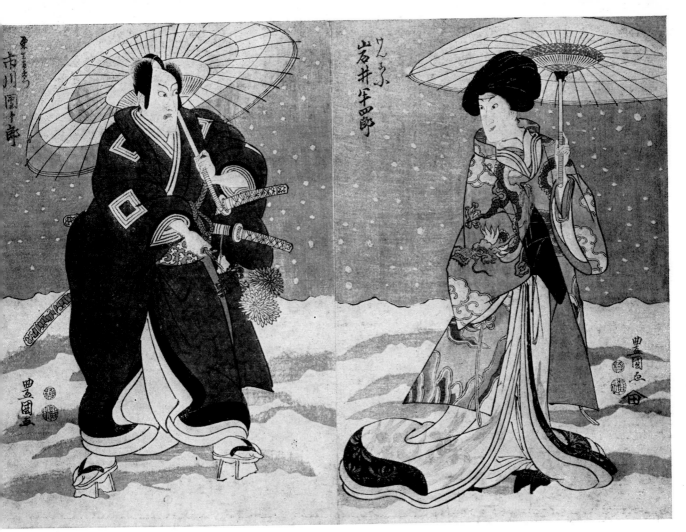

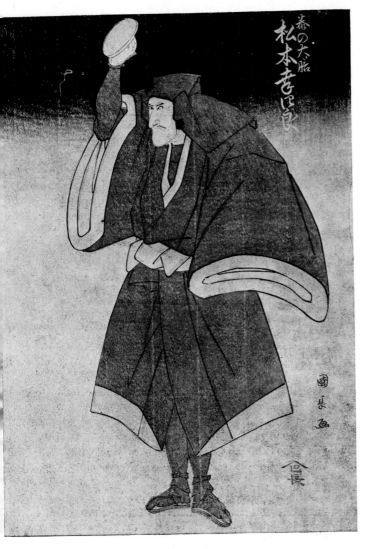

I 51
Toyokuni
Probably 1814

Snow-scene, with Ichikawa Danjuro VII, left, as Yurugi Saemon and Iwai Hanshirō V as Kenkō, probably from the production of *Some tazuna* at the Morita-za in the ninth month of Bunka 11 (October 1814). Publisher unidentified. Diptych.
Signed: *Toyokuni ga* Publisher's seal: *Ta*
Censor seal: *kiwame* Another circular seal: (unidentified).
37·4 × 50·8 (14¾ × 20) 21352.1 & 21352.2

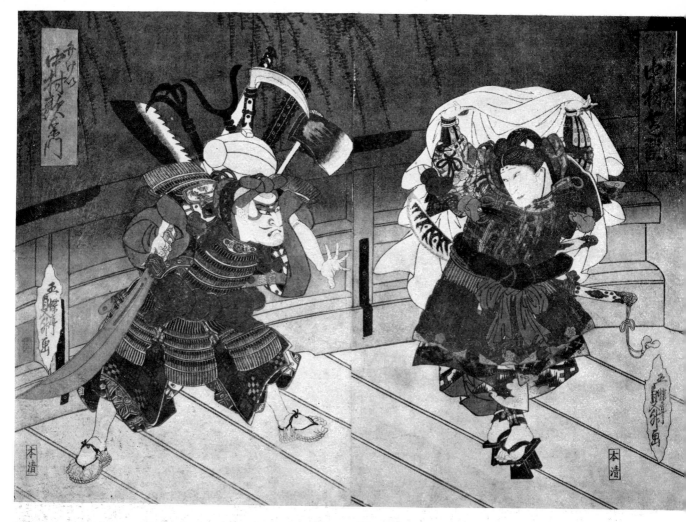

I 53
Kunimasu
c.1825

The fight on Gojō Bridge, with Nakamura
Utaemon III, left, as Benkei and Nakamura
Shikan (later Utaemon IV) as Minamoto no
Ushiwakamaru. Published by Honsei.
Signed: *Gochōtei Sadamasu ga* Publisher's
seal.
37·4 × 50·8 (14¾ × 20) E.12268–1886

For Benkei and Yoshitsune see V 18–V 22. The
fight on Gojō Bridge was the first meeting
between the two. Benkei had vowed to
collect 1000 swords. This he set about by
every night challenging people who crossed
the bridge, and taking their swords after
defeating them. He had notched up 999
victims when one night Yoshitsune ap-
proached. He seemed an easy mark, dressed in
the delicate clothing of a temple page, with a
woman's cloak over his head. To Benkei's
surprise the boy defeated him, and he swore to
be his faithful retainer.

I 54
Shigeharu
c.1825

Night fight in the rain: Nakamura Utaemon
III grapples with two opponents while a third
collides with a street lantern. Published by
Honsei. Diptych.
Signed: *Gyokuryūtei Shigeharu ga* Artist's
seal: (obscured). Publisher's seal.
37·2 × 47·0 (14⅝ × 18½) E.12448–1886

It is possible that this illustrates the same play
as I 11. It is most unusual for the actors' names
to be omitted from theatrical prints, although
a comparable night scene by Hokuei, I 56, also
lacks inscriptions.

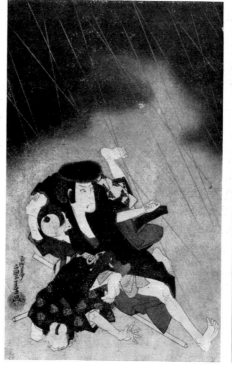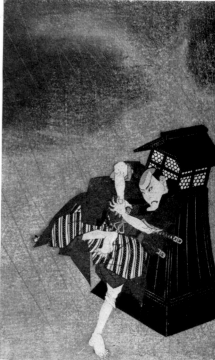

I 54

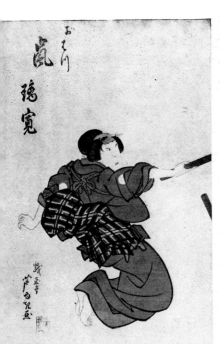
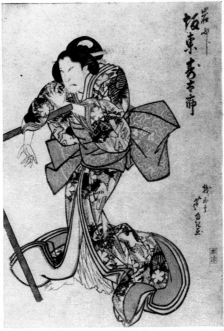

I 55

Ashiyuki

Probably 1828

Scene from the drama Kagamiyama, probably the production of 1828 at the Kadono-za, Osaka. Arashi Rikan II as O-Hatsu in a stick fight with Bandō Jutarō as the lady Iwafuji. Published by Honsei. Diptych.
Signed: *Kigadō Ashiyuki ga* Publisher's seal.
? Engraver's seal: ? *Rikimatsu*.
38·1 × 50·8 (15 × 20) E.2844–1886

I 56

Hokuei

c.1830

Scene from a play, with unidentified actors as a hooded girl with a sword and lantern, and as a man shielding his face with his hat. Diptych.
Signed: *Shunkōsai Hokuei ga* Artist's seal: *Fuyato no yuki* Engraver's seal: *Surimono hori Kasuke*.
37·4 × 50·8 (14¾ × 20) E.3873–1916

Given by the Misses Alexander

55

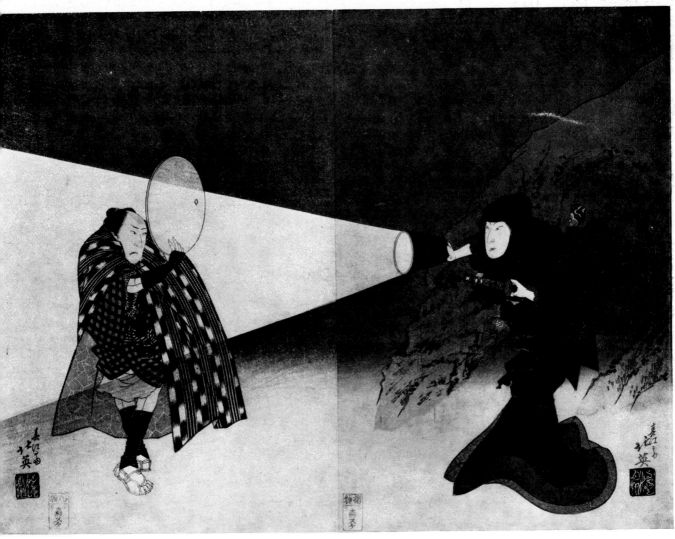

56

I 57
Hokuei

c.1830

Actors as heroes and a heroine of Suikoden: (left to right) Rorihakuto Chōjun (probably Arashi Rikan II), Kosanro Ichijosei (unidentified), Ju-unryū Kosonshō (Nakamura Utaemon III), and Kumonryū Shishin (probably Nakamura Shikan, later Utaemon IV). Published by Kinkadō Konishi. Tetraptych. Signed: *Shunkōsai Hokuei ga* Artist's seals: *Hokuei* and *Fuyato no yuki* Publisher's seal. Engraver's seal.

$37 \cdot 2 \times 102 \cdot 9 \, (14\frac{5}{8} \times 40\frac{1}{2})$ E.5005–1886

For Suikoden see V 53, V 54.

A particularly fine example of careful graded printing, with an unusually developed landscape background for a theatrical print.

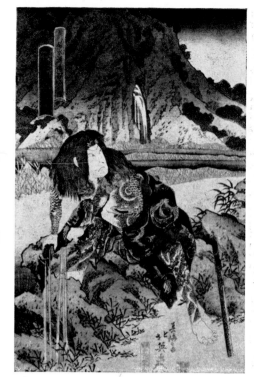
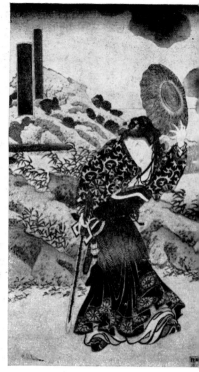

I 57

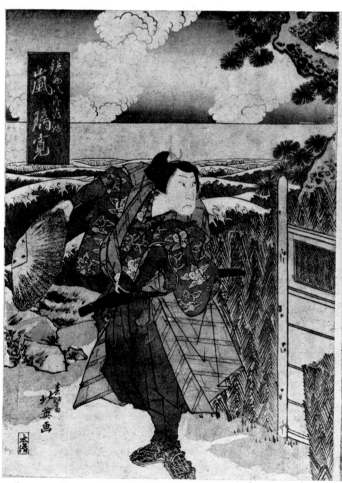
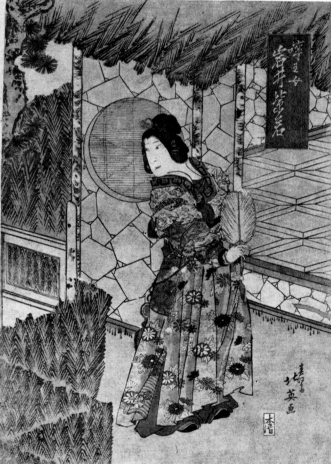

I 58

1 58
Hokuei
1833

Arashi Rikan II (left) as Chinzei Hachirō Tametomo and Iwai Shijaku, later Hanshirō VII, as Neigyoku-jō, the island princess, in the production of Yumi-hari-tsuki at the Nakano-za, Osaka in the winter of Tempō 4 (1833). Published by Honsei. Diptych.
Signed: *Shunkōsai Hokuei ga* Publisher's seal.
36·5 × 51·1 (14⅜ × 20¼) E.5114–1886

This play, like the last, was based on a novel of the same title by Bakin. This is a fictionalized version of the life and exploits of Minamoto Tametomo (1139–1170). He was renowned as a bowman, whose left arm was longer than his right, enabling him to handle an unusually large bow. He was a turbulent character who was several times exiled to offshore islands, once with the tendons of his arm cut.

The female role here, whose name means Kind Jade Maid, is given a peculiar hairstyle presumably as an indicator of her exotic nature.

1 59
Kunihiro
c.1831–1835

Scene from a production of the play Sakaya, with Arashi Rikan II as Akane-ya Hanshichi, in the boat, and Iwai Shijaku, later Hanshiro VII, as the courtesan Mino-ya Sankatsu. Published by Tenki (Kinkadō). Diptych.
Signed: *Kunihiro ga* Publisher's seal.
37·4 × 50·8 (14¾ × 20) E.5429–1886

This play is of the type known as sewamono which deals with the life of the Edo commoners. It is a domestic tragedy involving a man, Hanshichi, who has left his wife for a courtesan, Sankatsu, by whom he has a child. When he is charged with manslaughter he sends the child back to his parents with a letter begging forgiveness, and suggesting he marries his wife again in another incarnation. He and Sankatsu then set out together towards a double suicide, the traditional Japanese solution to otherwise irresolvable conflicts between love and duty. The scene here shows them starting on their journey.

It seems likely that 1 17 shows characters from the same play.

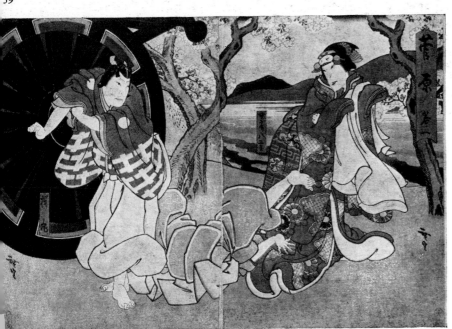

1 60
Hirosada
c.1840

Act 1 of the Sugawara drama, with actors as Sakuramaru (left) and the Lady Yae, his wife. Published by Dai-Jin. Diptych.
Signed: *Hirosada* Publisher's seal.
25·4 × 37·4 (10 × 14¾) E.2994–1886

The scene shown seems to be that known as Stopping the chariot, in which Sakura-maru encounters his brother Matsuōmaru (see 1 17) with his lord, stops the carriage and fights him. This is not usually the first scene in the play, but since the entire drama was very long, truncated versions were common.

See also the next entry.

I 61

Kunimaro

1844

Chūkō giyū arasoi no zu, Illustration of the
dispute between brave and loyal paragons of
filial piety: a scene probably from the produc-
tion of Sugawara at the Nakamura-za in the
fifth month of Kōka I (1844), with Ichikawa
Danjurō VIII as Toneri Umeō-maru and
Matsumoto Kōshirō VI as Matsuōmaru fight-
ing with rice-bales.
Published by Taka-Yū. Diptych.
Signed: *Ichiensai Kunimaro ga* and *Toyokuni no
monjin* (Pupil of Toyokuni, i.e. Kunisada).
Toshidama seal of the Utagawa school.
Publisher's seal. Censor seal: *Watari*.
37·4 × 49·5 (14¾ × 19½) E.5493–1886

This print introduces the third of the triplet
brothers, and shows a fight which took place
with Matsuōmaru during a reunion of the
brothers at their father's house.

This print is of particular interest since, despite
the omission of actors' names, it is an indis-
putably theatrical subject published very soon
after the ban of 1842.

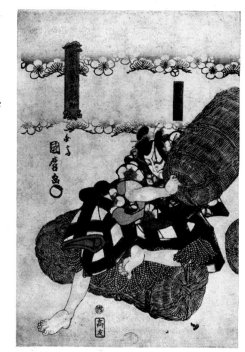 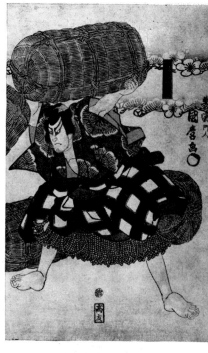

I 61

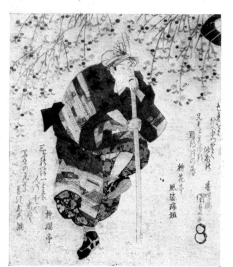 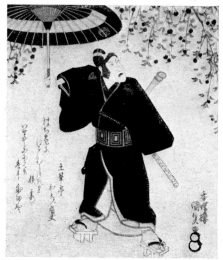 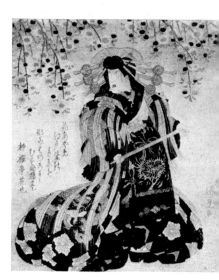

I 62

Kunisada

c.1835

Scene from Sukeroku, one of the eighteen
specialities of the Ichikawa family, with
Ichikawa Danjurō VII, centre, as Sukeroku,
flanked by Onoe Kikugorō III, left, and Iwai
Hanshirō VI as the courtesan Agemaki.
Surimono. Triptych.
Signed: *Kōchōro Kunisada ga* Double
toshidama seal of the Utagawa school.
21·6 × 57·2 (8½ × 22½) E.3904–1916

Given by the Misses Alexander

For Sukeroku see I 35

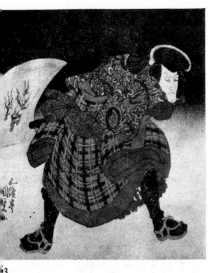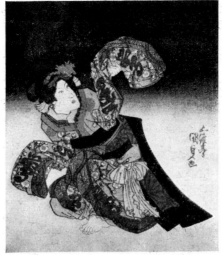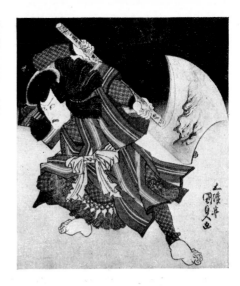

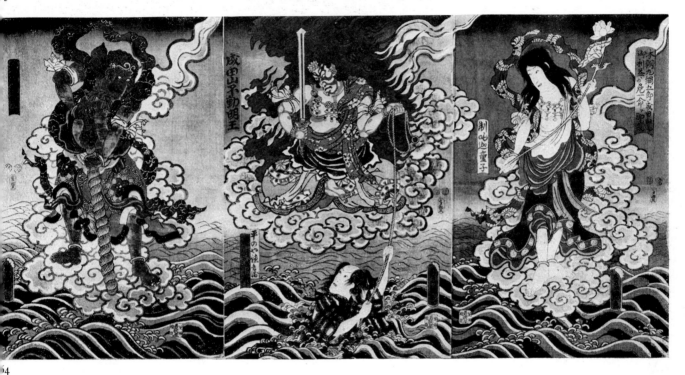

I 63
Kunisada
probably 1836

Scene probably from the production of
Kanagaki Soga at the Morita-za in the third
month of Tempō 7 (April 1836), with Iwai
Hanshirō VI, centre, flanked by Ichikawa Kuzō
(later Danzō VI) as Umeōmaru, left, and
Ichikawa Danjurō VII as Matsuōmaru.
Surimono. Triptych.
Signed: *Gototei Kunisada ga.*
21·0 × 56·2 (8¼ × 22⅛) E.3909–1916

Given by the Misses Alexander

I 64
Kunisada
1851–1852

Scene from Genji moyō produced at the
Ichimura-za in the ninth month of Kaei 4
(1851), with Ichikawa Danjurō VIII as Honchō
Tsunagorō being rescued by the Buddhist
deity Fudō Myō-ō, also played by Danjurō
VIII, flanked by Ichikawa Kuzō, later Danzō VI
(left), as the acolyte Kongara Dōji and Bandō
Shuka as Seitaka Dōji. Published by Wakasa-
ya Yoichi (Jakurindō). Triptych.
Signed: *Toyokuni ga* Publisher's seals.
Censor seals: *Muramatsu* and *Fuku* Another
seal: *shita-uri*, restricted sale.
36·2 × 74·3 (14¼ × 29¼) E.5596–1886

Fudō is one of the angry manifestations of the
Supreme Buddha Dainichi (Sanscrit:
Vairocana) whose sword represents wisdom
and cuts down the demons of ignorance. His
rope serves to bind demons and evil-doers,
and, as here, to save people from the ocean of
births and rebirths and lead them to the
supreme truth.

i 65

Kunisada

1855

An actor, perhaps Ichikawa Kodanji IV, as O-Tsuji the wet-nurse, doing penance under a waterfall, with a child actor as Tamiya Hōtarō, and Bandō Shuka as an apparition of the spirit of Zōzu-san. Published by Ebisu-ya Shōshichi. Diptych.
Signed: *Toyokuni ga* Publisher's seal.
Censor seals: *aratame* and *Hare 3*.
35·6 × 50·8 (14 × 20) E.5610–1886

Bandō Shuka, the foremost onnagata, player of female parts, of his time, died in the same month that this print was published. It may therefore be in the nature of a memorial portrait.

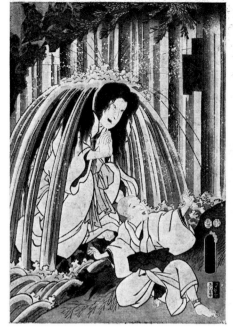

1 65

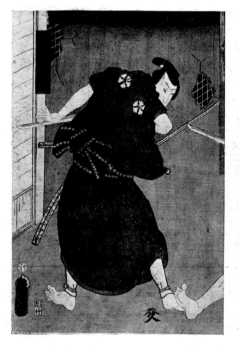
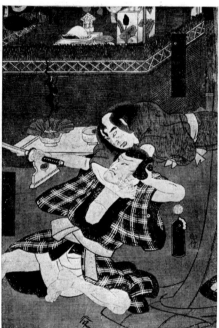
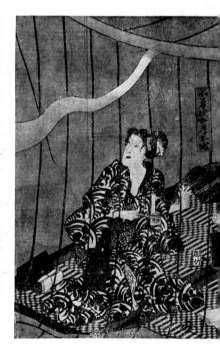

1 66

Kunisada

1859

Scene from the production of Kohata no Kai-i at the Ichimura-za in the seventh month of Ansei 6 (August 1859), with Ichikawa Kodanji IV as the ghost of Kohata Koheiji, strangling Seki Sanjurō III as Adachi Takurō during his fight with Sawamura Tosshō as Kōzai Kijirō. They are watched by Iwai Kumesaburō as O-Tsuka, wife of Koheiji. Published by Yamamoto-ya Heikichi (Eikyūdō). Triptych.
Signed: *Toyokuni ga* Publisher's mark.
Engraver's seal: *Hori take* Censor seal: *aratame* combined with *Goat 6*.
34·6 × 72·7 (13⅝ × 28⅝)
E.567, 568, 569–1961

Ghosts in Japan always lack feet, and the only use of a flying harness in Kabuki was for such parts. Ichikawa Kodanji IV was particularly famous for his ghost roles, and even managed to perform dances suspended from the ceiling.

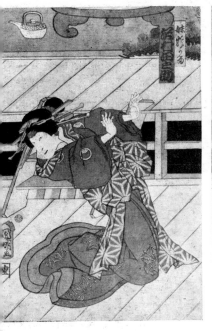

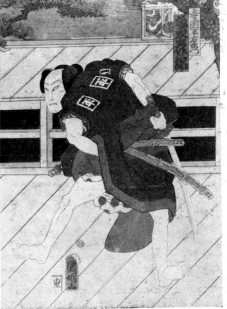

167
Kuniaki
1862

Scene from a production of the Chūshingura, with Bandō Hikosaburō v as Teraoka Heiemon threatening Sawamura Tanosuke as his sister O-Karu. Published by Yorozu-ya Zen. Diptych.
Signed: *Kuniaki ga* Publisher's mark.
Censor seal: *aratame* combined with *Dog 10*.
36·8 × 50·8 (14½ × 20) E.5232–1886

For the Chūshingura see v48–v52. O-Karu is the girl who is sold as a courtesan to help fund the revenge plot (see v49). This scene occurs after she has inadvertently read a letter to Yuranosuke, detailing the plot. Yuranosuke has arranged to buy her out, in order to silence her, unaware of her relationship to the plot. Her brother appears, and, aware that Yuranosuke intends to kill her, suggests that it is better to die at the hands of a relative than of a stranger and draws his sword. Yuranosuke overhears the exchange and all is saved. If it sounds complicated, it is, and characteristically so in this most tortuous of plays.

67

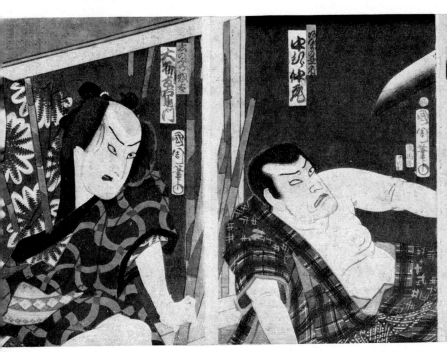
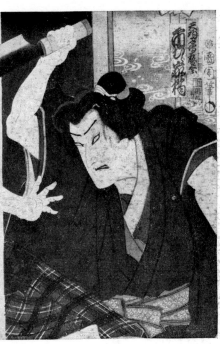

58

I 68
Kunichika
1868

Scene from a play with Ichimura Kakitsu as Tenguchi Okatarō attacking Nakamura Nakazō, as Amma no Chūichi, with a kitchen knife. Ōtani Tomoemon bursts through the bamboo partition on the left. Published by Yorozu-ya Zen. Triptych.
Signed: *Kunichika ga* Toshidama seal of the Utagawa school Publisher's seal. Engraver's seal: *Hori Toyo* Censor seal: *aratame* combined with *Dragon 2*.
36·2 × 71·8 (14¼ × 28¼) E.5293–1886

Books associated with section 1 (not illustrated)

1a

Bunchō and **Shunshō**
1770

Ehon butai ōgi, Theatrical fans. First
published 1770. 3 volumes.
E.561–E.563–1913

1b
Shunshō
c.1780

Ehon yakusha natsu no Fuji, Actors compared
with Mt Fuji in the summer (when it lacks its
concealing blanket of snow).
E.3528–1897

1c
Toyokuni
1800

Ezu yakusha sangai kyō, Actors offstage.
2 volumes.
E.3530–1897

1d
Kunisada
1827

Natsu no Fuji, Mt Fuji in the summer. (See
above, 1b.)
E.6805–1916

Given by the Misses Alexander

1e
Kunisada
c.1853

Edo nichi senryō, A thousand silver coins'
worth of Edo sunshine, the theatrical volume
of the series Kyōka tōto kanichi senryō, Comic
poetry: a thousand silver coins' worth of
flowers and sunshine from the capital.
E.6768–1916

Given by the Misses Alexander

美人

II *Bijin: Beautiful women, with a few intrusions*

The chief centre of pleasure in Edo, the Yoshiwara, was a separate quarter with its own gates. Within was a world of teahouses, brothels, known as the green houses from their characteristic external colour, and the hierarchy of waitresses, geishas, musicians and prostitutes which went with them. Here too would be found the actors in their leisure hours, for, despite their tremendous popularity and influence, their social status was low, and only in the Yoshiwara were the barriers lowered.

Although theoretically barred to the samurai class, the Yoshiwara received many of them as incognito clients, and samurai money, filtered through the merchants, was spread into the lower echelons of society by passing into the hands of the girls' families.

To the impoverished the green houses presented a lucrative alternative to infanticide in the matter of disposing of unwanted daughters. For the girls there was the opportunity of expert training in the arts of lovemaking, grooming, music and poetry. The apt pupil would have the chance of using her not inconsiderable share of the earnings to buy herself out, and favourable marriages with rich clients were not unheard of, with the accompanying redemption from the pariah status which they shared with the actors.

Paradoxically it was precisely this pariah status, and the consequent freedom from the rigid moral code of the respectable classes, which was responsible for their appeal. The merchants' wives, although not so strictly cloistered as the women of the aristocracy, were nevertheless inexperienced creatures in comparison with the gorgeously attired and worldly courtesans, and it is the easy, cultured companionship with which the latter performed their more earthy role which justifies the customary use of the name of courtesan.

The prints record the faces, the changing styles of hair and dress, and served variously as souvenir, introduction, and as symbols of excitement in what was otherwise a somewhat dull world.

The arrangement of this section is by format, to permit easy comparisons:

IIA Single figures, heads
IIB Single figures, full length
IIC Single figures, full-length, long format
IID Multiple figures, heads
IIE Multiple figures, full-length, outdoor
IIF Multiple figures, white line images
IIG Multiple figures, full-length, indoor
IIH Multiple figures, full-length, long format
III Polyptychs

II I
Utamaro
c.1790

Yoso iku no kihan, the boats returning to
harbour after visiting another place, from the
series Fūzoku ukiyo hakkei, Eight fashionable
floating world views. Published by Ise-ya
Sanjirō.
Signed: *Utamaro fude* Publisher's mark.
38·1 × 22·2 (15 × 9⅞) E.3244–1953

Bequeathed by Sidney Lee, RA, RE, RWS, and
Mrs Edith Mary Lee

For the eight views see III 34ff. The
relationship between the title and the subject
in most of this series is obscure, but it must be
confessed that this girl returning from a visit
does bear a resemblance to a sailing ship
running before the wind.

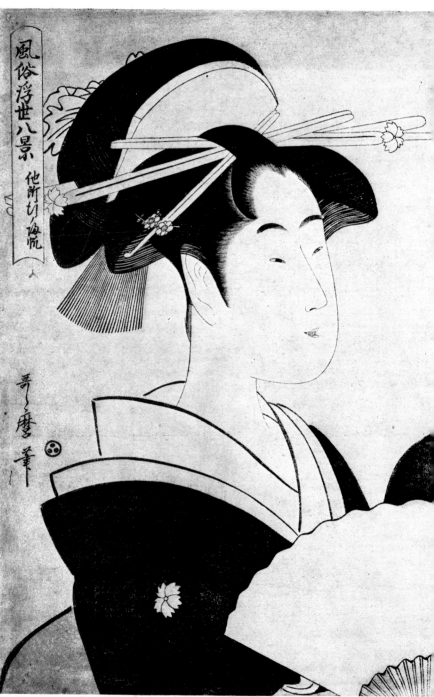

II I

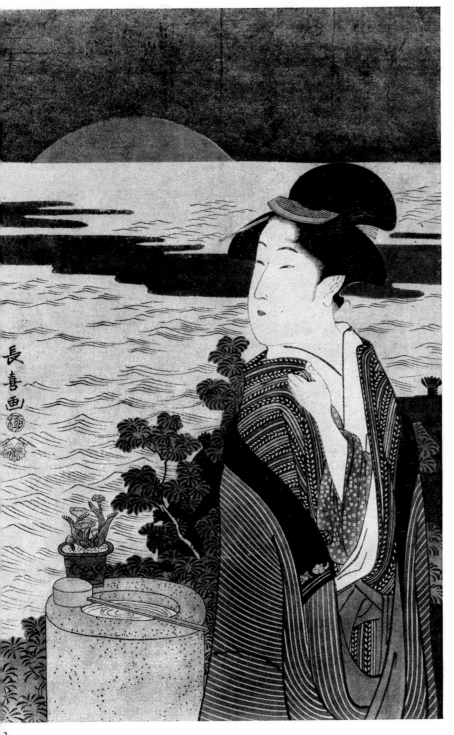

112
Chōki
c.1794

Girl and the sunrise over the sea at New Year.
Published by Tsuta-ya Jūsaburō (Kōshōdō).
Signed: *Chōki ga* Publisher's mark. Censor
seal: *kiwame*.
38·7 × 24·8 (15¼ × 9¾) E.3774–1953

Bequeathed by Marmaduke Langdale Horn

The allusion to the New Year is provided by
the plant on the water butt, the fukujusō, the
good fortune and longevity plant.
This print exists in a number of variants,
affecting principally the waves, the foliage
behind the girl and the dipper.

113
Utamaro
c.1800

The courtesan Oshichi of the Yao-ya.
Published by Tsuru-ya Kiemon (Senkakudō).
Signed: *Utamaro fude* Publisher's mark.
39·4 × 25·4 (15½ × 10) E.427–1895

The -ya termination signifies a place of
business. In the first case it is the brothel, and
in the second the publisher.

The plants in the roundel are almost certainly
an abstruse pun on the girl's name, a device
frequently used.

She is holding a letter from an admirer, with
whom the print purchaser is presumably to
identify. This supposition is supported by the
way the composition emphasizes the hands by
relating them in parallel to the edges of the
girl's multiple kimonos.

114
Eishō
c.1795

The courtesan Kasugano of the Sasa-ya,
emerging from the bath. From the series
Kakuchū bijin kurabe, A comparison between
beauties within the quarter. Published by
Yamaguchi-ya Chūsuke.
Signed: *Eishō ga* Publisher's mark.
37·5 × 24·8 (14¾ × 9¾) E.596–1903

The quarter is of course the enclosed quarter
of the Yoshiwara. The girl's name in
translation means 'field on a spring day', and
that of her house 'bamboo grass'.

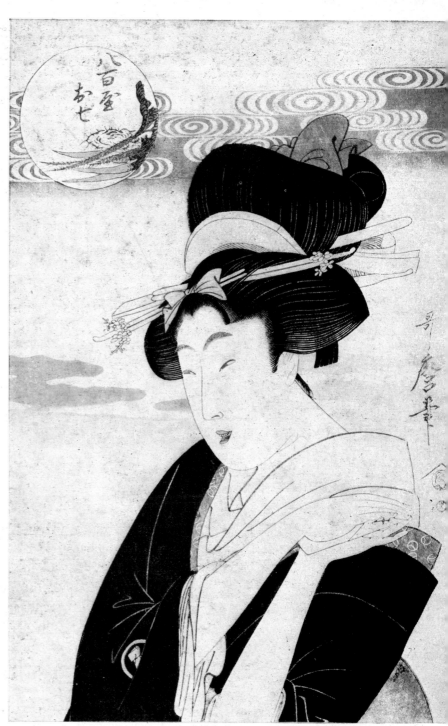

113

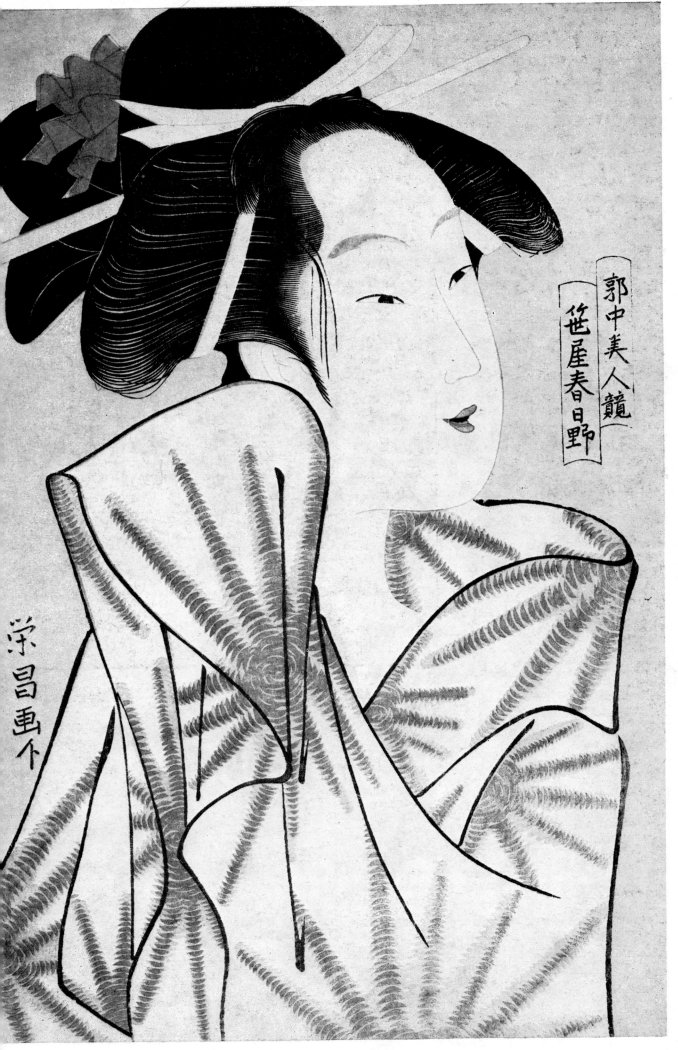

郭中美人競
笹屋春日野

榮昌画

14

115
Eishō
c.1795

The courtesan Yosooi of the Matsuba-ya.
Published by Yamaguchi-ya Chūsuke.
Signed: *Eishōdō Eishō ga* Publisher's mark.
38·4 × 25·4 (15⅛ × 10) E.1414–1898

Eishō had a penchant for transparency, here
exemplified by the gauze fan and the
translucent horn comb.

116
Shunchō
c.1800

The courtesan Hanaōgi of the Ōgi-ya.
Published by Tsuru-ya Kiemon.
Signed: *Shunchō ga* Publisher's mark.
39·4 × 26·0 (15½ × 10¼) E.21–1895

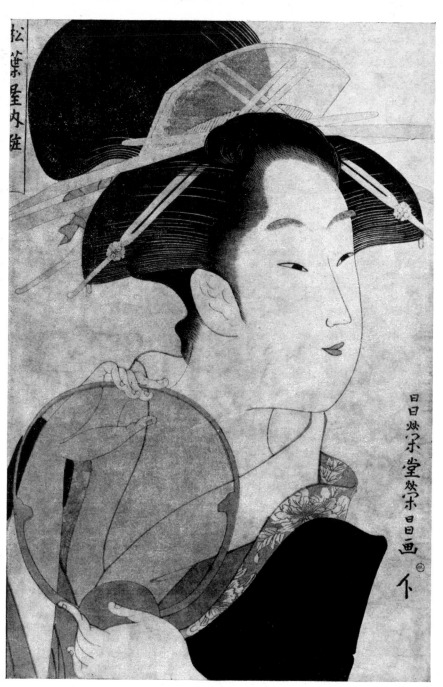

115

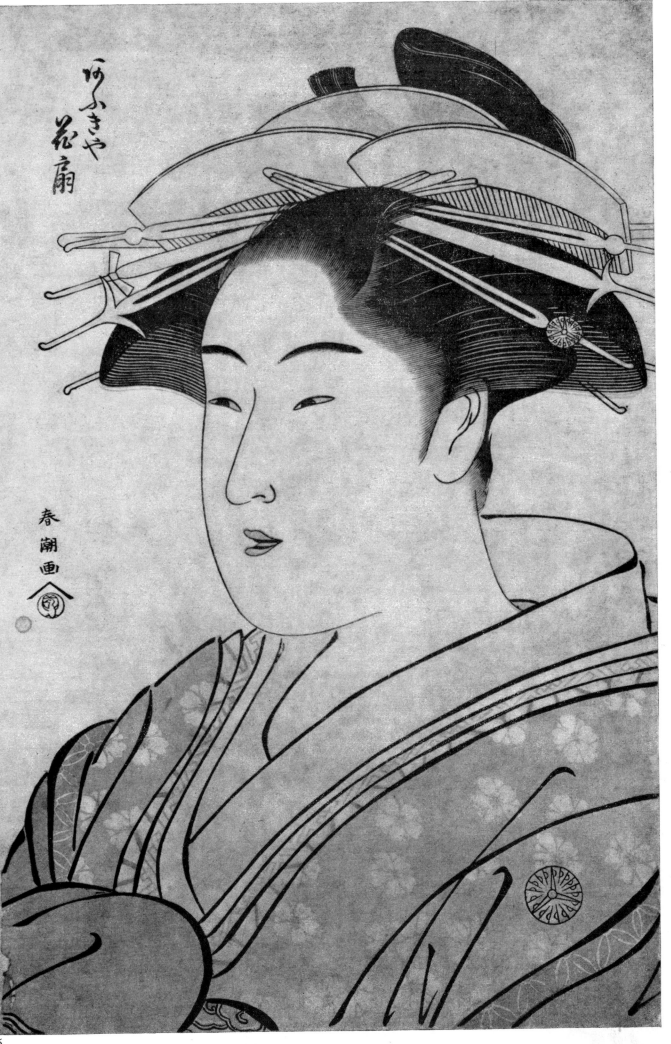

117
Eizan
c.1830

Woman at her mirror, from the series Azuma
sugata Genji awase, Genji comparisons, Edo
style.
Signed: *Kikugawa Eizan fude*
38·8 × 26·7 (15¼ × 10½)　E.38–1969

Bequeathed by Mr Paul Shelving

For Genji see V45–V47. The comparison here
is with chapters X and XX, the rectangular
cartouches containing rebuses appropriate to
these chapters.

The woman seems to express dismay at not
reaching the high standard of beauty set by
the loves of Prince Genji, for on her mirror-
stand is a book whose title translates
'Paragons of sophisticated beauty'. Eizan's
idiosyncratic habit of depicting the whites of
the eyes as coloured lends a peculiar manic
intensity to the faces so treated.

118
Kunisada
1855

Touch and textile, from the set of three,
Mitate sambasō, Comparison between the
three pairs (of senses and their objects).
Published by Iba-ya Sensaburō (Dansendō).
Fan print.
Signed, within a cartouche formed from the
Utagawa mark: *Toyokuni ga*　Publisher's
mark.　Engraver's seal: *Hori take.*　Censor
seals: *aratame* and *Hare first.*
21·6 × 29·2 (8½ × 11½)　E.12091–1886

117

118

Kuniyoshi

1855

Taste and fruit, from the same series, with the
same publisher as the previous entry. Fan
print.
Signed: *Ichiyūsai Kuniyoshi ga* Artist's
paulownia seal. Rest as previous entry.
21·6 × 29·2 (8½ × 11½) E.12092–1886

The third print, a rather disappointing
composition by Hiroshige, is Sight and a
silver decorated black lacquer box, Museum
no. E.12090–1886.

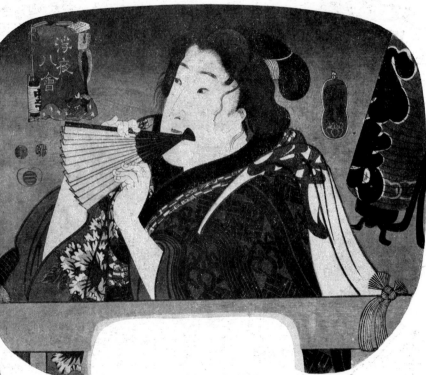

110

Kuniyoshi

1847–1850

A geisha in male dress performing a dance
called the Niwaka, from the series Ukiyo
Hakkai, Eight gatherings of the floating
nights. Published by Iba-ya Sensaburō
(Dansendō). Fan print.
Signed: *Ichiyūsai Kuniyoshi ga* Artist's
paulownia seal. Publisher's mark. Censor
seals: *Mera* and *Murata*.
22·9 × 29·2 (9 × 11½) E.12123–1886

The role of the geisha was purely that of
entertainer at parties, as opposed to the more
intimate services provided by the courtesans.
This dance, the significance of which I have
been unable to determine, provides a nice
contrast with the reverse role reversal typical
of Kabuki.

The series title is a pun on Ukiyo Hakkei,
Eight views of the floating world.

II 11
Fusatane
1851–1852

A woman with a packet of paper
handkerchiefs hanging from her teeth, and a
background riverside village, from the series
Kōdai meishō sen, A set of famous places of
ancient times. Published by Sōsen. Fan print.
Signed: *Fusatane ga* Publisher's mark.
Censor seals: *Murata* and *Kinugasa*.
22·9 × 30·5 (9 × 12) E.2935–1913

Given by Mr R. Leicester Harmsworth

The view is not identified. Note the
ingenious silhouette treatment of the shore,
which, without sacrificing detail, serves to
emphasize the foreground figure.

II 12
Kyōsai
c.1870

Girl painting a still life. Fan print.
Signed: *Shōjō Gyōsai* Artist's seal: *Shō*.
22·2 × 28·6 (8¾ × 11¼) E.1668–1913

Given by Mr Arthur Morrison

It is difficult not to believe that the 'drunken
sprite' (see v 28) Kyōsai is not being ironic
about this simpering creature with her
screaming blue kimono.

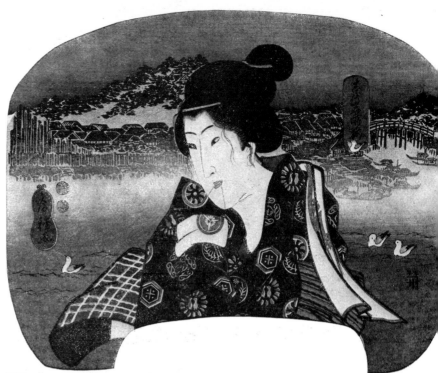

II 11

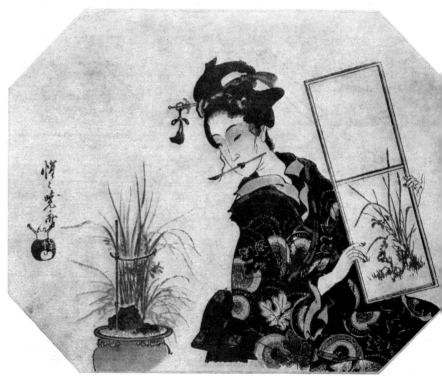

II 12

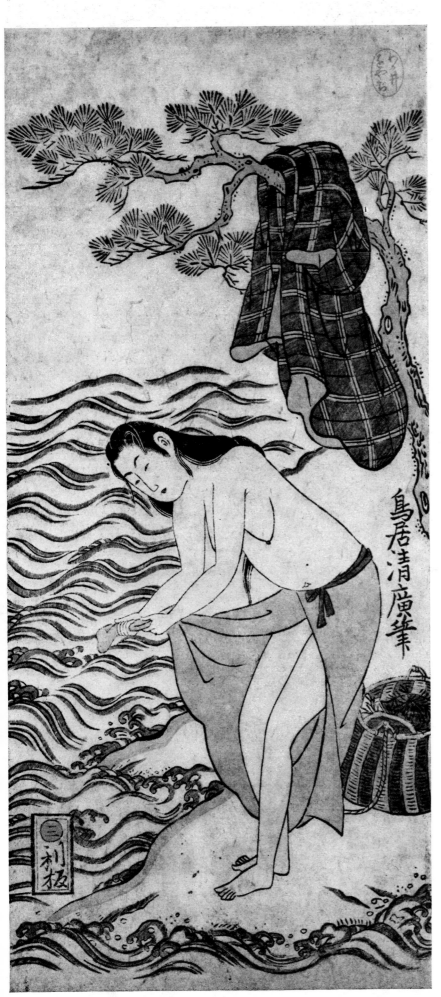

1113
Kiyohiro
c.1750

Awabi diver wringing out her skirt.
Published by Mikawa-ya Rihei.
Signed: *Torii Kiyohiro fude* Publisher's seal.
Seal of the Wakai collection.
29·9 × 13·8 (11¾ × 5⅜) 1914–10–12–03

Lent by permission of the Trustees of the
British Museum.

The women who dive for the awabi shells
live in the tiny province of Shima, and are
remarkable for their ability to withstand
extreme cold.

Representations of them are among the rare
examples of the naked human form in
Japanese art. (Compare v 55, where the
possessed women are clearly based on them).
The only other regular occurrence of nudity
is in bath-house pictures (see II 53), for even
the erotica regularly leave the body partially
covered.

1114
Kiyohiro
c.1755–1760

Courtesan chasing her wind-blown love
letters.
Signed: *Torii Kiyohiro fude*
29·5 × 13·4 (11⅝ × 5¼) 1945–11–01–06

Oscar Raphael Bequest

Lent by permission of the Trustees of the
British Museum

The poem makes a pun between scandal
blowing in the South-East wind, and the
availability of female genitalia in the
unlicensed brothel quarter at Fukagawa, in
the South-East of Edo.

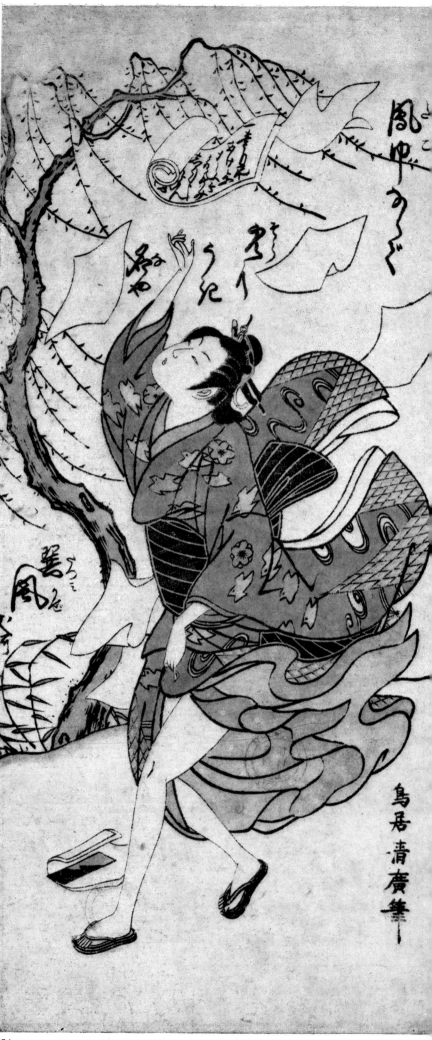

1114

1115
Kiyohiro
c.1755–1760

Courtesan knocking the snow off the eaves.
Published by (?) Urokugata-ya.
Signed: *Torii Kiyohiro fude* Publisher's mark.
35·0 × 14·0 (13¾ × 5½) 1948–04–10–07

Lent by permission of the Trustees of the
British Museum

新製
五色墨
娘形

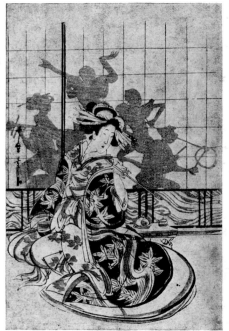

1117

1116
Utamaro
c.1789

Musume kata, The type of the young woman,
from the series Shinsei Goshiki Sumi, Newly
produced ink of variegated colours.
Published by Tsura-ya Kinsuke (Shōkakudō).
Signed: *Utamaro fude* Publisher's mark.
36·5 × 24·1 (14⅜ × 9½) E.3–1897

The title cartouche is in the form of a stick of
ink, newly unwrapped.

The youth of the girl is indicated both by the
somewhat arch knuckle-sucking, and by the
origami bird motif on the kimono.

Note the way in which the volume of the
body is indicated by the drapery folds. This
focusing on the container rather than the
contained perhaps accounts for the ungainly
qualities evident when the naked body is
attempted (see above 1113).

1117
Utamaro II
c.1805

Courtesan with a long pipe. Published by
Yamaguchi-ya Tōbei (Kinkyōdō).
Signed: *Utamaro fude* Publisher's mark.
34·4 × 22·8 (13½ × 9) E.15–1969

Bequeathed by Mr Paul Shelving

This sort of black and grey print is not
common, and it has been suggested that they
are either publisher's proofs, or later
productions. The Museum possesses similar
works by Toyohiro which should date from
about the same period. Certainly the lines are
much more free than is usual in prints, and it
may be that these were an attempt to approach
the qualities more typical of monochrome
ink painting.

The calm aloofness of the courtesan is
emphasized by the frenetic silhouettes of the
musicians cast on the paper wall.

Note the way in which the obi, the long
girdle, is tied in front. This distinguishes the
courtesan from the respectable woman.

1118
Eishi
c.1795

The courtesan Itsutomi, holding the plectrum
of the samisen which lies behind her. From the
series Seirō zōsha sen, Selected treasures of the
Green Houses. Published by Iwato-ya
Kisaburō (Eirindō).
Signed: *Eishi zu* Publisher's seal. Censor
seal: *kiwame*.

39·4 × 26·0 (15½ × 6) E.3762–1953

Bequeathed by Marmaduke Langdale Horn

The long vertical curve of the body is
stabilized by the pool of skirts at the base, and
by the diagonal of the samisen. The colours
are enlivened by the use of iridescent mica
powder on the background, a practice also
favoured by Sharaku (see 12, 141) and
Utamaro (see 1134, where it has almost
disappeared).

This print is widely held to be among Eishi's
best.

1119
Toyohiro
c.1810

Woman with an umbrella on a windy day.
Published by Matsuyasu. Sheet from a
triptych.
Signed: *Toyohiro ga* Publisher's seal.
31·8 × 21·6 (12½ × 8½) E.425–1895

This and the next entry serve to indicate how
a portion of a larger composition was
conceived so as to be a satisfactory design
when isolated from the whole.

1120
Kiyomine
c.1815

Anger, from a triptych of Joy, Sorrow and
Anger. Published by Nishimura-ya Yohachi
(Eijudō). Sheet from a triptych.
Signed: *Kiyomine ga* Publisher's mark and
seal. Censor seal: *kiwame*.
38·1 × 25·4 (15 × 10) E.5209–1886

The anger is communicated by the straight
line of the unusually wide mouth, and by the
coiled spring-like tension induced by the
arrangement of the striped kimono.

1121
Kuniyoshi
1843–1846

Girl and a chrysanthemum plant, from a series
of girls and flower arrangements.
Published by Iwa-Kyū.
Signed: *Ichiyūsai Kuniyoshi ga* Publisher's
seal. Censor seal: *Muramatsu*.
36·8 × 25·4 (14½ × 10) E.4931–1916

Given by the Misses Alexander

Here, as in so many of the prints of women,
the emphasis is on the clothing. Indeed, as
noted above, it is the sweep of the lower
draperies which prevents the figure from
floating in a picture plane which gives no
direct clues to the shape of the ambient space.

The faces of the girls in these later prints seem
much harder and less graceful than those of
Eishō or Utamaro, almost as if the strain
of behaving like flowers was beginning to tell
on them.

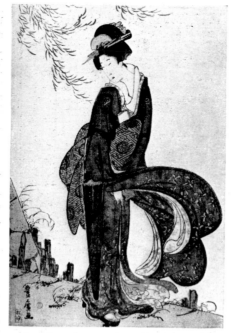

1119

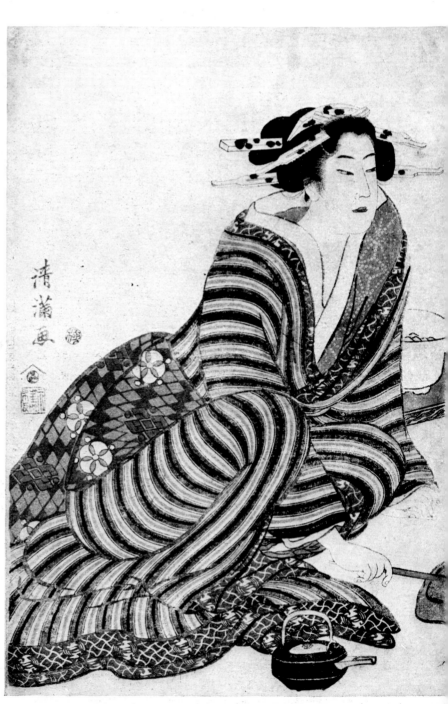

1120

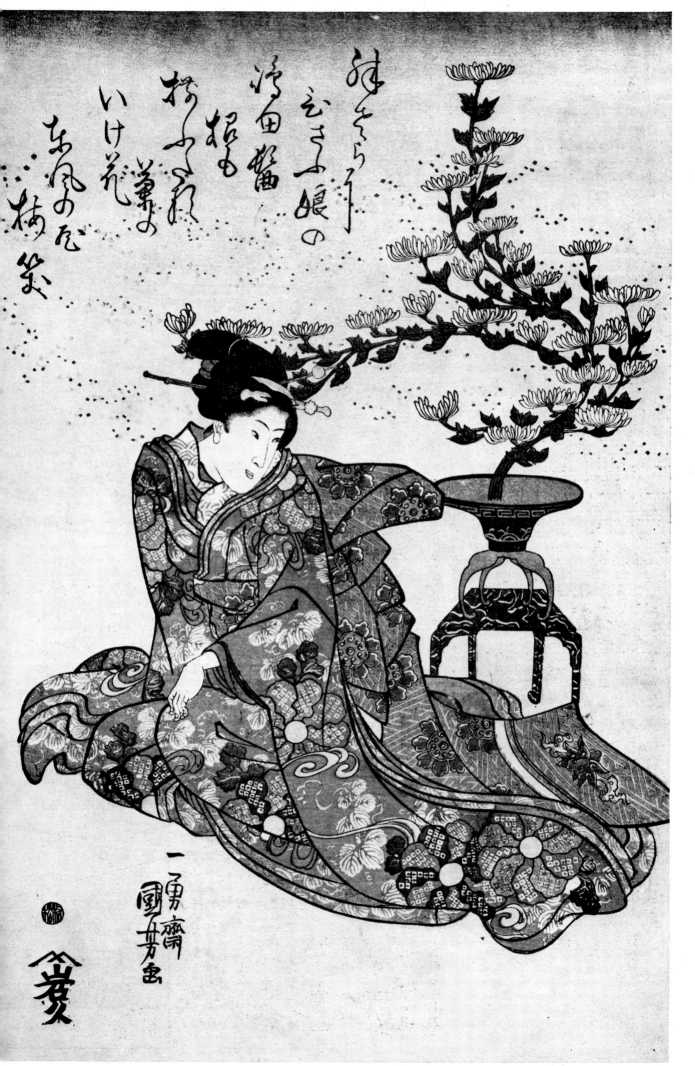

1122
Koryūsai
c.1770

Musician teasing her dog with her samisen.
Hashira-e.
Signed: *Koryūsai ga* Artist's seal: *Masakatsu*.
69·5 × 12·1 (27⅜ × 4¾) E.3756–1953

Bequeathed by Marmaduke Langdale Horn

The hashira-e format, the pillar print, is
designed to fit on the side of the narrow pillar
which is the structural support in traditional
Japanese domestic architecture.

1123
Koryūsai
c.1775

Courtesan as Jurōjin, the god of longevity,
with crane, tortoise and pine tree. Hashira-e.
Signed: *Koryūsai ga*
66·7 × 11·8 (26¼ × 4⅝) E.2659–1909

The character on the girl's kimono is a seal
script version of 'ju', longevity. For the crane
see IV 8, for the tortoise IV 16.

Koryūsai had a particular talent for the difficult
compositional problems inherent in the shape
of the pillar print, and made full use of the
diagonals: here, for example, the head of the
girl, the beak of the crane and the head of the
tortoise lie on the top left to lower right line.

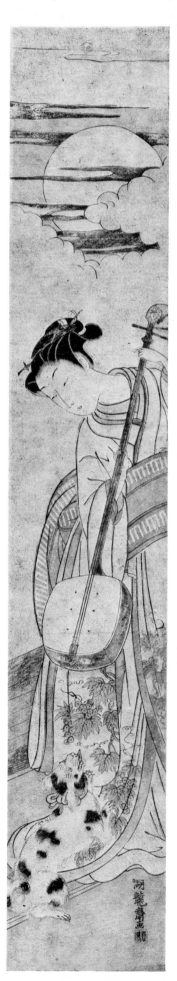

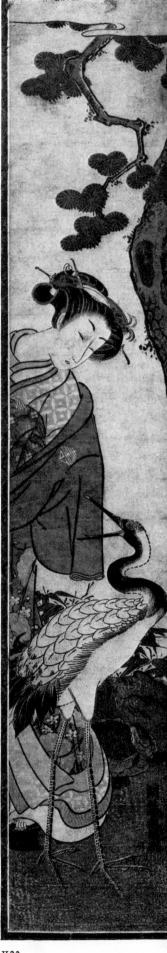

1122

1123

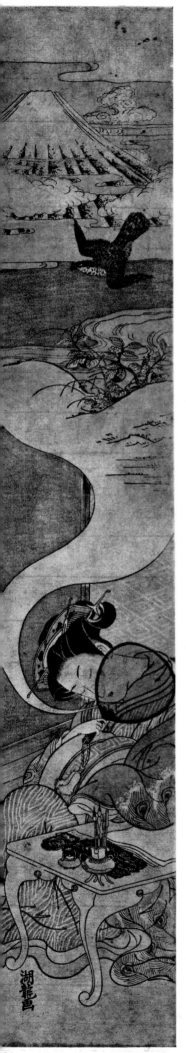

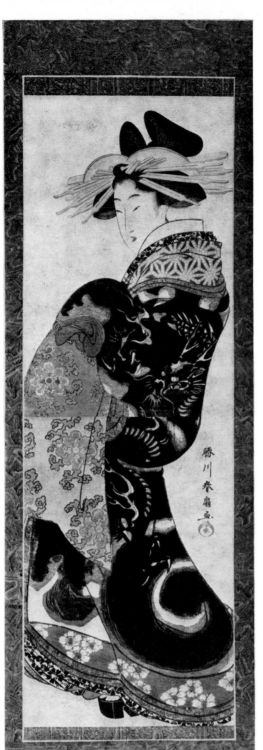

1125

1124
Koryūsai
C.1775

A courtesan's lucky dream. Hashira-e.
Signed: *Koryū ga*
69·5 × 12·1 (27⅜ × 4¾) E.3757–1953

Bequeathed by Marmaduke Langdale Horn

One falcon is missing here, for the traditional prescription for this dream presaging prosperity was one Fuji, the abode of the gods, two falcons, the sport of the nobles, and three aubergines, for reasons I have been unable to discover.

It is of interest to note the full use made compositionally of the predecessor of the speech bubble familiar in comic strips. Note that the bubble emerges from the heart.

Koryūsai made use of this figure fallen asleep at the writing table many times in similar compositions, varying only the type of brushpot, water dropper and inkstone, and the contents of the dream bubble.

1125
Shunsen
C.1820

Courtesan in full parade costume. Kakemono-e.
Signed: *Katsukawa Shunsen ga* Artist's seal: *Shun*.
76·2 × 23·5 (30 × 9¼) E.12564–1886

One of the more picturesque habits of the Yoshiwara was the formal promenading of the senior courtesans, known as oiran, in their most gorgeous kimonos, accompanied by servants and maids. The kakemono-e, or hanging scroll print, provided a perfect format to display them.

1126
Eizan
c.1820

Oiran on parade. Kakemono-e.
Signed: *Kikugawa Eizan fude* Artist's seal: *Ei.*
73·7 × 24·8 (29 × 9¾) E.13326–1886

The taste of the wearer is shown in the way
the various layers blend and contrast, from the
soft under-kimono, a trace of which is here
visible above the geta, or clog, through the
successive layers of six-pointed star pattern,
a formalized hemp leaf, picked out in dif-
ferent colours, to the magnificently figured
top layer, worn off the shoulder and
contrasted with the checkered obi.

1127
Eizan
c.1815

Courtesan dressed as a komusō. Kakemono-e.
Signed: *Kikugawa Eizan*
71·1 × 24·8 (28 × 9¾) E.13310–1886

The komusō were wandering monks who
wore large basket hats hiding their faces and
played the five holed flute called the
shakuhachi. The girl holds the characterist-
ically curved flute in her right hand, and the
hat in her left. The other allusion to priestly
garb is provided by the black stole fastened
with a ring across the left shoulder.

The komusō garb, with its convenient
anonymity, was frequently used by samurai
visitors to the Yoshiwara, since the pleasure
quarters were officially banned to them.

1128
Eizan
c.1825

Plump courtesan emerging from behind a
curtain. Kakemono-e.
Signed: *Kikugawa Eizan fude*
71·8 × 24·8 (28¼ × 9¾) E.13314–1886

1129
Eisen
c.1830

Oiran on parade. Published by Sano-ya
Kihei (Kikakudō). Aizuri-e. Kakemono-e.
Signed: *Keisai Eisen ga* Publisher's seal.
Censor seal: *kiwame*.
73·7 × 24·8 (29 × 9¾) E.12904–1886

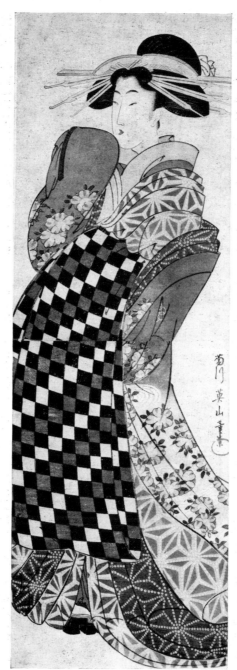

1126

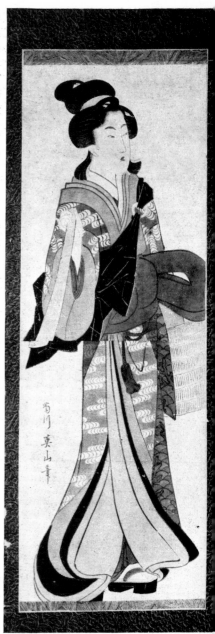

1127

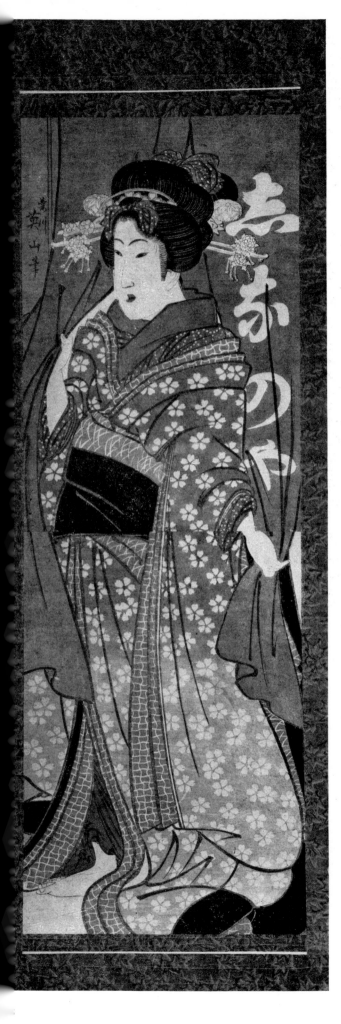
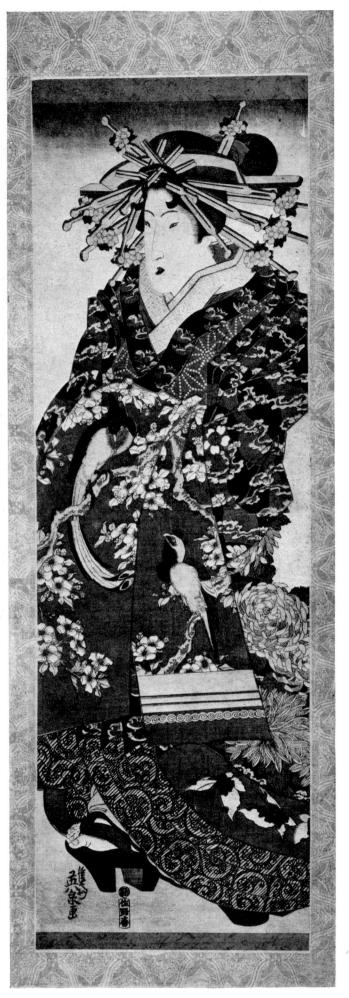

1130
Eisen
c.1830

Woman fastening her hair ornament.
Published by Matsumoto. Kakemono-e.
Signed: *Keisai Eisen ga* Publisher's seal.
73·7 × 24·8 (29 × 9¾) E.12890–1886

1131
Kunisada
c.1825

Girl wiping her face. Published by
Yamamoto-ya Heikichi. Kakemono-e.
Signed: *Gototei Kunisada ga* Publisher's seal.
Unidentified seal. Censor seal: *kiwame*
72·4 × 24·8 (28½ × 9¾) E.388–1954

Given by Mrs Sidney D. Aris

The costume is triply auspicious: the bat for
good fortune, because the words sound alike
in Japanese; the carp for prosperity (see IV 13);
and the character 'ju' for longevity.

Note, in this and the previous print, how the
sash was used as a pocket.

1132
Kunisada
1844–1845

Girl trimming her nails. Published by
Maru-ya Kiyojirō (Jukakudō). Kakemono-e.
Signed: *Kunisada aratame nidai Toyokuni ga*
Publisher's seal. Censor seal: *Tanaka*.
70·5 × 24·8 (27¾ × 9¾) E.5578–1886

This print coincides with the period when
Kunisada assumed the name of Toyokuni,
hence the long signature.

1133
Kunisada
1844–1845

Girl offering a cat a sweet on her tongue, with
the title Chō shoku jisei no konomi,
Purchasing fabric in contemporary taste.
Kakemono-e.
Signed: *Motome ni ōjite Kunisada aratame
nidai Toyokuni ga* Artist's Utagawa seal.
Censor seal: *Yoshimura*.
72·4 × 25·1 (28½ × 9⅞) E.5571–1886

This is a good example of a print serving as a
fashion plate. The obi with the mandarin
ducks (see 112) is probably the special feature.
The package behind the woman is the source
of the sweet.

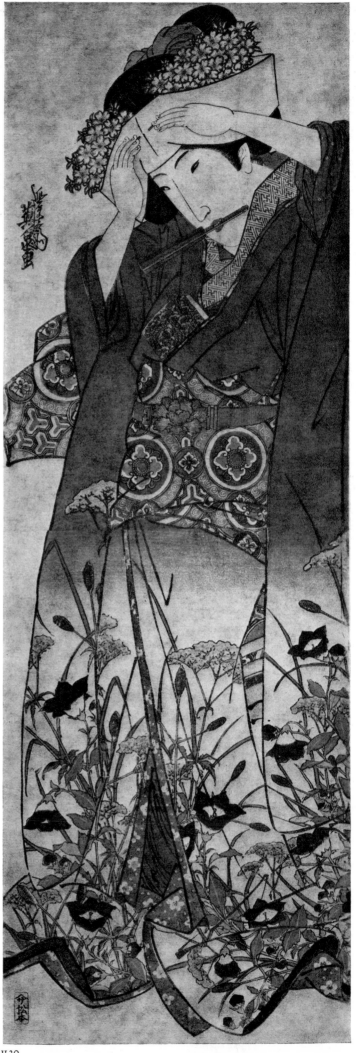

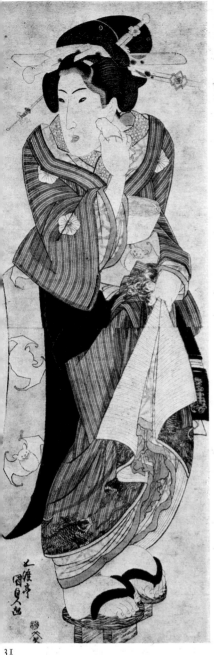

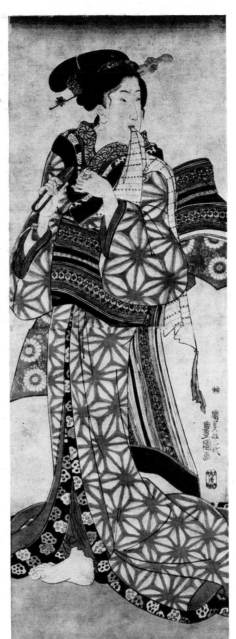

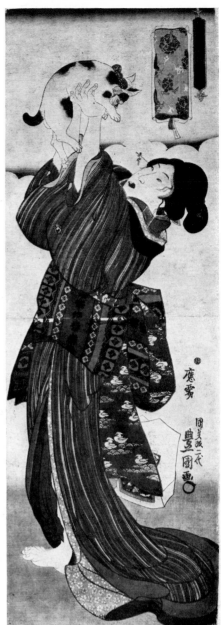

31

II 32

II 33

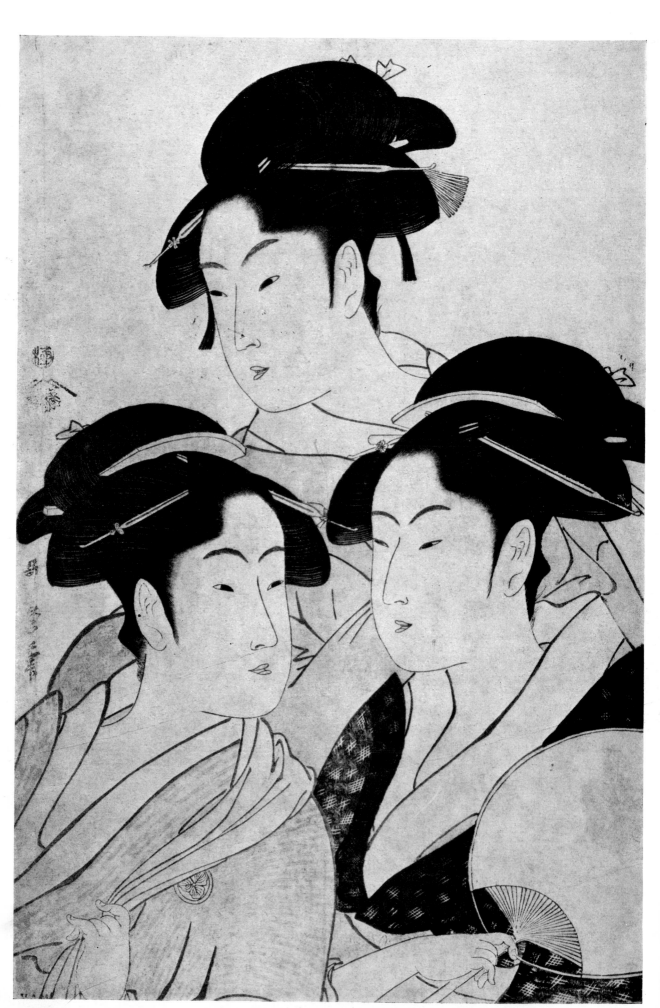

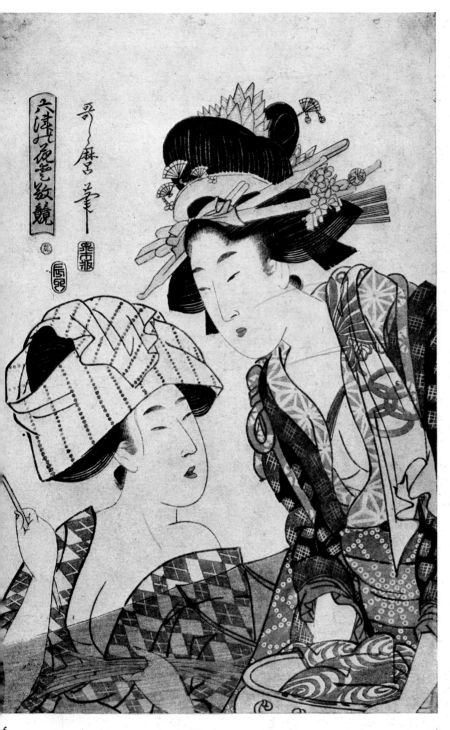

1134
Utamaro
1792–1793

Tōji san bijin, Three contemporary beauties:
Tomimoto Toyohina (right), Naniwaya
Okita (centre), and Takashima Ohisa (left).
Published by Tsuta-ya Jūsaburō (Kōshodō).
Signed: *Utamaro fude* Publisher's mark.
Censor seal: *kiwame*.
37·2 × 24·5 (14⅝ × 9⅝) E.263–1934

Bequeathed by Sir Edward David Stern

These tea-house waitress beauties figure
prominently in Utamaro's oeuvre, the names
being taken from another state of this print
with titles. The pyramidal composition of
heads was a favourite device too, with its rich
possibilities for linear interaction between the
figures. They are set against a reflecting
ground of powdered mica, which has largely
disappeared in this example. (For other
examples with mica see II2, II18, I 2, I 41).

1135
Utamaro II
1808

Washerwomen, from the series Mutsu no
hana o kyōkei, Respectful comparison of
snowflakes.
Published by Izumi-ya Ichibei (Kansendō).
Signed: *Utamaro fude* Publisher's seal.
Censor seal: *Dragon 4*.
36·8 × 24·1 (14½ × 9½) E.428–1895

Snowflakes, literally six-pointed flowers, is a
metaphor for beautiful women.

Note how much weaker than his master's is
the second Utamaro's sense of space and
volume. His two-dimensional design is
nonetheless attractive.

1136
Mitsunobu
c.1730

Courtesan accosting a client.
25·5 × 36·1 (10 × 14⅛) 1965–06–12–03

Lent by permission of the Trustees of the
British Museum

The spider's web motif on the courtesan's
kimono must surely be the artist's comment
on the nature of her trade. The man is wearing
a straw hat like that of a komusō (see 1127).

1137
Shigenaga
c.1750

Hotei ferrying a girl across a river. Published
by Yamashiro.
Signed: *Senkadō Nishimura Shigenaga Hyakuju
fude* Publisher's seal.
32·4 × 15·2 (12¾ × 6) E.136–1911

Hotei is one of the Seven Gods of Good
Fortune, his particular forte being content-
ment. He is normally surrounded by crowds
of happy children anxious for the treasures in
his bag, but he has here succumbed to the
charm of a young beauty.

Shigenaga was the teacher of Harunobu, and
it is interesting to compare the difference in
feeling between two apparently similar heads
in this print and the next.

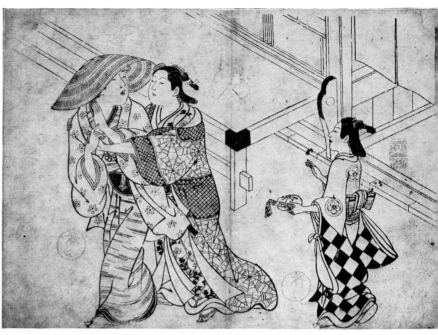

1136

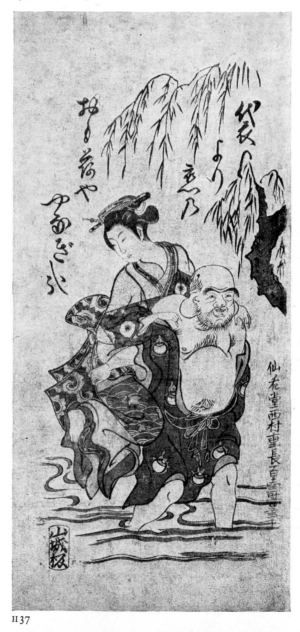

1137

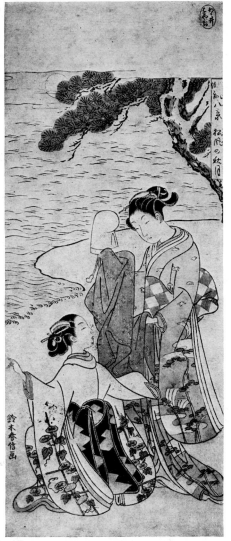

1138

1138
Harunobu
c.1765

Matsukaze no shūgatsu, The autumn moon of
the breeze in the pines, from the series Fūryū
butai hakkei, Eight views in fashionable
theatrical style.
Signed: *Suzuki Harunobu ga*　Seal of the
Wakai collection.
34·9 × 14·6 (13¾ × 5¾)　　E.81–1969

Bequeathed by Mr Paul Shelving

For the traditional eight views see III 34 ff. For
variants see e.g. II 1, II 52.

The 'theatrical' in the title refers to the Nō
play Matsukaze, which concerns events in the
life of Ariwara no Yukihira, brother of
Narihira (see V 41, V 42).

1139
Harunobu
c.1767

Travelling lovers, from a set of 24.
18·7 × 28·0 (7⅝ × 11)　　E.221–1968

Erotic prints formed a considerable part of the
oeuvre of most ukiyo-e print makers. Known
as Shunga, Spring pictures, they served to
advertise the delights and instruct in the
manners of sex. The aesthetic effect ranges
from the light and humorous, as in many of
Haronobu's shunga, to the intense and
viciously crude in some nineteenth century
examples.

Of interest in this series is the inclusion of the
tiny and somewhat detached voyeur figure,
here seen lighting his pipe with an expression
of calm complaisance.

The mark of a successful explicit erotic
composition is for the picture to display the
sexual activity of both (or all) participants
clearly, without making the postures seem
awkward and implausible, a more difficult
demand than it may on first thoughts appear.

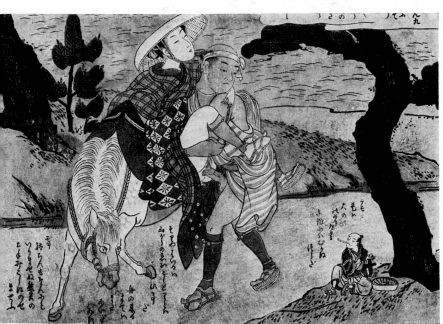

1140
Harunobu
c.1768

Courtesan watching her maids build a snow
dog.
Signed: *Harunobu ga*
26·6 × 21·0 (10¼ × 8¼) E.7–1897

1141
Utamaro
1788

Lovers resting by a tree, from the album Uta
makura, Poem of the pillow.
24·8 × 37·4 (9¾ × 14¾) E.97–1954

Bequeathed by Marmaduke Langdale Horn

This album contains the most famous of
Utamaro's shunga, and in delicacy of engrav-
ing, richness of detail and mastery in printing
is fully worthy of its fame. The sensuousness is
conveyed not so much by the erotic motif
itself, as by the slow lingering way in which
the eye is led across the picture surface by the
sinuous lines of the garments.

For others from this album see 1158–1161

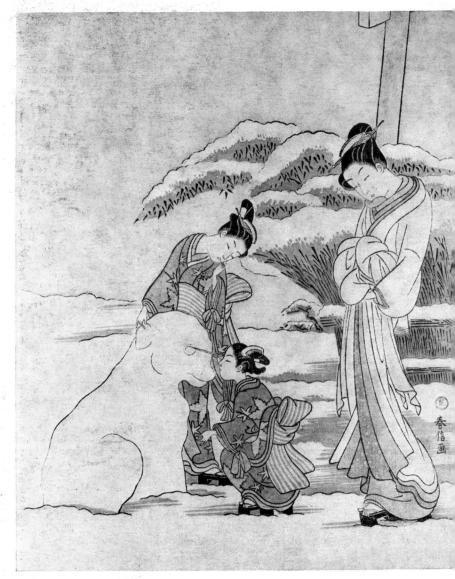

1140

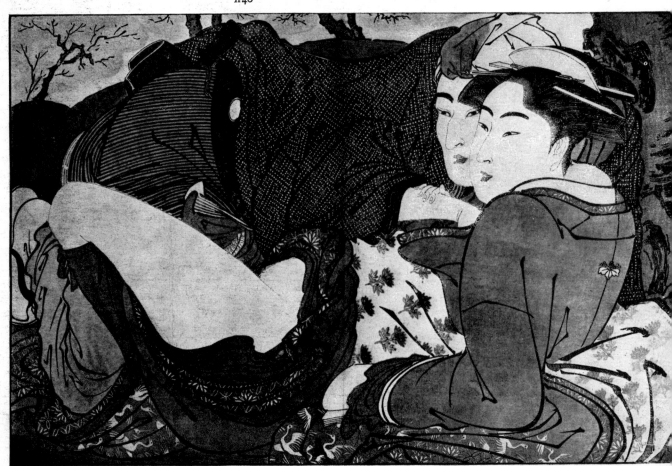

1141

42

[U]tamaro

1804

[W]asherwomen, by the banks of the Tama
[R]iver in Musashi province, from the series
[F]iryū Mu Tamagawa, contemporary views
[of] the six Tama rivers. Published by Maru-ya
[I]mpachi (Enjūdō).
[Si]gned: *Utamaro fude* Publisher's seal.
[?]·7 × 25·4 (15¼ × 10) E.4235–1897

[T]he six Tama, jade, rivers were another
[fa]vourite group of subjects. Utamaro has
[tr]eated the landscape aspect in a purely
[ac]cessory way, related to the screens of the
[R]impa school, and has concentrated on the
[fi]gures. Compare the seated girl with an
[ex]ample fifteen years earlier in II 16.

[?]3

[U]tamaro

[1]804

[Gi]rls picking persimmons. Published by
[W]akasa-ya Yoichi (Jakurindō). Right sheet
[fr]om a triptych.
[Si]gned: *Utamaro fude* Censor seal: *kiwame*.
[?]·8 × 24·5 (14⅞ × 9⅝) E.1069–1963

[Be]queathed by Lady Evelyn Malcolm

[A] good example of the compositional
[ad]equacy of a single sheet from a well
[de]signed triptych. The colours here have
[fa]ded to autumnal hues entirely appropriate
[to] the subject matter.

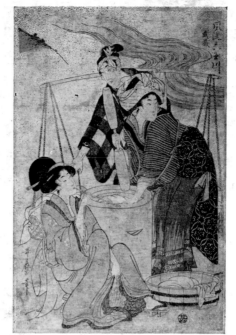

II 42

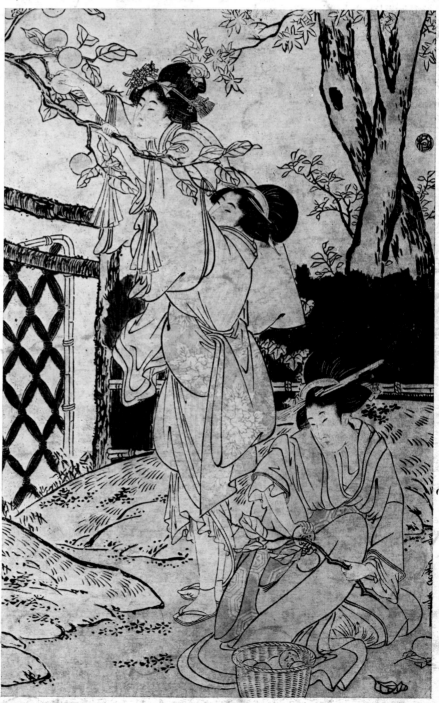

II 43

1144
Kiyonaga
1785

Jōrurihime and her maids listening to the flute
of Yoshitsune. Published by Nishimura-ya
Yohachi (Eijudō). Right sheet from a triptych.
Signed: *Kiyonaga ga* Publisher's seal and
mark.
38·1 × 25·4 (15 × 10) E.895–1951

For Yoshitsune see v18–v22. Jōrurihime is
the heroine of a love story which is peripheral
to the main legend. Yoshitsune appears on
the left sheet of this triptych, the main function
of which is not so much narration as it is
presentation of beautifully dressed women in
elegant surroundings.

1145
Eishō
c.1800

A European with a courtesan.
25·4 × 38·1 (10 × 15) E.170–1954

Bequeathed by Marmaduke Langdale Horn

This print is loosely based on one from the
Uta makura album by Utamaro, where
both figures are Europeans, their grotesque
appearance clashing oddly with the sumptuous
production of the print. With publicity like
this – the only contact the Japanese had with
Europeans before the opening-up by Perry –
it is scarcely surprising that they were
regarded as demonic.

1146
Shunchō
c.1800

Lovers on a balcony, from the series Kōshoku
zu-e junikō, The twelve hours of lovemaking,
illustrated.
24·8 × 37·4 (9¾ × 14¾) E.225–1968

The atmosphere here is that of a particularly
blissful summer afternoon.

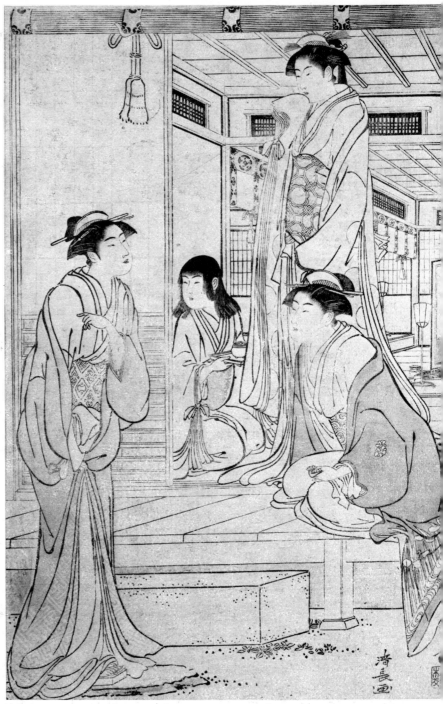

1144

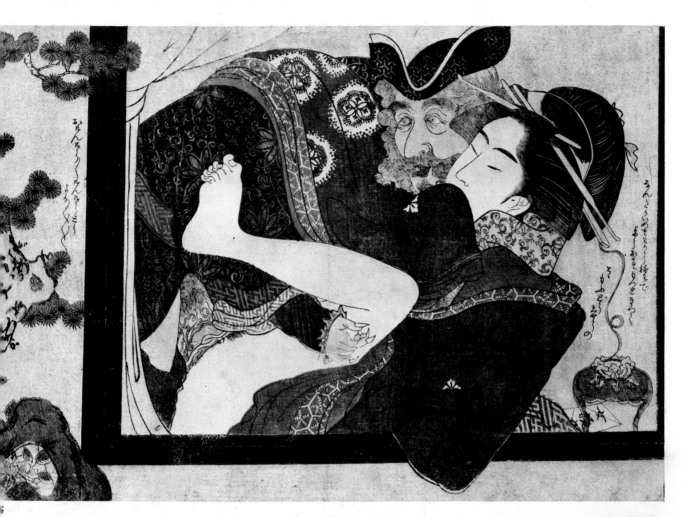

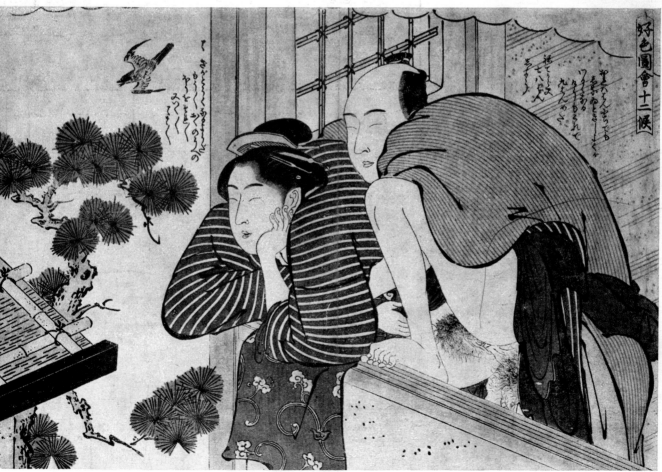

1147
Shimposai
?c.1700

Samurai and servant on a journey. Possibly
printed from stone.
Signed: *Shimposai.*
37·8 × 35·2 (14⅞ × 13⅞) E.1136–1912

Prints with a white-line image, like the wood
engravings of Thomas Bewick, are unusual
in the Japanese tradition. They are usually
intended to imitate ink squeezes taken from
stone in China. The texture of the black and
the soft edges of the image suggest that this
print by an unrecorded artist may be in
fact taken from a stone, and not merely a
woodblock imitation.

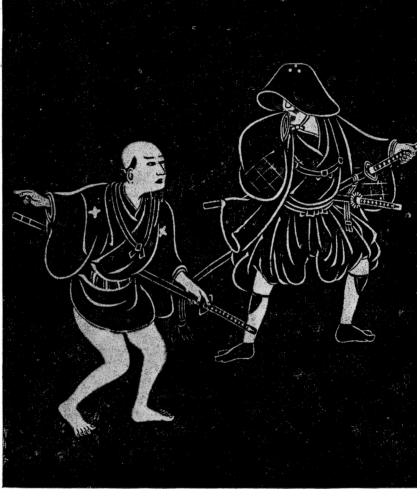

1147

1148
Masanobu
?c.1710

Courtesan and her maid with grotesque
masks.
Signed: *Okamura Masanobu zu*
36·8 × 27·3 (14½ × 10¾) E.346–1901

This may well be a later reworking of a
Masanobu theme, the rather clumsy lines in
the faces supporting this conclusion. Such
prints were, nevertheless, produced in the
18th century, Masanobu's name being linked
with them.

1149
Utamaro
?c.1785

Fishing party by the sea. Left sheet from a
triptych. Printed in blue.
Signed: *Utamaro ga* Censor seal: *kiwame.*
39·1 × 26·7 (15⅝ × 10½) E.137–1911

The same doubts as to date of production
apply to this image as it did to the previous
one. The design exists as a normal multi-
colour print, and the date is taken from that.

1148

1149

1150

Masanobu

c.1720

Maid bringing refreshments to a courtesan
and her client.
Signed: *Yamato Eshi Okamura Masanobu zu*
28·6 × 39·1 (11¼ × 15¾) E.350–1901

The strength of this composition lies in the
echoes and continuities of the principal motifs
in the secondary: the line of the courtesan's
outer kimono is taken up by the foreground
shore in the landscape screen; the curve of the
back of the man's head by the sleeve of the
same kimono, and the 'S' curve of the maid's
hair by the ripples on the right of the screen.

1151

Harunobu

c.1768

Lovers by a landscape screen.
Signed: *Harunobu ga*
19·5 × 27·0 (7⅝ × 10⅛) E.222–1968

A composition based on the strong diagonals
of the rail and the division in the matting. An
unstated diagonal runs from the bottom left
corner, through the genitals, the intersection
of the back wall and the screen, and the tiny
figures in the screen.

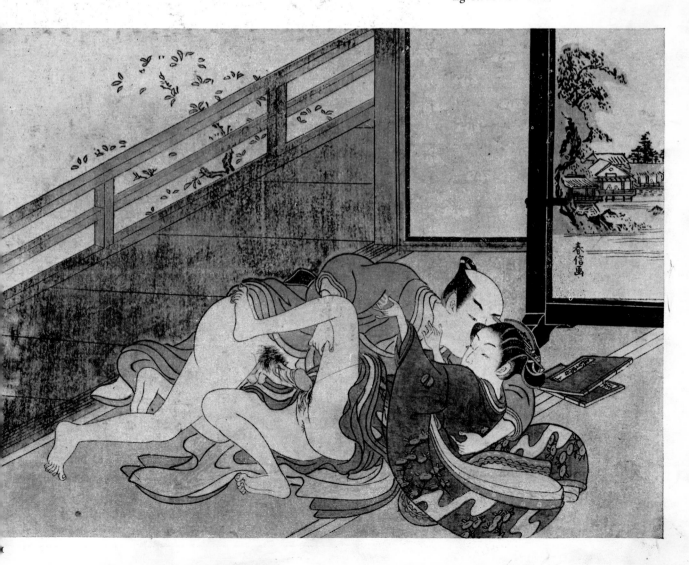

II 52
Harunobu
c.1768

Courtesan and her lover reading a letter, a parody on an incident in the Chūshingura.
Signed: *Harunobu ga*
28·6 × 21·6 (11¼ × 8½) E.1053–1963

Bequeathed by Lady Evelyn Malcolm

For the Chūshingura see v 48–v 52. The incident parodied is that where a spy under a balcony reads a letter which dangles down from its recipient above.

The diagonals are again critical: the line of the top of the screen passes through the girl's head, of the bottom through the man's. The line of the edge of the cloth on which the girl sits is continued by the ground line in the screen.

II 53
Harunobu
c.1766

Returning sails of the towel rack, from the series Zashiki Hakkei, Eight parlour views
26·4 × 20·6 (10⅜ × 8⅛) E.55–1955

Another variant on the Hakkei theme (see II 1). Here the towel drying on its bamboo rack is the link with the boats returning to harbour.

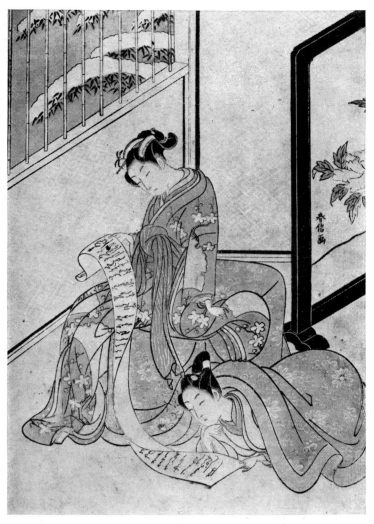

II 52

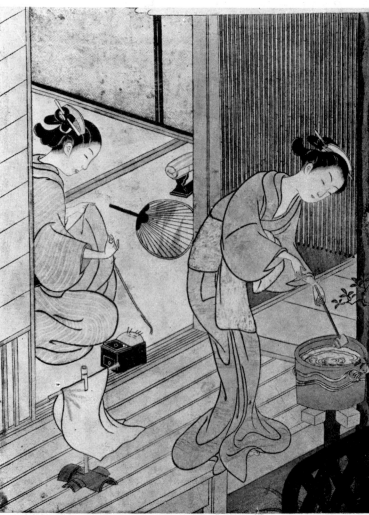

II 53

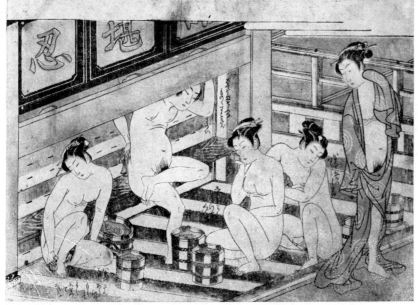

II 54

II 54
Koryūsai
C.1770

The baths.
$17 \cdot 8 \times 24 \cdot 8 \left(7 \times 9\frac{3}{4}\right)$ E.149–1954

Bequeathed by Marmaduke Langdale Horn

II 55
Koryūsai
?c.1768

Love interrupts the making of silk wadding.
$17 \cdot 8 \times 24 \cdot 8 \left(7 \times 9\frac{3}{4}\right)$ E.113–1954

Bequeathed by Marmaduke Langdale Horn

The wadding is made out of floss silk, which is pressed flat and dried on heated lacquer domes. The soft texture of the silk is represented by blind printing.

The date of this print is taken from the open book on the floor.

II 56
Koryūsai
C.1770

Lovers behind a folding screen.
$17 \cdot 8 \times 24 \cdot 8 \left(7 \times 9\frac{3}{4}\right)$ E.144–1954

Bequeathed by Marmaduke Langdale Horn

The recession of the figures in space is aided by the bedcovers, which form a succession of little hills, echoing the curve of the man's buttocks.

Note the wooden pillow beneath the girl's head. The black handled box contains smoker's requisites.

55

5

II 57
Koryūsai
c.1775

The servant toys with the maid while the
master loves the courtesan.
17·8 × 25·4 (7 × 10) E.223–1968

The maid holds an iron kettle for hot sake,
rice spirit.

II 58
Utamaro
c.1804

Amagoi Komachi, Komachi praying for rain,
from the series Futaba gusa nana Komachi,
The seven episodes from the life of Komachi
compared to double leaved plants.
Published by Tsuru-ya Kihei (Senkakudō).
Signed: *Utamaro fude* Publisher's mark (cut).
35·9 × 25·2 (14$\frac{1}{8}$ × 9$\frac{7}{8}$) E.21–1969

Bequeathed by Mr Paul Shelving

Ono no Komachi was one, the only woman,
of the Rokkasen, the six sages of poetry of the
9th century. There is a classic set of episodes
from her life, of one of which this is a parody:
In 866 the countryside was suffering from an
extended drought. Komachi recited aloud a
verse of such beauty that the clouds gathered
and the rain fell, a feat which all the priests
had been unable to achieve with their
intercessions.

II 57

II 58

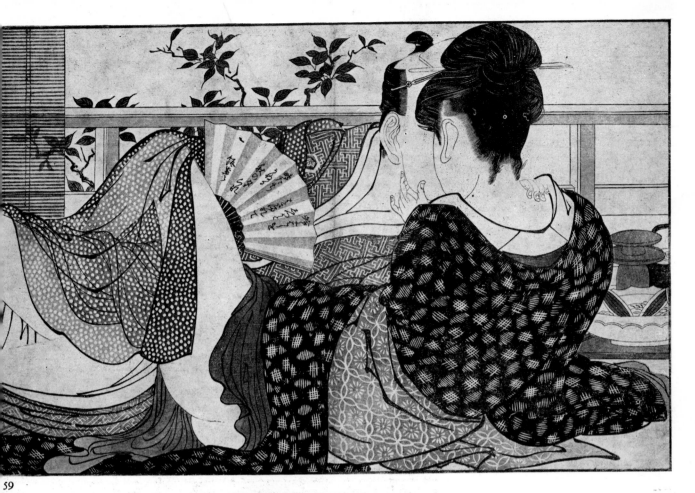

59

60

11 59–1162
Utamaro
1788
Frontispiece and three plates from the album
Uta-makura, The poem of the pillow.
Each 24·8 × 37·4 (9¾ × 14¾)
E.98, E.99, E.100 & E.103 –1954

Bequeathed by Marmaduke Langdale Horn

The quality in these prints is self-evident.
There is a suggestion, based on a close
similarity of dress to that in an avowed
portrait, that the man in 1159 is Utamaro
himself. It would be an appropriate role for a
life-long devotee of the more elegant aspects
of Yoshiwara life.

1161

1162

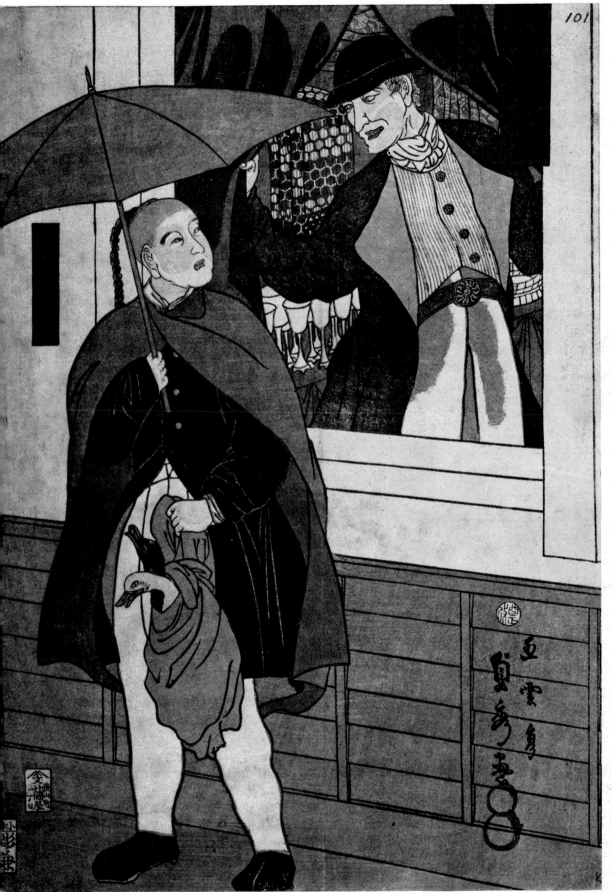

1163
Sadahide
1861

Yokohama shōka ijin no zu, Igirisujin and
Nankinjin, Pictures of foreign merchants in
Yokohama, an Englishman and a Chinese
from Nanking. Published by Tsujioka-ya
Bunsuke.
Signed: *Gountei Sadahide ga* Artist's
Utagawa seals. Publisher's seal.
Engraver's seal: *Hori Kane*.
34·6 × 24·1 (13⅝ × 9½) E.12137–1886

1164
Masanobu
c.1745

Courtesan giving advice to her maid.
Kakemono-e. Coloured by hand.
Signed: *Hōgetsudō shōmei Okumura Bunkaku*
Masanobu shō fude. Artist's seal: *Tanchōsai.*
61·0 × 25·0 (28 × 9¾) 1933–10–14–06

Lent by permission of the Trustees of the
British Museum

1165
Koryūsai
c.1775

Youth and courtesan as Watanabe no Tsuna
and the demon of Rashōmon. Hashira-e.
Signed: *Koryūsai ga.*
68·6 × 11·7 (27 × 4⅝) E.2660–1909

The lightning and cloud motif identify the
girl as a personification of the demon which
grasped Watanabe no Tsuna by the helmet.
The umbrella he holds bears the 'mon',
badge, of Watanabe. See v 58 for a later
episode from the story, and a note on
Watanabe.

1166
Eisui
c.1790

Shop assistant and customer. Published by
Suruga-ya. Hashira-e.
Publisher's mark and seal.
60·3 × 10·5 (23¾ × 4⅛) E.597–1903

The composition is based on a zig-zag motion:
from the hem of the dress to the girl's knee;
from her hand to her head; from the man's
pipe to his head, to the open showcase back
to the girl's head.

1167
Shunsen
c.1800

Umegawa and Chūbei. Published by
Idzumi-ya Ichibei (Kansendō). Hashira-e.
Signed: *Shunsen ga* Publisher's seal.
61·0 × 10·2 (24 × 4) E.348–1895

These are the protagonists of a rather sordid
Yoshiwara story: Chūbei was in love with
the courtesan Umegawa, and, to buy her out,
stole money which was being sent through
the government's courier system. He was
forced to go into hiding to avoid detection.
Overcome by shame the couple committed
suicide.

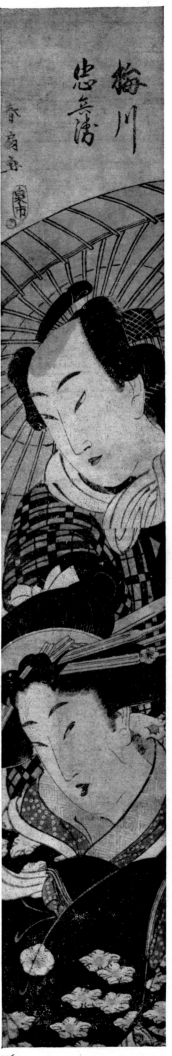

1165

1166

1167

1168

Eizan
c.1820

Not a ghost.
Signed: *Kikugawa Eizan fude*
43·2 × 24·8 (29 × 9¾) E.13311–1886

The title is based on the superstition that, while ghosts and demons were capable of assuming human form, this deception did not extend to their reflections. See also v66, where the demon is revealed.

Compare the treatment of the water-butt motif with that in 112.

1169
Utamaro
c.1804

Edo meibutsu nishiki-e kōsaku. Famous things of Edo: the making of multi-colour prints. Published by Tsuru-ya Kiemon (Senkakudō). Diptych.
Signed: *Utamaro fude* Publisher's mark.
36·8 × 50·8 (14½ × 20) E.5–1897 &
E.855–1914

Utamaro has employed a favourite device: to substitute fashionable beauties for the less attractive real craftsmen. There exists a companion diptych, showing the finished prints on display in the publisher's shop, eager customers examining them.

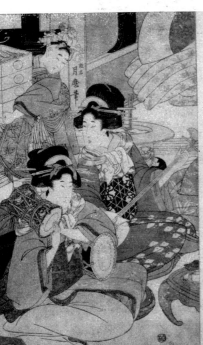
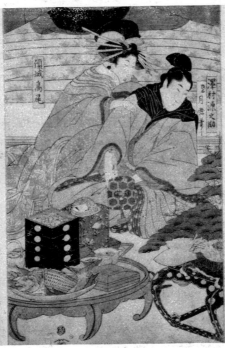
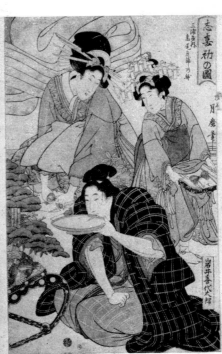

1170
Kikumaro
c.1804

Shiki sho no zu, Picture of the preliminary stages of the determination to enjoy oneself: Miura-ya no uchi Takao yashiki no tei, The apartments of Takao of the Miura brothel. Published by Tsuta-ya Kichizō (Kōeidō). Triptych.
Signed: *kaimei* (name changed to) *Tsukimaro fude* Publisher's mark. Censor seal: *kiwame*.
36·8 × 71·8 (14½ × 28¼) E.2124–1899

This scene shows particularly lavish refreshments being consumed by the actors Iwai Kiyotarō (right) and Sawamura Gennosuke in the apartments of a senior courtesan. The season may well be the New Year, as a junior courtesan and a senior maid are tying parcels on the right. Behind the musicians a junior maid, distinguishable by her partly shaven head, carries in another box of noodles.

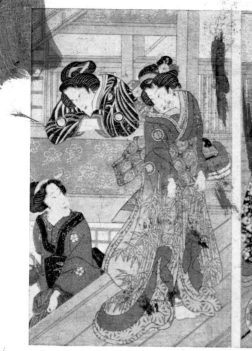
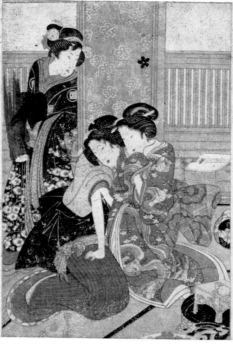
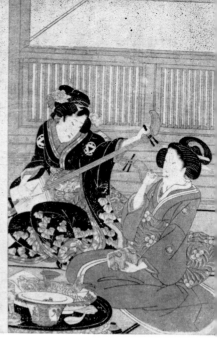

1171

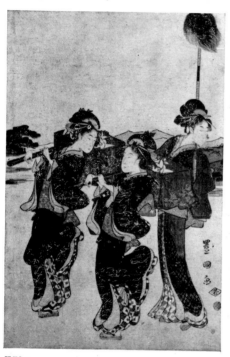
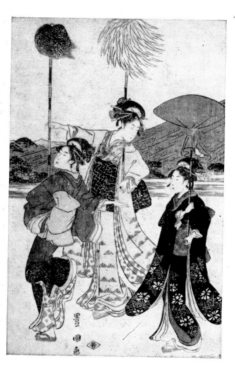
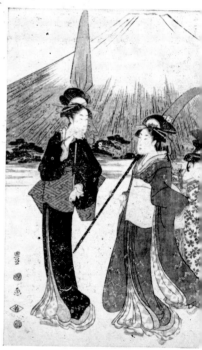

1172

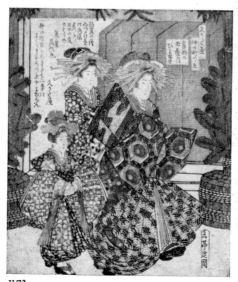
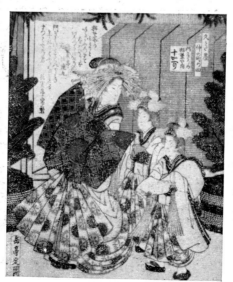
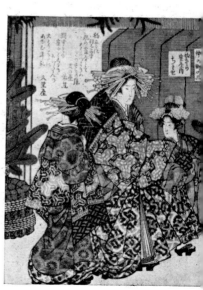

1173

1171
Toyokuni
c.1810

The womenfolk of a rich merchant family in their apartments. Published by Yamato-ya Heikichi (Eikyūdō). Triptych.
Signed: *Toyokuni ga* Publisher's mark.
Censor seal: *kiwame*.
36·2 × 71·8 (14¼ × 28¼) E.12642–1886

The married women may be distinguished by their shaved eyebrows.

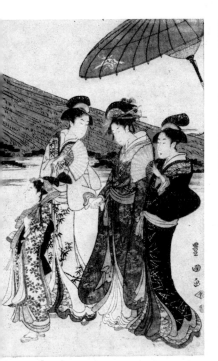

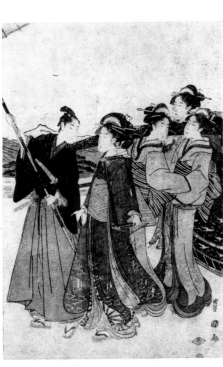

1172
Toyokuni
c.1805

Women imitating the procession of a daimyō passing in front of Mt Fuji. Published by Wakasa-ya Yoichi (Jakurindō). Pentaptych.
Signed: *Toyokuni ga* Publisher's seal.
Censor seal: *kiwame*.
36·2 × 127·0 (14¼ × 50) E.2125–1899

The daimyō were the feudal lords of Japan: their processions with their retainers on the way to pay homage to the shōgun in Edo were a familiar sight on the highways (see 1161). The substitution of elegant beauties for them is an adequate indicator of the feelings of the city towards them.

1173
Gakutei
c.1815

Hisakata-ya, The house of heavenly beings: Courtesans and their attendant minions parading during the New Year on Nakanochō. Published by Shugyokudō. Pentaptych. Surimono.
Signed: *Gakutei Sadaoka* Publisher's seal.
20·3 × 88·9 (8 × 35) E.592–1899

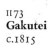

Hisakata is 'a meaningless word used in poetry to describe heavenly beings'. Nakanochō is the main street in the Yoshiwara. The New Year is indicated by the pine shrubs in front of the green blinds from which the brothels gained the name of the green houses.

The courtesans are, from right to left, Suehiro of the Ōgi-ya, Kuramode of the Wakana-ya, Chitose of the Tsuru-ya, Togane of the Matsuba-ya, and Hitofude of the Tama-ya.

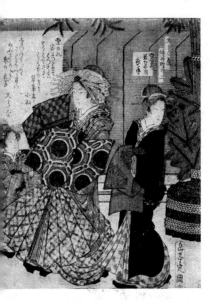

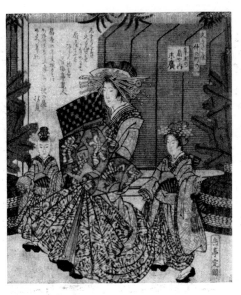

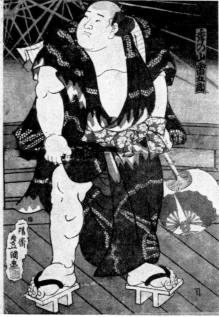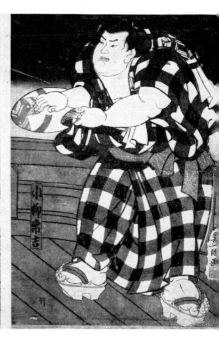

1174
Kunisada
c.1844

The sumō wrestlers, from right to left,
Koyanagi Tsurekichi, Hidenoumi Raigorō
and Orauma Kichigorō. Published by
Yorozu-ya Jūbei. Six sheet triptych.
Signed: *Kunisada aratame nidaime Toyokuni ga*
Artist's seal: *Ichiyōsai.* Publisher's mark.
Censor seal: *Hama.*
50·8 × 109·5 (20 × 43⅛) E.1113–1912

This print, matching its subject in unusual
size, will serve to indicate that the interests of
the Edo townsfolk were not restricted to the
merely pretty.

1175
Kuniyoshi

Shiohi goban, Five low-tide pictures:
Shellfish gathering at Shinagawa.
Pentaptych. Surimono.
Signed: *Ichiyūsai Kuniyoshi ga*
21·3 × 90·5 (8⅜ × 35⅝) E.367–E.371–1910

Compare with the pentaptych by Gakutei
(1173). In both the individual sheets will serve
as separate compositions, but the Kuniyoshi,
with its less uniform background, and more
diverse postures, makes a more satisfying
complete unit.

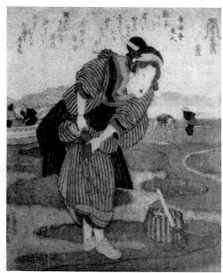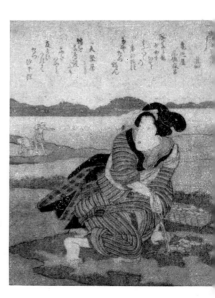

1175

Books associated with section II (not illustrated)

IIa
Moronobu
1681

Ukiyo hyakunin onna, One hundred women of the Floating World.

Lent by Mr & Mrs Jack Hillier

IIb
Moronobu
1683

Bijin ezukushi, A series of pictures of beautiful women.

Lent by Mr & Mrs Jack Hillier

IIc
Hambei
1687

Jōyō kimmō zui, An encyclopedia for the use of women, with fashion pictures.

Lent by Mr & Mrs Jack Hillier

IId
Sugimura Jihei
1700

Eiri shin onna imagawa, Instructions for women.

Lent by Mr & Mrs Jack Hillier

IIe
Sukenobu
1723

Hyakunin Jōrō hina sadame, Portraits of a hundred beauties. Volume 2.
E.14872–1886

IIf
Sukenobu
(1735) 1755

Ehon chiyomi gusa, Plants to be seen for a thousand generations: illustrated poems. 3 volumes. ? 4th edition.
E.2664–E.2666–1925

IIg
Harunobu
1767

Ehon chiyo no matsu, Pines for a thousand generations: illustrated poems. Volume 2 from 3.
E.14997–1886

IIh
Minkō
(1770) 1784

Saiga shokunin burui, Illustrations of craftspeople at their work. Volume 1 of 2. 2nd edition.
E.2760–1925

IIi
Kitao Masanobu
1783

Seirō meikun ji-hitsu shū, Collected beauties of the Green Houses, with poems in their hand.
E.2498–1925

IIj
Utamaro
1786

Waka Ebisu, Illustrated comic poems for the New Year.
E.2957–1925

IIk
Toyokuni
1802

Ehon Imayō sugata, Illustrated fashionable styles. Volume 1 of 2.
E.6765–1916

Given by the Misses Alexander

IIl
Kiyomine and other artists
c.1815

Seirō rokkasen, The six sages of poetry as courtesans.
E.6814–1916

IIm
Hokkei
c.1820

Hokuri junichi, A day in the Yoshiwara.
E.14890–1886

IIn
Kuniyoshi
1829

Chi-u-shin-gu-ra, The heart's long stalk drawn into the mouth, an erotic parody of Chūshingura.

Lent by Mr B. W. Robinson

IIo
Kuniyoshi
1837

Hana Ikada, Flowers with abundant benefit 2 volumes.

Lent by Mr B. W. Robinson

IIp
Kuniyoshi

Chimpen shinkeibai, The pillowed boudoir A parody on the Chinese erotic novel Chin p'ing mei. 2 volumes.

Lent by Mr B. W. Robinson

IIq
Sadahide
1862

Yokohama kaikō kembushi, A record of the opening of the port of Yokohama (to foreigners). 2 volumes from 3.
E.2806–1925

風

景

III *Fukei: Landscapes and views*

Landscape was slow to develop as a distinct genre in Ukiyo-e, and early examples have a distinctly, and perhaps deliberately, archaic appearance when compared with the sophisticated if often lifeless monochrome landscape painting of the Kano school, with its roots in the styles of the Sung academy in China. They recall rather the abbreviated landscape formulae in early Japanese Buddhist scrolls.

The introduction of multi-colour printing in the eighteenth century necessitated a more developed landscape vocabulary than the charming graphisms of Moronobu, but landscape remained largely an accessory to the figures until the advent of Hokusai and Hiroshige. Inhibited by the Tempō reforms of 1842, which effectively banned courtesan prints, and temporarily depressed theatrical ones, the publishers were forced to turn to other subjects. Consequently series of views, first of famous beauty spots around Edo, then along the great highways, and eventually of all the provinces were produced in greater abundance than previously.

The emphasis here on the work of Hiroshige partly reflects his real dominance of landscape art, and partly the bias of the museum's collection. His Tōkaidō series, which has been much shown, is here omitted, and a number of his equally meritorious, though, because rarer, less well known, fan prints have been included. The results of his extensive travelling are represented by some of his plates from the Kisokaidō series; this offers the opportunity to compare his approach with that of Eisen, from whom the series was originally commissioned.

This section has not been subdivided in the same way as the others, in the hope that continuity of motifs from one print to another will facilitate the journey in the head which lies behind the enjoyment of landscape pictures.

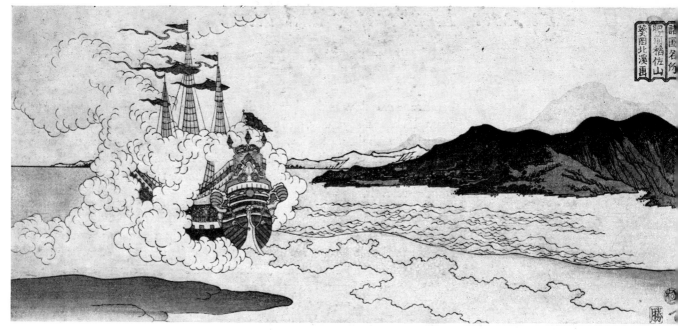

III 1
Hokkei
c.1835–1840

Mount Tateyama, Hizen province, from a series of Shokoku Meisho, Famous places of all provinces. Published by Nishimura-ya Yohachi (Eijudō) and Nakamura-ya Katsugorō.
Signed: *Kikō Hokkei ga* Publisher's seal and mark. Censor seal: *kiwame*.
E.573–1899

Hokkei has economically created a composition which makes a transition from the vaporous to the solid, moving from the cloud band to the smoke of the saluting guns, to the crinkled line of the foaming wake, to the finely varied ripples, and finishing in the dark solid mass of the mountains. The European galleon, with its archaic rig, is almost certainly derived from the Namban school, which treated the curious appearance

of the foreign ships in Nagasaki. This scene i located outside Nagasaki harbour. This was the only port open to any Europeans, the Dutch having an enclave there in Deshima, until the arrival of Perry's American gunshi in the 1850s.

An appropriate entry into the Japanese landscape.

III 3
Hiroshige
1857

View of the whirlpools at Naruto in the province of Awa. Published by Tsuta-ya Jusaburō (Kōshōdō). Triptych.
Signed: *Hiroshige fude* Artist's seal: *Tōto Hitotsuya* (Lonely house in the Eastern Capital). Publisher's mark. Censor seals: *aratame* and *Snake 4*.
34·3 × 71·1 (13½ × 28)
E.3782, 3783, 3784–1953

Bequeathed by Marmaduke Langdale Horn

This triptych is one of a set of three, representing snow, moon and flowers. This is the flowers, the whirlpools being known poetically as *nami no hana*, flowers of the waves.

It is interesting to contrast the wide-angle treatment in this print, with the narrower view in the next. The rearrangement of the elements of the scene to suit the format has necessitated a different treatment of the water, the magnificent sweeping movement of the former being replaced by a coarser but more powerful flow in the latter. The narrowing of the distance between the rock masses in the fan results in a view, which, while still a fine composition, lacks the unique breathtaking qualities of the panorama.

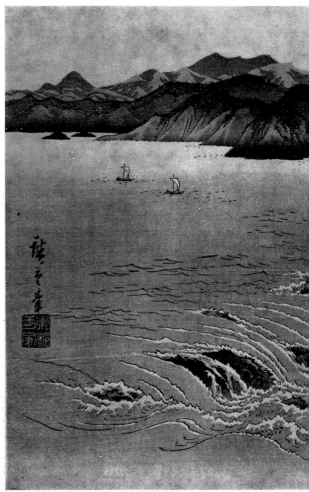

III 3

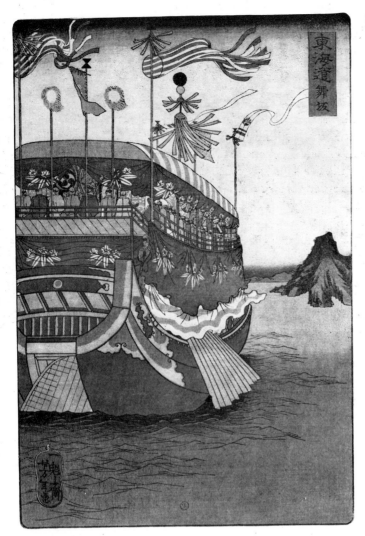

III 2

Yoshitoshi

c.1865

Maizaka, Stage 30 of the Tōkaidō.
Published by Shirokane-ya.
Signed: *Ikkaisai Yoshitoshi ga* Publisher's
seal. Engraver's seal: *Hori Naga.* Censor
seal: *aratame*, combined with (worm damage).
34·0 × 22·5 (13⅜ × 8⅞) E.14159–1886

The Tōkaidō is the eastern sea road which
links Edo, the capital of the military
government, and Kyōto, the imperial capital.
It was provided with fifty-three staging posts
which provide the locales for views along the
road. (See also III 27, III 28).

The galley belongs to one of the daimyōs, the
feudal lords of Japan, whose annual visits to
Edo were along the Tōkaidō (see III 61).

The composition, dominated by a large
foreground object in exaggerated perspective,
is derived from the later work of Hiroshige,
often ascribed to the incompetence of his
assistant and denigrated. Here it is handled
with dexterity and with a gaiety of colour
which vitiates such criticism.

III 2

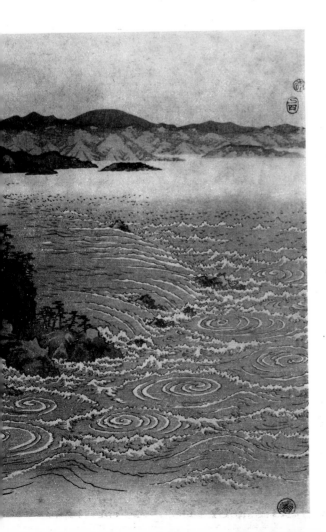

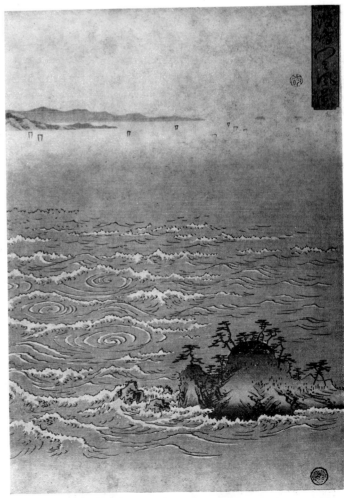

III4
Hiroshige
1854–1858

Awa no Naruto, from a series of Shokoku meisho, Famous places in the provinces. Published by Ise-ya Sōemon (Daieidō). Fan print.
Signed: *Hiroshige fude* Publisher's seal. Censor seal: *aratame*.
22·2 × 28·9 (8¾ × 11⅜) E.12076–1886

III5
Sadahide
c.1850

The seaweed gatherer. Publisher unidentified. Fan print.
Signed: *Sadahide ga* Publisher's mark.
22·9 × 28·6 (9 × 11¼) E.4940–1919

Intimate contact with the sea is a necessity for all island peoples: Sadahide has communicated the magnificent nonchalance of the deftly poised figure apparently doomed by the threatening fingers of the wave.

Considering the marks of use as a fan this print is in fine condition.

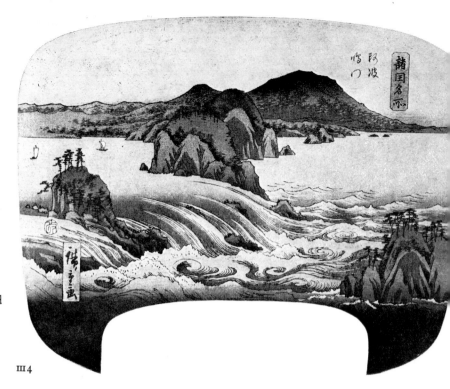

III4

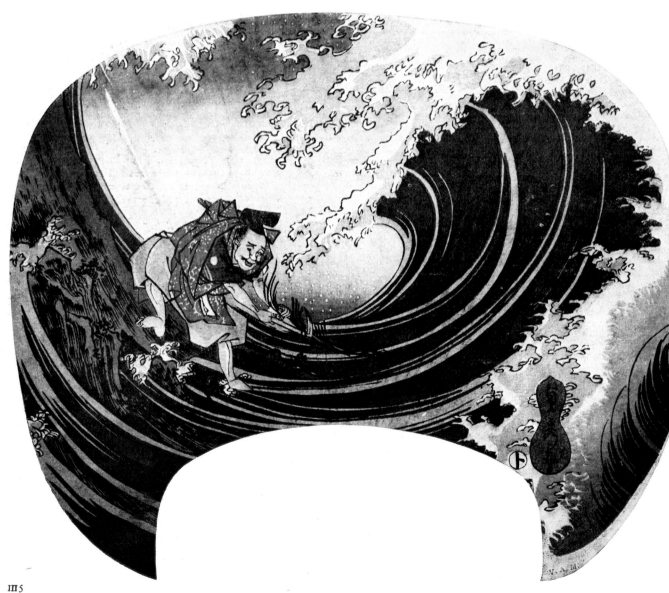

III5

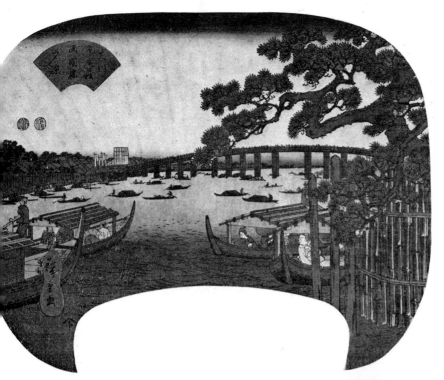

1116
Hiroshige
1849–1853

Ōkawa Shubi no matsu Ryōgokubashi yū suzumi, The great river: the Shubi pine tree at Ryōgoku bridge in the cool of the evening, from a series of views in Edo on the Sumida river. Published by Enshū-ya Matabei. Fan print.
Signed: *Hiroshige ga* Publisher's mark.
Censor seals: *Magome* and *Hama*.
22·5 × 29·2 (8⅞ × 11½) E.4863–1919

Notice the way in which the fan rib marks here are utterly appropriate to the evening scene, supplying echoes of the setting sun.

Rivers and bridges have a strange potency as images. The rivers are the arteries of the landscape, and the bridges magic structures which require gods to keep them in place.

The following sequence of prints shows some of the potential for unusual composition which they afforded, and indicates the place of the waterways in city life.

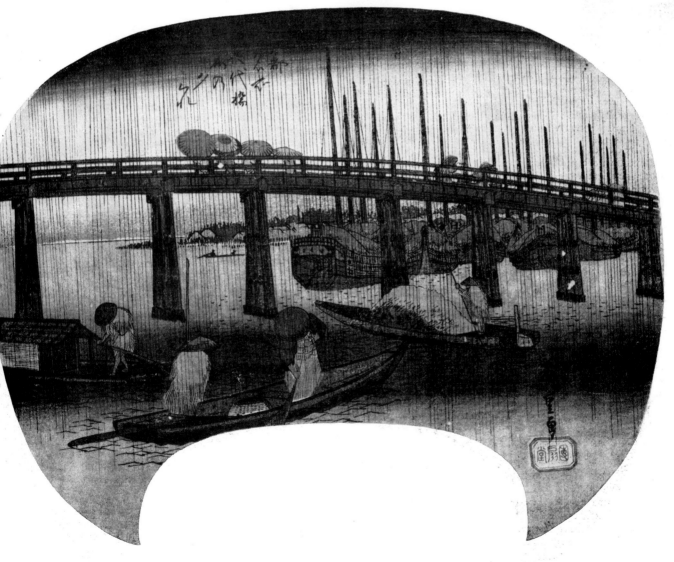

7
iroshige
840?

ening rain at Eitai bridge, from a series of
lo meisho, Famous places in Edo.
ablished by Iba-ya Sensaburō (Dansendō).
 print.
gned: *Hiroshige ga* Publisher's seal.
·2 × 29·5 (8¾ × 11⅝) E.4938–1919

Climatic and seasonal aspects of landscape were to a considerable extent formalized, most notably in the Eight Views of Lake Biwa sets (see III 34 seq.). Night rain was one of these. This composition is a fine example of parallel motifs: the hats of the boatmen and the umbrellas on the bridge, and the rain and the masts of the ships. The line of the foreground boats, leading from the bridge to the foreground and back under is handled in an ingenious manner suggesting the constant flow of traffic on the river.

III 8
Hiroshige
c.1840?

Distant view of Ryōgoku bridge from
beneath the Ōhashi (great bridge), from a
series of Tōto meisho, Famous places in the
capital. Published by Kitamago.
Signed: *Hiroshige fude* Publisher's seal.
21·6 × 28·9 (8½ × 11⅜) E.4922–1919

The cool dark blues and greys combined with
the rusty reds give this scene a late autumn,
early winter feeling, enhanced by the solid
grey vegetation wall in the distance, and the
dark fade in the sky. For a more summary
treatment of an under-the-bridge
composition see IV 7.

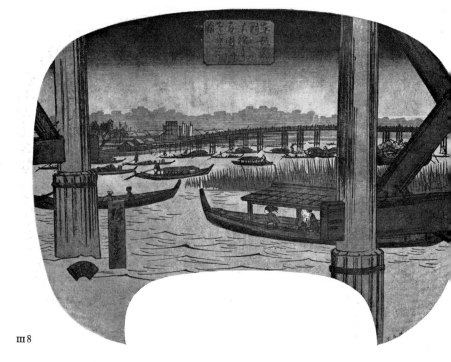

III 8

III 9
Hiroshige
1846

Water, from the series Edo jiman gogyō
mitate, The pride of Edo compared with the
five elements. Published by Hon-ya Kinsuke.
Fan print.
Signed: *Hiroshige ga* Publisher's mark.
Censor seal: *Murata*.
21·9 × 29·2 (8⅝ × 11½) E.4857–1919

The five elements with which this and the
next print are compared are the wood, fire,
earth, metal and water of Taoist proto-
science. The scene here is the Ocha no mizu
(Tea-water canal), which supplied water for
the Shōgun's tea.

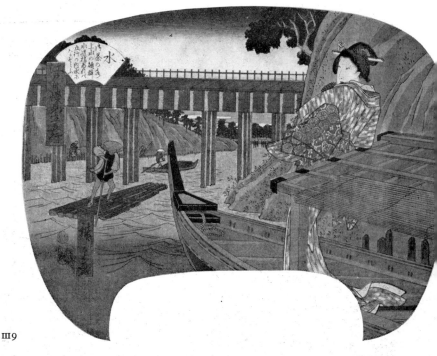

III 9

III 10
Hiroshige
1846

Fire, from the same series and with the same
publisher as III 9. Fan print.
Signed: *Hiroshige ga* Publisher's seal.
Censor seal: *Murata*.
22·2 × 29·9 (8¾ × 11⅜) E.543–1911

The fire is the braziers with which the
fishermen attract the fish to their nets, and
the lantern carried by the woman. This
is emphasized by the compositional
counterpoint between the figure and the
fumes from the braziers.

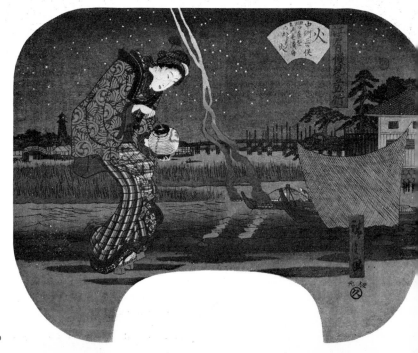

III 10

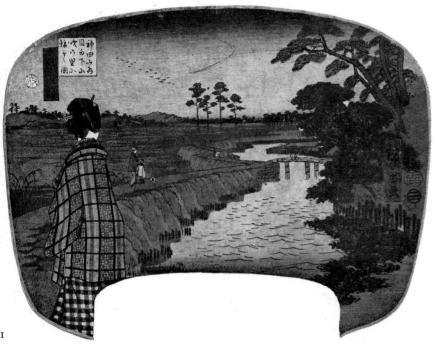

I.

III 11
Hiroshige
1857

The Kanda river in autumn, from the series Tōto meisui kagami, Mirror of the famous waters of the capital. Published by Iba-ya Sensaburō (Dansendō). Fan print. Signed: *Hiroshige ga* Publisher's mark. Censor seals: *aratame* and *Snake I*.
21·6 × 29·2 (8½ × 11½) E.12083–1886

The autumn colours, the level view stretching into the distance and the well-wrapped solitary figure, placed so as to push the rest of the composition back in space, combine to give a feeling of melancholy which is not susceptible to any expressionist analysis. This sort of unstated but undeniable feeling is characteristic of much of the best of Japanese landscape art, and is a quality which unites the otherwise disparate schools.

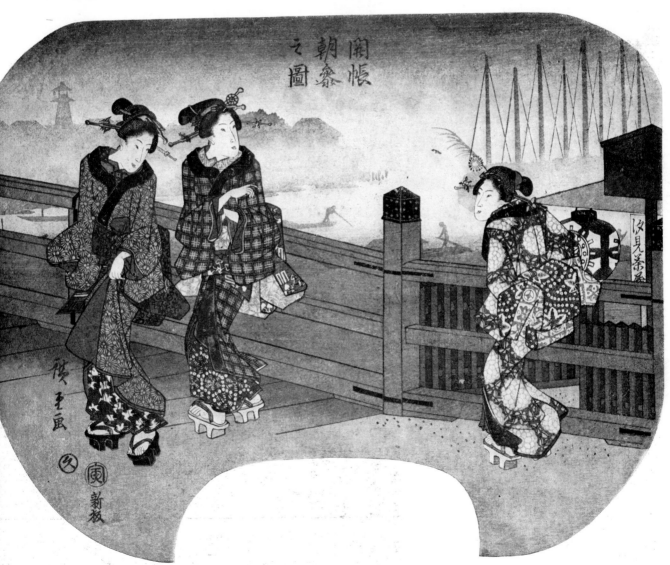

III 12
Hiroshige
1842

Kaichō asa mairi no zu, Visiting a shrine at dawn to open the curtain (in front of the Buddha image). Published by Hon-ya Kinsuke. Fan print.
Signed: *Hiroshige ga* Publisher's seal.
Censor seal: *Tiger*.
22·2 × 29·5 (8¾ × 11⅝) E.538–1911

The simple device of foreground clarity set against a softly silhouetted background conveys the feeling of early morning with pleasing economy. For a similar compositional device by Hiroshige's follower Fusatane see II 11.

III 13
Hiroshige
1847–1850

Tonosawa, from the series Hakone shichitō zu-e, Pictures of the seven hot springs of Hakone. Published by Iba-ya Sensaburō (Dansendō). Fan print.
Signed: *Hiroshige ga* Publisher's mark.
Censor seals: *Murata* and *Mera*.
22·2 × 29·2 (8¾ × 11½) E.4847–1919

Hakone, with its below sea-level cold lake, mountain passes, and health-giving hot springs was a favourite resort for those who were jaded with the pleasures of Edo.

The warm red of the woodwork and the intense blue of the water suggest the tingling feeling of the figure on the right, newly emerged from the volcanic baths.
A refreshing composition.

III 14
Hokusai
1827–1830

Mikawa province. Yatsuhashi, The eightfold bridge, from the series Shokoku meikyō kiran, Unusual view of famous bridges in the provinces. Published by Nishimura-ya Yohachi (Eijudō).
Signed: *Zen Hokusai I-itsu fude* Publisher's seal. Censor seal: *kiwame*.
24·8 × 36·8 (9¾ × 14½) E.36–1895

III 14

This bridge has inspired many painters, most notably Ogata Kōrin of the Rimpa school, who focused on the bridge and the profusion of purple iris flowers. Hokusai's composition leads one to focus on the people, the implications of different directions in the hats contrasted with the stillness of the scene giving the picture a curious dreamlike quality.

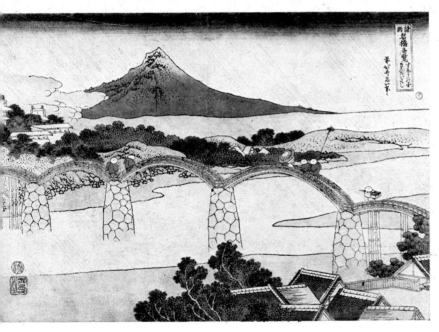

III 15
Hokusai
1827–1830

Shimotsuke province. The bridge hanging in the clouds, Mt Gyōdō, Ashikaga, from the same series, with the same publisher as the previous entry.
Signed: *Zen Hokusai I-itsu fude* Publisher's seal. Censor seal: *kiwame*.
25·7 × 38·1 (10⅛ × 15) E.3778–1953

Bequeathed by Marmaduke Langdale Horn

The curiously unnatural cloud band which snakes behind the bridge recalls Buddhist paintings of the sort known as Amida Raigō, where the deities arrive to greet the souls of the faithful leaving just such cloud trails. The associations between high mountains and the immortals, who also ride on clouds, reinforce this feeling.

III 16
Hokusai
1827–1830

Suō province. Kintai bridge, from the same series, with the same publisher as the previous entry.
Signed: *Zen Hokusai I-itsu fude* Publisher's seal. Censor seal: *kiwame*.
24·8 × 36·8 (9¾ × 14½) E.41–1895

It is interesting to compare how in these last three prints, the manipulation of similar elements in two dimensions can result in such different three-dimensional implications, the same graphic formulae serving as distant trees and as foreground moss clumps. The secret lies in the scale cues implied by overlap and by the size of the human figures.

The mountain in this print bears a strong resemblance to Mt Fuji (see III 18, III 19).

III17
Toshinobu
c.1730?

Mounted noble with a fashionable beauty
substituting for the usual attendant.
Published by Izumi-ya Gonshirō. Coloured
by hand.
Signed: *Yamato Eshi* (Japanese artist) *Okumura
Toshinobu fude* Artist's seal: *Mitsuoki*.
Publisher's jar-shaped seal.
32.7×15.9 ($12\frac{7}{8} \times 6\frac{1}{4}$) E.1419–1898

This early Fuji picture is still in the realm of
ideograms, the mountain being symbolized in
a form that survives in the superscript of many
publishers' seals (see e.g. III24, lower left
corner). This deliberate avoidance of a more
developed form of representation is echoed in
the nationalistic form of the signature which
defiantly separates the artist from the sinicized
culture of the upper classes. The figures may
be seen as an icon of the samurai being led
astray by the women of the floating world.

III18
Hokusai
1823–1829

Gaifū Kaisei, Fuji in clear weather, from the
series Fugaku sanjūrokkei, Thirty-six views
of Mt Fuji. Published by Nishimura-ya
Yohachi (Eijudō).
Signed: *Hokusai kaimei I-itsu fude*.
24.8×36.2 ($9\frac{3}{4} \times 14\frac{1}{4}$) E.4813–1916

Given by the Misses Alexander

Mt Fuji, according to the oral tradition,
was thrown up at the same time as the for-
mation of Lake Biwa (see III41–III48), in a
cataclysmic upheaval in 286 BC. It is regarded
as the seat of the Shintō gods of Japan, and is
dotted with temples, receiving many pilgrims.
Hokusai had a particular love for this most
regular of mountains, producing many series
of variations on the subject.
This deceptively simple composition is justly
famous for the calm majesty it gives the
volcano, a calm enhanced by the opposition of
the softly blended orange of the peak, the
clear blue of the sky, and the rhythmic vitality
of the mackerel clouds.

III19
Hokusai
1823–1829

Sanka no Haku-u, Fuji above the lightning,
from the same series, with the same publisher
as the previous entry.
Signed: *Hokusai kaimei I-itsu fude*.
24.8×36.2 ($9\frac{3}{4} \times 14\frac{1}{4}$) E.4814–1916

Given by the Misses Alexander

III17

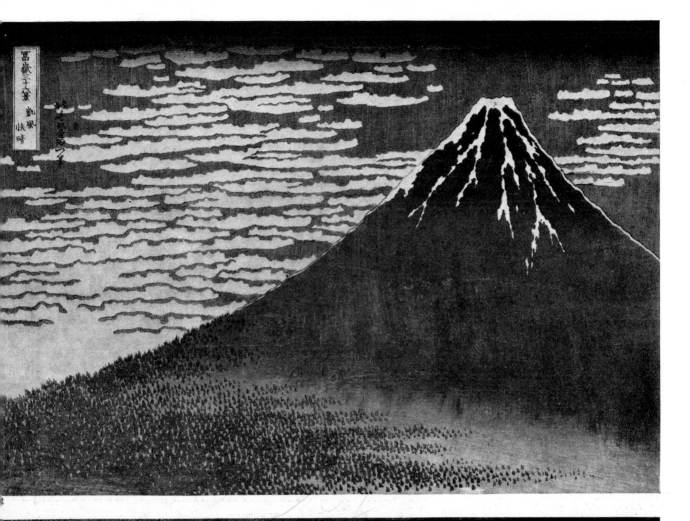

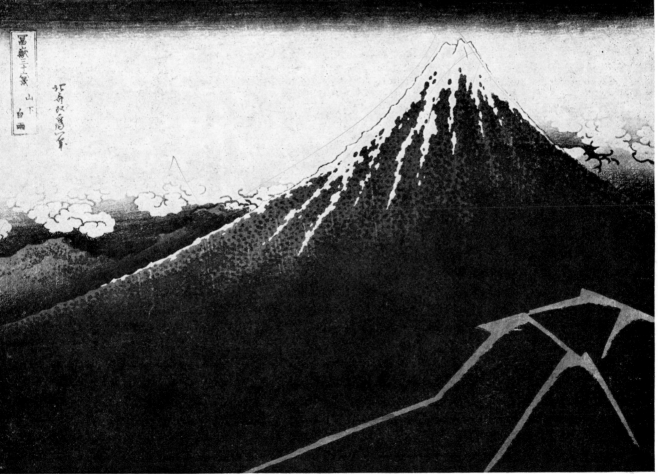

9

III 20

Hiroshige

1852

Raigō ravine, Sagami province, from the
series Fuji sanjūrokkei, Thirty-six views of
Mt Fuji. Published by Sano-ya Kihei
(Kikkakudō).
Signed: *Hiroshige ga* Publisher's seal.
Censor seals: *Kinugasa, Murata* and *Rat 12*.
17·8 × 25·4 (7 × 10) E.1460–1910

For the significance of Raigō see III 15.

A fine composition based on triangular forms,
from the details of rock structure on the right
to the shape of the ravine itself. The clouds
once again are used as a stabilizing contrast.

III 21

Hiroshige

Wind-blown waves at Shichi-ri, Sagami
province, from the same series, with the same
publisher as the previous entry.
Signed: *Hiroshige* Artist's seal: *Hiro*.
Publisher's seal. Censor seals: *Fuku* and
Muramatsu.
17·8 × 25·4 (7 × 10) E.1430–1910

The contrast between the transient wave-
mountain and Fuji is an appropriate one for a
society tuned to Buddhist ideas of
impermanence.

III 22

Hiroshige

1852

The sea shore at Izu, from the same series,
with the same publisher as the previous entry.
Signed: *Hiroshige ga* Publisher's seal.
Censor seals: *Kinugasa, Murata* and *Rat 12*.
17·8 × 25·4 (7 × 10) E.1431–1910

Fuji is reduced to the characteristic
ideogrammatic profile discussed in III 17.
Compare with the top of the publisher's seal
in the next three entries.

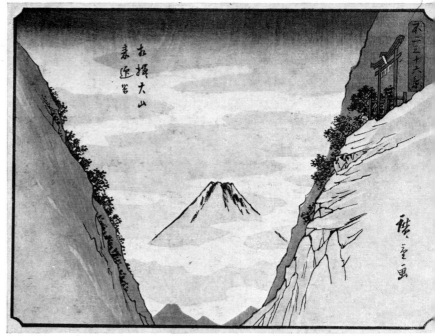

III 20

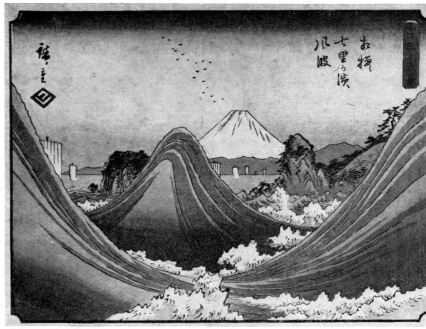

III 21

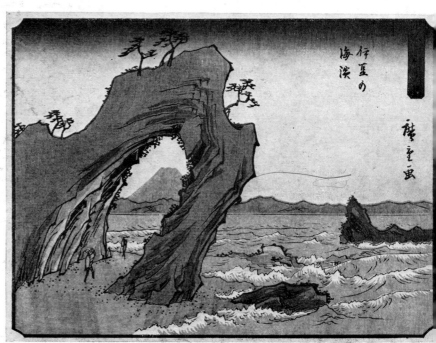

III 22

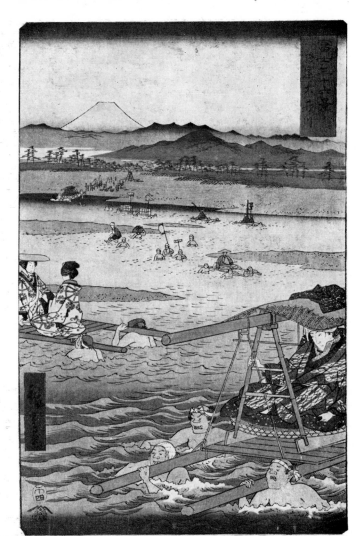

III23

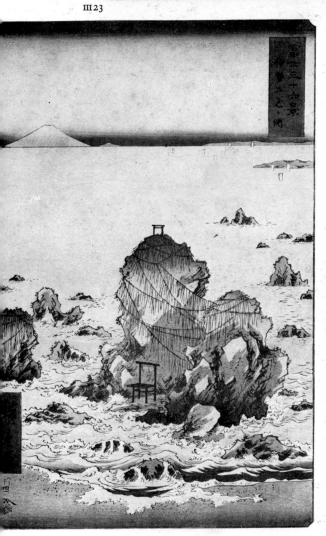

III25

III23–III25
Hiroshige
1858

Three prints from a series of Fuji sanjūrokkei, Thirty-six views of Mt Fuji. Published by Tsuta-ya Kichizō (Kōeidō).
Each signed: *Hiroshige ga* Publisher's mark.
Censor seal: *Horse 4*.
Each: 34 × 21·9 (13⅜ × 8⅝) E.1280, E.1286 & E.1264–1922

T. H. Lee Bequest

III23 The ford across the Ōi river, Suruga province E.1280–1922

III24 The shore at Futami, Ise province E.1286–1922

III25 In the middle of the mountains, Izu province E.1264–1922

It is in such late works of Hiroshige as these that the hand of his assistant Shigenobu, who succeeded to the name of Hiroshige on his master's death, has been adduced. Whatever may be the truth about this, many of the designs have a harsh vitality which was not present in earlier works (compare e.g. III13–III33). It may well be that Hiroshige modified his designs to suit the cruder colours and higher production rate that his popularity led his publishers to tolerate.

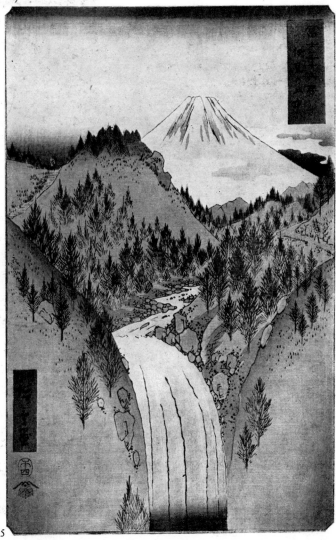

Hiroshige
1858

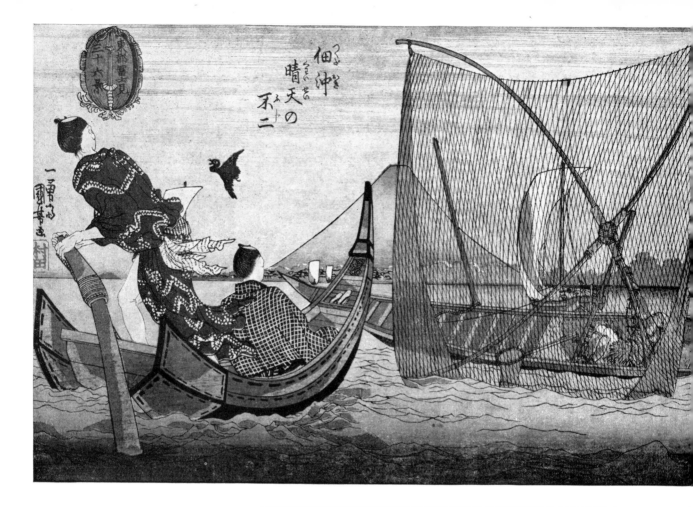

III 26
Kuniyoshi
c.1843–1844

Tsukuda oki kaisei no Fuji, Fuji on a clear day from Tsukuda, from the series Tōto Fuji mi sanjūrokkei, Thirty-six views of Fuji seen from the capital. Published by Murata.
Signed: *Ichiyūsai Kuniyoshi ga* Publisher's seal. Censor seal: *Mura*.
22·9 × 33·7 (9 × 13¼) E.2269–1909

Kuniyoshi has settled for a severely symmetrical Fuji, and has used the length of one slope as a module for several crucial intersections, e.g. the prow of the boat on the left to the water and the length of the oar. A fine composition of rotating curves. The use of parallel hatching in the sky is a result of his study of European engravings.

III 27
Hokuju
c.1820

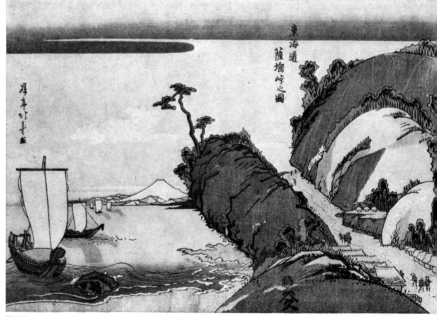

III 27

Tōkaidō: Satta-tōge no zu, Satta mountain pass on the Tōkaidō. Published by Yamamoto-ya Heikichi (Eikyūdō).
Signed: *Shōtei Hokuju ga* Publisher's mark. Censor seal: *kiwame*.
26 × 38·1 (10¼ × 15) E.588–1899

Hokuju had a particular penchant for combining near and distant views, but often, as here, committed inconsistencies of scale which give his prints a particular gauche charm.

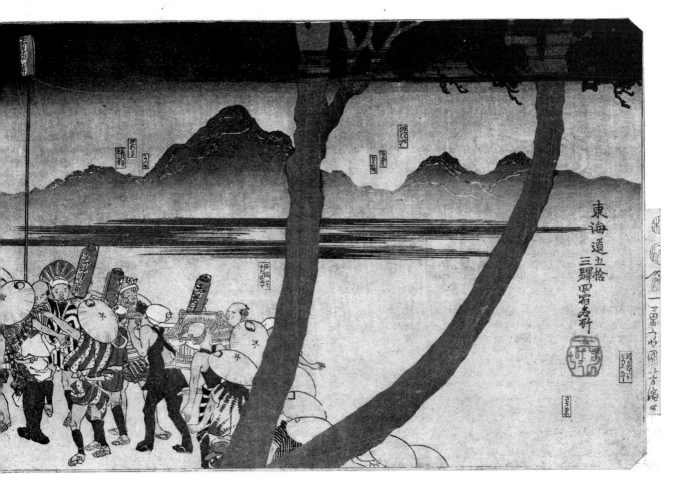

III 28
Kuniyoshi
c.1834–1835

View of the post-stations of Hodogaya,
Totsuka, Hiratsuka, Fujisawa. The second of a
series of twelve prints: Tōkaidō gojūsan eki
shishuku meisho, Famous places among the
53 stations of Tōkaidō gojusan eki shishuku
meisho, Famous places among the 53 stations
of Tōkaidō, four (or more) at a time.
Published jointly by Tsuru-ya Kihei
(Senkakudō), and Tsuta-ya Kichizō (Kōeidō).
Signed: *Ichiyūsai Kuniyoshi shuku ga* (*drew this
contracted version*) Publisher's marks.
Censor seal: *kiwame*.
22·9 × 35·6 (9 × 14) E.2254–1909

The jostling party of pilgrims with their shrine
seem almost an intrusion in this rather
forbidding landscape. In a characteristic way
Kuniyoshi has placed his Utagawa mark,
Toshidama, on their hats.

III 29–III 33
Eisen and **Hiroshige**
1835–1848

Five prints from the series Kisokaidō
rokujūku tsugi. The sixty-nine stations of
the Kisokaidō. Published by Takenouchi
(Hōeidō), and Ikenaka Iseri (Kinjudō).
(See note).
Each: 26 × 36·8 (10¼ × 14½) E.3778,
E.3791–1886; E.392–1954; E. 3802, E.3806–
1886

This series has an interesting publishing
history: it was originally commissioned from
Eisen by Hōeidō, but something went wrong,
and Hiroshige was called upon to finish the
series. Kinjudō came in at this point, and
many of the prints carry the marks of both.
Kinjudō then acquired the blocks, and reissued
the Eisen plates without signature, as here,
possibly hoping that the Hiroshige aura would
extend to them and sell them.

The Kisokaidō itself is an alternative, inland
and mountainous, highway from Edo to
Kyōto, and the road, like the prints series,
seems never to have been as popular as the
Tōkaidō.

III 29

III 30

III 31

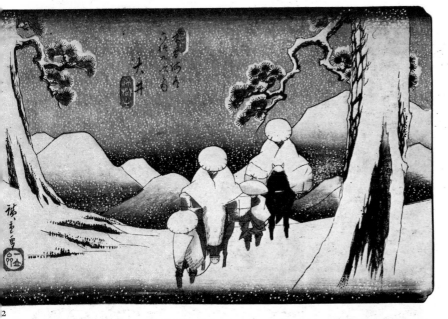

2

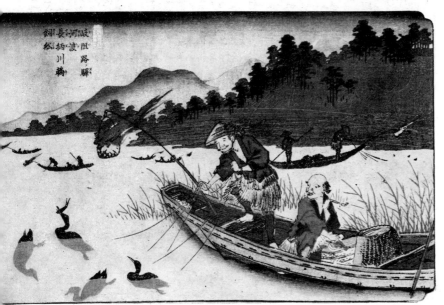

3

III 29
Hiroshige
Karuizawa, no. 19 of the series.
Signed: *Hiroshige ga* Artist's seal: *Tōkaidō*.
Publisher's seals. Censor seal: *kiwame*.
E.3778–1886

Note the combined psychological and compositional linkage in the figure group provided by the pipes.

III 30
Eisen
Kutsukake, View of Hiratsuka moor in the rain, no. 20 of the series.
Publisher's mark: *Takenouchi*.
E.3791–1886

The peasant leading the buffaloes serves to direct the eye back into the picture, and up the slope again by way of the cloak of the figure trudging against the rain.

III 31
Hiroshige
Miya-no-koshi, no. 37 of the series.
Signed: *Hiroshige ga* Artist's seal: *Ichiryūsai*.
Publisher's seal: *Kinjudō*. Censor seal: *kiwame*.
E.392–1954

It is in prints like this that so much depends on careful printing, and where impressions differ most.

III 32
Hiroshige
Ōi, no. 47 of the series.
Signed: *Hiroshige ga* Artist's seal: *Ichiryūsai*.
Publisher's seal: *Kinjudō*. Censor seal: *kiwame*.
E.3802–1886

The covered faces of the approaching figures engender an eerie sense of intrusion in the viewer.

The impression is not a perfect one; note the slipped register particularly on the seals, but the image does not suffer too badly.

III 33
Eisen
Gōto: fishing with cormorants on the Nagae river, no. 55 of the series.
E.3806–1886

Compare with Hiroshige's treatment of fire-fishing (III 10).

The scratchy lines on the background hillside are caused by a worn baren taking-up uneven amounts of pigment from the block.

III 34
Kiyomasu II
c.1730

Mii no banshō, The evening bell at Miidera, no. 4 of the set Ōmi Hakkei, Eight views of Lake Biwa. Published by Iga-ya. Coloured by hand.
Signed: *Eshi* (Drawing master) *Torii Kiyomasu fude* Publisher's seal.
31·4 × 14·6 (12⅜ × 5¾) E.575–1903

The eight views group of subjects was taken from China, where it had been applied to the Hsiao and Hsiang rivers, in Hunan. The favourite locus for the Japanese set was Lake Biwa, but other landscapes were also given the same treatment. All the scenes are of the time of rest from labour in the evening, and are spread across the seasons. A complete set with titles is given below (III 41–III 48).

Compare with III 17. A somewhat more complex scene is attempted here, but the same comments about representational means apply.

III 35
Toyokuni II
c.1830

Ōyama no yau, Night rain on Ōyama, a view of the shrine of the Buddhist deity Fudō Myōō, from the series Meishō hakkei, Eight views of famous places. Published by Ikenaka Iseri.
Signed: *Toyokuni fude* Artist's seal: *Utagawa.* Publisher's seals.
22·5 × 35·2 (8⅞ × 13⅞) E.579–1899

Toyokuni II is usually dismissed as a pale imitation of the first man to use the name (see Section I), but in the series of landscapes from which this is drawn he achieved some striking and original designs. The near parallel diagonals of the rain and the bruised colours convey the feeling of tension relieved which accompanies a heavy downpour.

III 36
Hiroshige
1830–1835

Karasaki no yau, Night rain at Karasaki, from the series Ōmi hakkei, Eight views of Lake Biwa. Published by Mita-ya Kihachi (Eisendō).
Signed: *Hiroshige ga* Publisher's seal.
Censor seal: *kiwame.*
22·9 × 33·0 (9 × 13) E.3697–1886

The pine tree at Karasaki, its profusion of branches supported on props, is the epitome of the pine tree as symbol of longevity.

The horizontal spread of the mist-obscured foliage, the shifting blends of grey, and the insistent downpour undisturbed by the slightest of breezes all contribute to evoking the hypnotic effect of night rain. Fuji appears as the faintest of silhouettes in the right background emphasizing the depth of the mists.

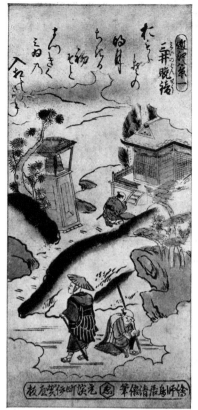

III 34

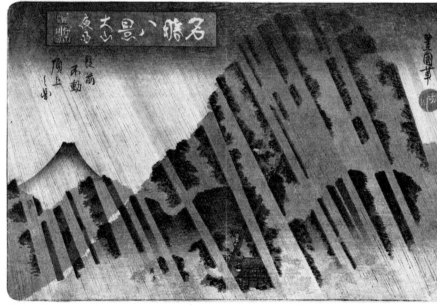

III 35

III 36

III 37

Hiroshige

1830–1835

Ottomo no kihan, Boats returning to harbour at Ottomo, from the series Kanazawa hakkei, Eight views of Kanazawa. Published by Koshimura-ya Heisuke.
Signed: *Hiroshige ga* Artist's seal: *Ichiryūsai*.
Publisher's seal. Censor seal: *kiwame*.
25·4 × 38·1 (10 × 15) E.3155–1886

Kanazawa is near Yokohama, the Ostia to Edo's Rome. The series is apparently rare.

This print gains much of its compositional stability from horizontal alignments between the boats, their sails, and the branches of the trees. The mood is that of an autumn evening.

III 38–III 40

Fusatane

1854

Three sheets from the series Ōmi hakkei, Eight views of Lake Biwa. Published by Mori-ya Jihei (Kinshūdō).
Each signed: *Fusatane ga* Publisher's seal.
Censor seals: *aratame* and *Tiger 9*.
Each 22·2 × 34·3 (8¾ × 13½) E.2234, E.2231 & E.2235–1886

These prints by a thoroughly minor artist are included to show that even the application of apparently arid formulae to print design can produce enjoyable images.

The mark on the sail of the large boat in III 38 is that of the publisher.

III 38 Awazu no seiran, Clear weather at Awazu E.2234–1886

III 39 Karasaki no yau, Night rain at Karasaki E.2231–1886

III 40 Katata no rakugan, Geese landing at Katata E.2235–1886

37

III 38

III 39

III 40

III41–III48
Sadanobu
c.1840

Ōmi Hakkei, Eight views of Lake Biwa.
Published by Konishi Tenki.
Each signed: *Sadanobu hitsu* Publisher's seals.
11·1 × 17·3 (4⅜ × 6⅝) E.12299–E.12306–
1886

This complete set, in an unusually small
format, is based closely, although not
slavishly, on a set by Hiroshige.

Its chief joy lies in its very size, and in the light
clarity of the colours.

III41 Ishiyama no shūgatsu, The Autumn
moon at Ishiyama E.12299–1886

III42 Hira no bosetsu, Lingering snow on
Mt Hira E.12300–1886

III43 Seta no sekishō, Evening glow at Seta
E.12301–1886

III44 Mii no banshō, Evening bell at
Mii-dera E.12302–1886

III45 Yabase no kihan, Boats returning to
harbour at Yabase E.12303–1886

III46 Awazu no seiran, Clear weather at
Awazu E.12304–1886

III47 Karasaki no yau, Night rain at Karasaki
E.12305–1886

III48 Katata no rakugan, Geese landing at
Katata E.12306–1886

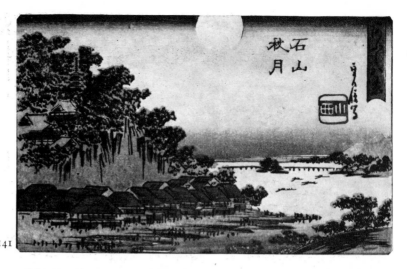

III41

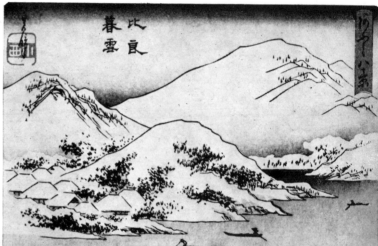

III42

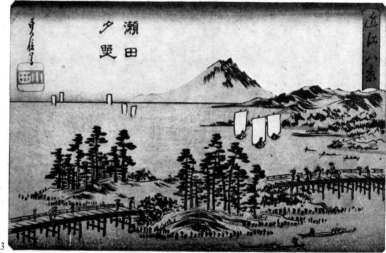

III43

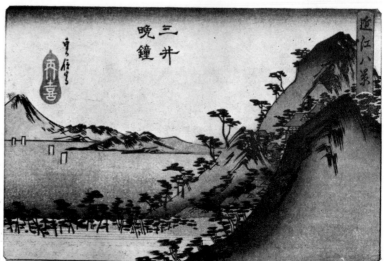

III44

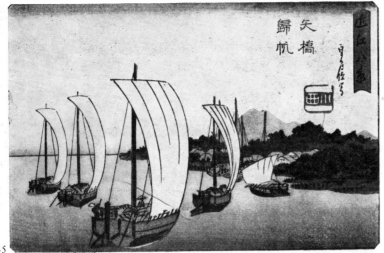

III 45

III 46

III 47

III 48

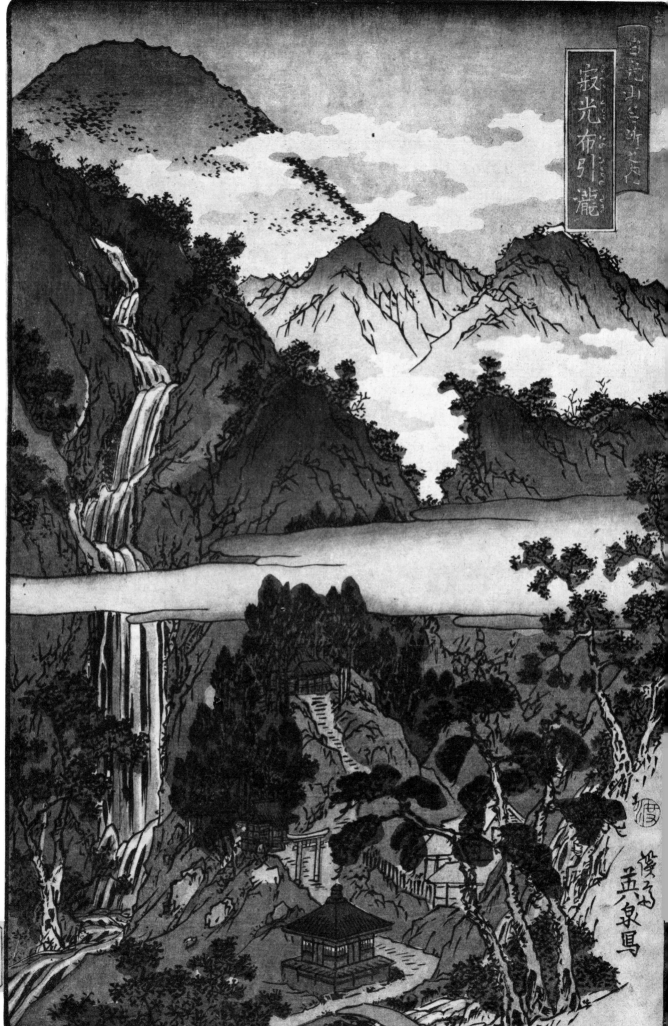

III 49
Eisen
1843–1845

Jakkō Nunobiki no taki, The Jakkō Nunobiki falls, from the series Nikkōsan meisho, Famous places of Mt Nikkō. Published by Yamamoto-ya Heikichi (Eikyūdō).
Signed: *Keisai Eisen ga* Publisher's seal.
Censor seal: *Watari*.
34·3 × 24·1 (13½ × 9½) E.2248–1909

Mt Nikkō, Shimotsuke province, is a place of astounding natural beauty, enhanced by a multitude of attractive temples and shrines. It is reputed to be one of the most visited places in Japan.
This landscape by Eisen is unusually fully worked for ukiyo-e, and is only flawed by the rather irritating central cloud band which separates foreground from middle. As in almost all prints with complicated colouring, impressions are liable to differ considerably.

II 50
Hiroshige
1853

Shimotsuke, Nikkōsan Urami no taki, The Urami falls, Mt Nikkō, Shimotsuke province, from the series Rokujūyo-shū meisho zu-e, Pictures of famous places in the sixty-odd provinces. Published by Koshimura-ya Heisuke.
Signed: *Hiroshige fude* Publisher's seal.
Engraver's seal: *Hori take*. Censor seals: *Kinugasa, Murata* and *Ox 8*.
34·3 × 22·9 (13½ × 9) E.3577–1886

Compare with previous entry, and with III 23–III 25, the comments on which apply here also.

III 51
Hiroshige
1856

Satsuma, Bō no ura, Sōken seki, The twin sword rocks, Bō no ura, Satsuma province, from the same series, with the same publisher, as the previous entry.
Signed: *Hiroshige fude* Publisher's seal.
Engraver's seal: *Hori take*. Censor seals: *aratame* and *Dragon 3*.
34·3 × 22·9 (13½ × 9) E.3617–1886

A sheet from the series which is not under the burden of the rather violent colouring of the previous entry. The series was published over a number of years, and is subject to considerable variation, both as to quality of design and of production.

III 52
Hirokage
1859

Fishing in the Ocha no mizu, from a series of Edo meisho, Views of Edo. Published by Tsujioka-ya Bunsuke (Kinshōdō).
Signed: *Hirokage ga* Publisher's seal.
Censor seal: *aratame* combined with *Goat first*.
33·3 × 21·9 (13⅛ × 8⅝) E.2968–1886

In the hands of his minor followers Hiroshige's landscape formulae rapidly degenerated. In an attempt to infuse new interest into them, large numbers were issued incorporating a comic incident. This example is lifted a little above the general level of such products by the ingeniously twisted relationship between the foreground figures.

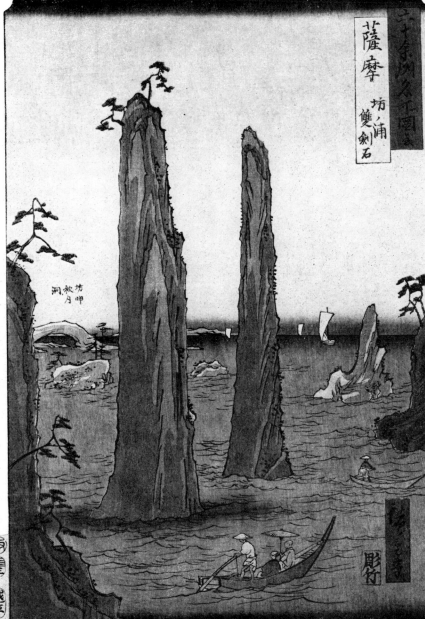

III 53
Kunikazu
c.1860

Matsunohana. One of Naniwa Hyakkei, One
hundred views of Osaka. Published by
Ishiwa.
Signed: *Kunikazu ga* Publisher's seal.
25·1 × 18·4 (9⅞ × 7¼) E.5465–1886

An unpretentious and effective example of the
uncommon genre of non–metropolitan series.

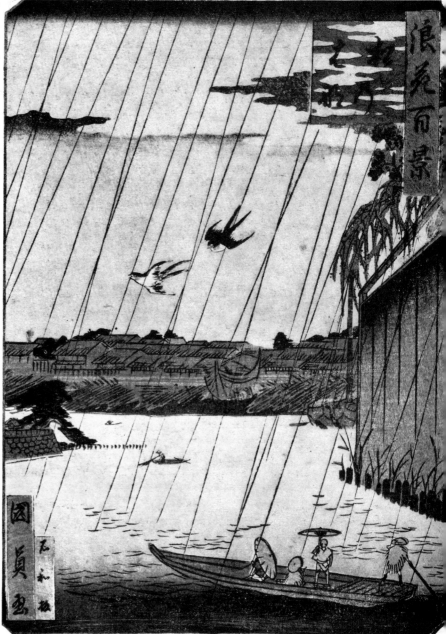

III 53

III 54

III 54–III 56
Gakutei
1838

Tempōzan shōkei ichiran, Views of Mt Tempō, Ōsaka. Published by Takaki. Each signed: *Gogaku* Artist's emblem. Some with publisher's mark.
Each: 25·4 × 36·8 (10 × 14½) E.745, E.746 & E.748–1910

This superb set of six prints in all, was originally designed to accompany a guide book of Ōsaka, and is extremely rare. The general approach here should be compared with that of Hokusai's two other landscape producing pupils: Hokkei (III 1) and Hokuju (III 27). The colouring is notable as a successful attempt to use strong yellow, orange and green without producing a garish effect.

III 54 Tempōzan mansen nyūshin no zu, Fleet returning to harbour at Mt Tempō
E.745–1910

III 55 Ōsaka Ajikawa Tempōzan ama yadori, Sheltering from the rain by the Aji river, Mt Tempō, Ōsaka
E.746–1910

III 56 Ōsaka Ajikawa Shinzan ishibashi, The stone bridge at Shinzan, Aji river, Ōsaka
E.748–1910

III 57
Moronobu

c.1680

Travellers passing on the road. Coloured by hand.

27·0 × 41·0 ($10\frac{5}{8}$ × $16\frac{1}{8}$) 1945–11–1–046

Lent by permission of the Trustees of the British Museum

A party of courtesans with their servants and a samurai with his. This print is very close in style to the first sheets in a series of views of the Yoshiwara, and may well be part of such a sequence.

III 58
Shunchō

c.1790

A promenade through the rice fields. Diptych. Signed: *Shunchō ga* Artist's seal: *Nakabayashi*

37·5 × 50·8 ($14\frac{3}{4}$ × 20) E.390–1895

Landscape was considerably developed in the backgrounds to such costume display panoramas as this. Shunchō was much influenced by Kiyonaga (see next entry), but other contemporaries such as Utamaro and Toyokuni also produced interesting examples (see II 43, II 72).

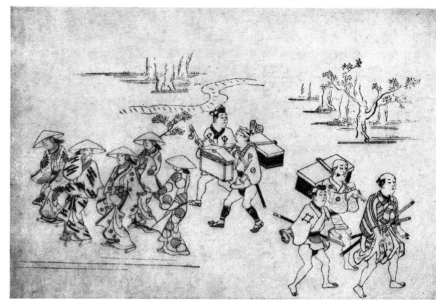

III 57

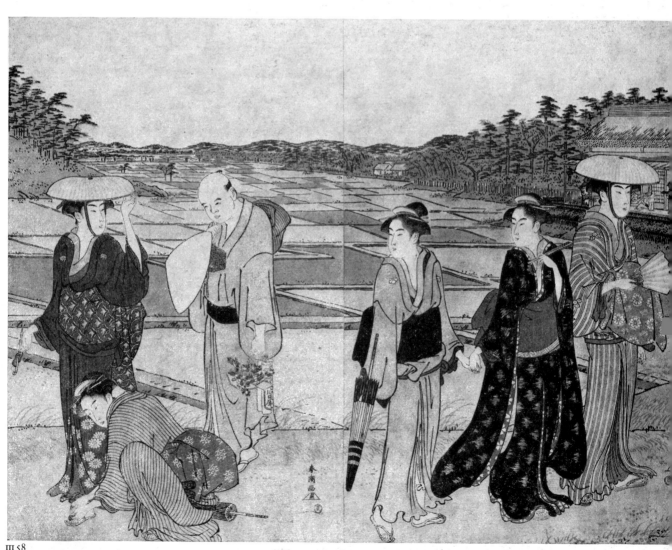

III 58

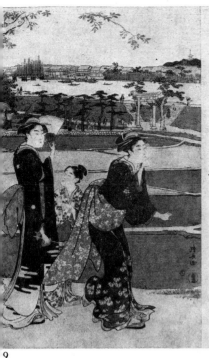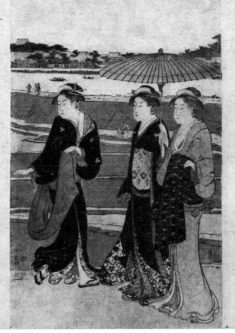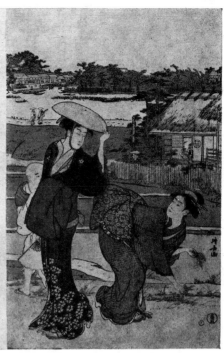

9

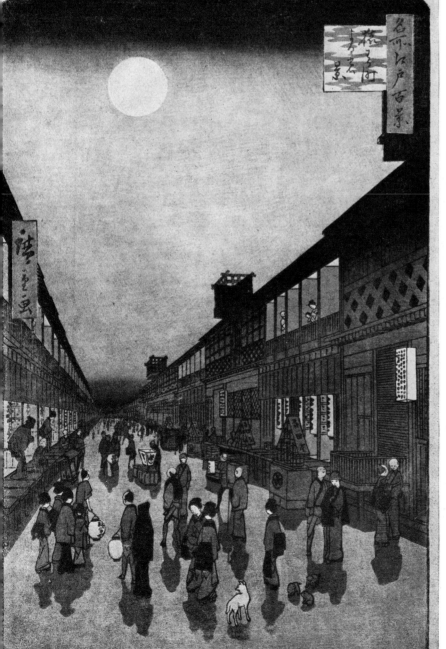

III 59
Kiyonaga
c.1787

Strolling by the river. Published by
Takatsu-ya Isuke. Triptych.
Signed: *Kiyonaga ga* Publisher's seal.
38·7 × 76·2 (15¼ × 30) E.392–1895

III 60
Hiroshige

Saruwaka-chō, from the series Meisho Edo
hyakkei. Published by Uwo-ya Eikichi.
Signed: *Hiroshige ga* Publisher's seal.
Censor seals: *aratame* and *Dragon 9*.
35·9 × 24·8 (14⅛ × 9¾) E.88–1969

Bequeathed by Mr Paul Shelving

This brilliant evocation of Edo nightlife is one
of the finer plates from an uneven series. On
the left are the theatres touting for trade. The
depiction of shadows is unusual, but is an
effective way of emphasizing the power of the
moonlight.

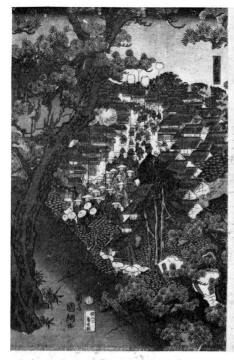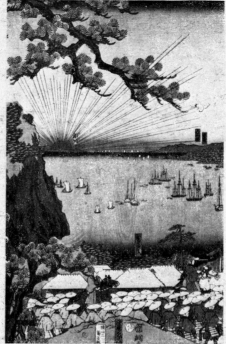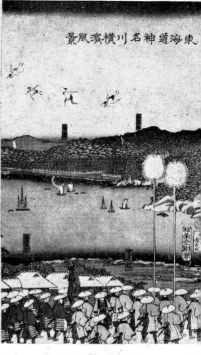

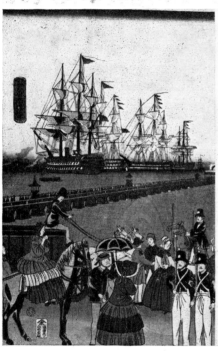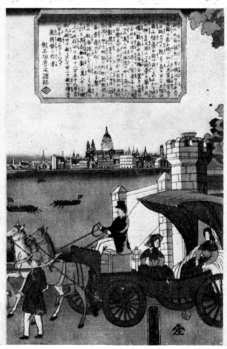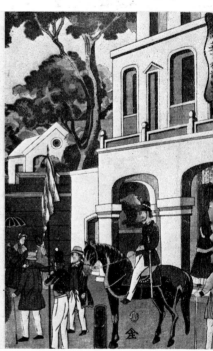

III 61
Kunitsuna
1862

Tōkaidō Kanagawa Yokohama fūkei, Panorama of the Tōkaidō at Yokohama. Published by Kikuichi. Triptych. Signed: *Kunitsuna ga* Publisher's seal. Engraver's seal: *Shōōedi hori kane.*
35·6 × 72·4 (14 × 28½) E.10426–1886

The last three prints in this section serve to show the transition between traditional, inward-looking Japan, and the new interaction with the international scene.

This scene shows the procession of the retainers of a feudal lord making its way to Edo to render fealty to the shōgun, while beyond in the bay lie the foreign ships, the symbols of western intervention.

III 62
Yoshitora

Igirisu Rondon kaikō, The Port of London, England, from the series Bankoku meishō jinkei, A complete mirror of famous places in barbarian countries. Published by Yamada-ya Shōhei (Kinkyōdō). Triptych. Signed: *Yoshitora ga* Publisher's seal. Censor seal: *? Dragon 2.*
35·6 × 72·4 (14 × 28½) E.13935–1886

The opening up of Japan stimulated an interest in the barbarians which was catered for by derivative images like this one, very much in the mould of the older Namban art devoted to the strange doings of the Portuguese and Dutch. The text emphasizes the greed and rapacity of the natives, and the enormous volume of their trade.

The picture has a pleasingly gauche quality, but it is difficult to believe that it is from the same hand as the delicate fan of swallows under a bridge (IV 7)

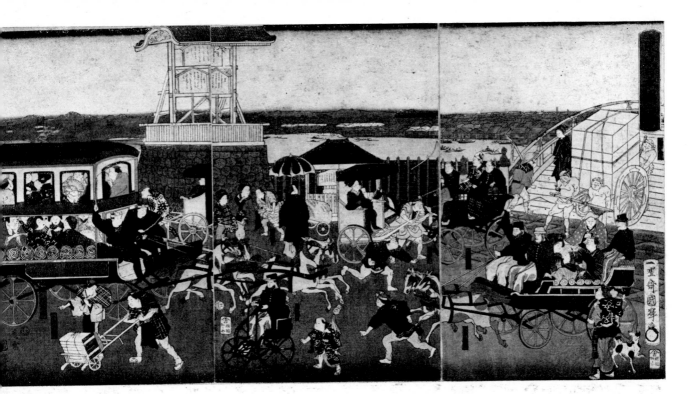

III 63
Kuniteru
1870

Tōkyō Nihonbashi no kei, A view of the
Nihon bridge in Tokyo. Published by
Kaga-ya Kichibei. Triptych.
Signed: *motome ni ōjite* (by special request)
Ichiyōsai Kuniteru ga Publisher's seal.
Censor seal: *aratame* combined with *Horse 4*.
36·3 × 70·4 (14⅛ × 27¾) E.99–1969

Bequeathed by Mr Paul Shelving

Here we see the beginnings of modern Tokyo:
the name of the city has been changed to
celebrate the restoration of imperial rule,
foreigners are on the streets, and there is an
embryonic traffic problem.

Books associated with section III (not illustrated)

IIIa
Yoshikiyo
1704–1710

Karaku saiken zu. Views of temples and shrines around Kyōto. Volumes 2 and 8 from a set.
E.2961, 2962–1916

Given by the Misses Alexander

IIIb
Sukenobu
1740

Ehon chitoseyama, Mountains of a thousand years. Illustrated stories and poems. 3 volumes.
E.15042–15044–1886

IIIc
Shigenaga
1779

Ehon Edo miyage, Noted places in Edo, with short stories. 3 volumes. First published 1765.
E.15068–15070–1886

IIId
Kiyonaga
c.1785

Edo meisho: ehon monomi ga oka, Famous places of Edo: Picture book of sight-seeing from the hill. 2 volumes.
E.6802, 6803–1916

Given by the Misses Alexander

IIIe
Shunman (and others)
1796

Hyaku saezuri, One hundred birdsongs. Illustrated poems.
E.6899–1916

Given by the Misses Alexander

IIIf
Hokusai
1800

Tōto shōkei ichiran, Famous places in the capital. 2 volumes.
E.6705, 6706–1916

Given by the Misses Alexander

IIIg
Hokusai
1804

Ehon kyōka yama mata yama, Comic poe mountain after mountain. Scenes in and around Edo.
E.6708–1916

Given by the Misses Alexander

IIIh
Hokusai
c.1830

Manga, Sketches, Volume 14.
E.2375–1925

IIIi
Hokusai
1834

Fugaku hyakkei, One hundred views of Fu 2 volumes from 3, mounted as an album.
E.4658–4718–1916

Given by the Misses Alexander

IIIj
Gakutei
1823

Ichirō gafu, sansui, Painting album by Ichi (Gakutei), landscapes.
E.15066–1886

IIIk
Hiroshige
1853

Kyōka tōto kanichi senryō, Comic poetry thousand silver coins worth of flowers and sunshine from the capital. Uniform with Ic
E.6929–1916

Given by the Misses Alexander

花
鳥

IV Kacho-e: Birds and flowers, including animals and water life

The category of bird and flower painting was already established as early as the Sung dynasty in China, and is one area where the ukiyo-e tradition departed early from its root preoccupations with Kabuki and with the pleasure quarters of the Yoshiwara.

There are two dimensions to the effects to be expected from a Japanese looking at such pictures as these: firstly there would be the complex feelings associated with seasonal change, derived from the natural environment; secondly there is the more symbolic dimension of association between plants and animals and various gods, myths and superstitions, which relates to human behaviour. Aspects of this symbolic dimension have been indicated where they have been accessible. It should be pointed out that the two are not necessarily distinct modes of understanding, for in the Far East Heaven, Earth and Man are simply the interconnecting parts of a continuously modulating whole.

IV I
Koryūsai
c.1770

Snowy heron and crow on a branch of
flowering plum in winter. Published by
Nishimura-ya Yohachi (Eijudō). Surimono.
Signed: *Koryū ga* Publisher's seal.
26·7 × 19·7 (10½ × 7¾) E.5219–1886

The crow, with its black plumage, is
considered to be a representative of the yin
forces: wintry, yielding and treacherous. The
white heron displays the characteristics of the
yang: light, summery, firm and trustworthy.
Koryūsai has echoed this aspect of the
relationship between the two birds in their
posture, which recalls the familiar yin/yang
diagram.

The crow is additionally considered the bird
of ill-omen: presage of conflagration,
messenger of the spirits, friend of the
sorcerers, related to the tengu (see v18–v22).
In its three-legged form it is a solar emblem
and the cause of sunspots, the moon having a
parallel in the three-legged toad which lives
there.

The heron is the thinker and the emblem of
purity, often being compared with the
Buddhist saints. The dominant position of the
heron in this composition, and the blossom on
the plum branch, symbolize the triumph of
integrity against adversity.

IV I

IV 2

Koryūsai

c.1770

A pair of mandarin ducks in winter.
Published by Nishimura-ya Yohachi
(Eijudō). Surimono.
Signed: *Koryū ga* Publisher's seal.
26·7 × 19·4 (10½ × 7⅝) E.5221–1886

Mandarin ducks, which mate for life, are the
classic Far Eastern symbol of marital fidelity.
The winter environment adds a note of
poignancy and the bamboo one of resilience.

IV 2

IV 3

Shigemasa

c.1770

River bank with a pair of mandarin ducks and
a peony plant in bloom. Fan print.
Signed: *Kitao Shigemasa ga.*
28·8 × 26·0 (9 × 10¼) E.355–1912

The peony is emblematic of spring, and also
of the month of July.

3

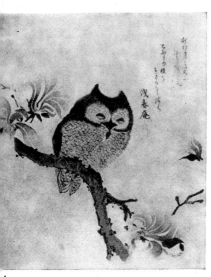

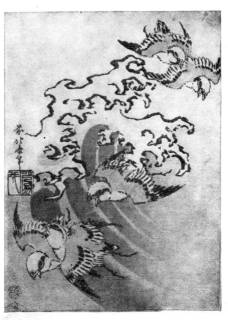

IV 4

Shunman

c.1800

Owl on a flowering branch of magnolia.
Surimono.
18·4 × 17·8 (7¼ × 7) E.4434–1914

Given by Sir William Ingram, Bt

IV 5

Hokusai

c.1820

Wave and chidori, from a series of birds, fish
and flowers. Published by Mori-ya Jihei
(Kinshindō). Aizuri-e.
Signed: *Zen Hokusai fude* Artist's seal: *I-itsu*
Publisher's mark. Censor seal: *kiwame.*
21·6 × 15·9 (8½ × 6¼) E.605–1899

The chidori is a variety of beach-dwelling,
sparrow-like plover. They are often referred
to poetically as the metamorphosed droplets
thrown off by the wave. They have pink feet.

4

IV 5

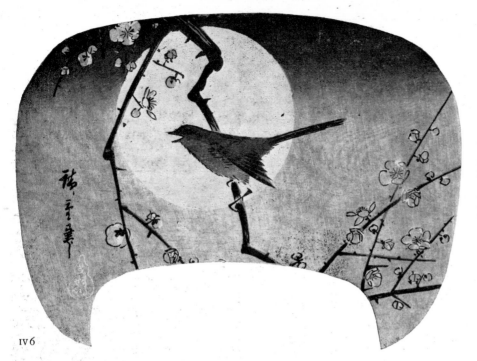

IV 6

Hiroshige

c.1840

Uguisu on a flowering plum branch against the full moon. Published by Maru-ya Kiyojirō(Jukakudō). Fan print. Aizuri-e. Signed: *Hiroshige fude* Publisher's seal. 21·3 × 29·5 (8⅜ × 11⅝) E.4898–1919

The uguisu is the nightingale of Japan, and, like the plum with which it is almost invariably associated, is a harbinger of spring Its song, the epitome of frustrated longing when caged, is full of happiness when free, a happiness so pure that it is said to be chanting a phrase from the Lotus Sutra.

IV 6

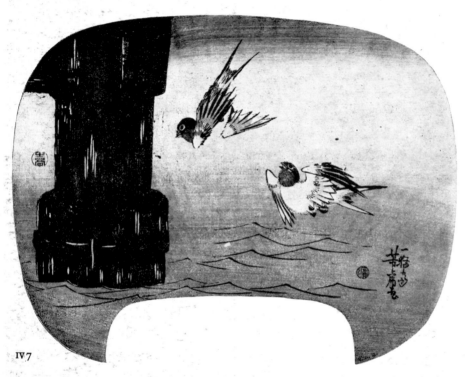

IV 7

Yoshitora

1843–1846

Summer, from a set of the four seasons. Published by Ise-ya Kisaburō. Fan print. Signed: *Ichimōsai Yoshitora ga* Publisher's seal. Censor seal: *Hama*. 21·3 × 28·9 (8⅜ × 11⅜) E.4904–1919

IV 7

IV8

Koryūsai

c.1770

Nine cranes and a pine tree with the rising sun.
Hashira-e.
Signed: *Koryūsai ga.*
66·0 × 10·7 (26 × 4¼) E.595–1899

This print is triply a talisman of longevity,
for crane, pine and sun all signify incredible
age. The crane is one of the companions of
Jurōjin, the god of longevity, and was thought
to live for centuries. The vehicle, and
sometimes the transformation, of the
magicians who lived in the mountains, the
sennin, the crane is found as a motif in almost
every variety of decoration in the Far East.

Note the irregular grouping of the birds into
three, one, two and three. This was a device
regularly employed in a composition with
many similar elements.

IV9

Hiroshige

c.1830

White heron landing behind a clump of
flowering iris. Published by Fujioka-ya
Keijirō (Shōrindō).
Signed: *Hiroshige fude* Artist's seal: *Hiroshige.*
37·8 × 17·0 (15 × 7) E.2382–1912

The iris, which blooms in May, is associated
with the boys' festival which takes place on
the fifth of that month. Its combination with
the heron thus carries the meaning of
youthful purity.

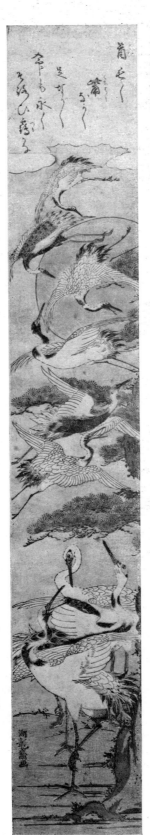

IV 8

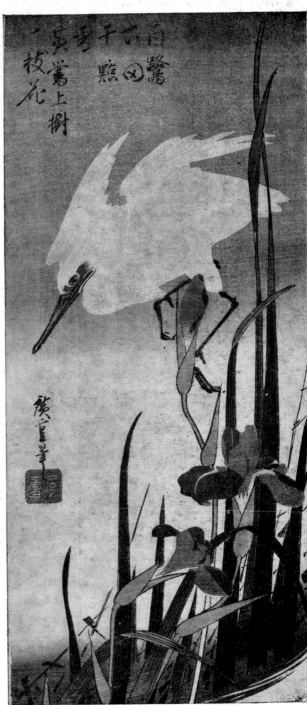

IV 9

Hiroshige
1830

Hiyodori (brown-eared bulbul) on a branch
of loquat. Published by Sano-ya Kihei
(Kikakudō). Aizuri–e, with seals in red.
Signed: *Hiroshige fude* Publisher's seals.
Publisher's label: *Tempō shin chō* (*A new
print for the Tempō era*). Censor seal: *kiwame*.
38·1 × 17·1 (15 × 6¾) E.539–1913

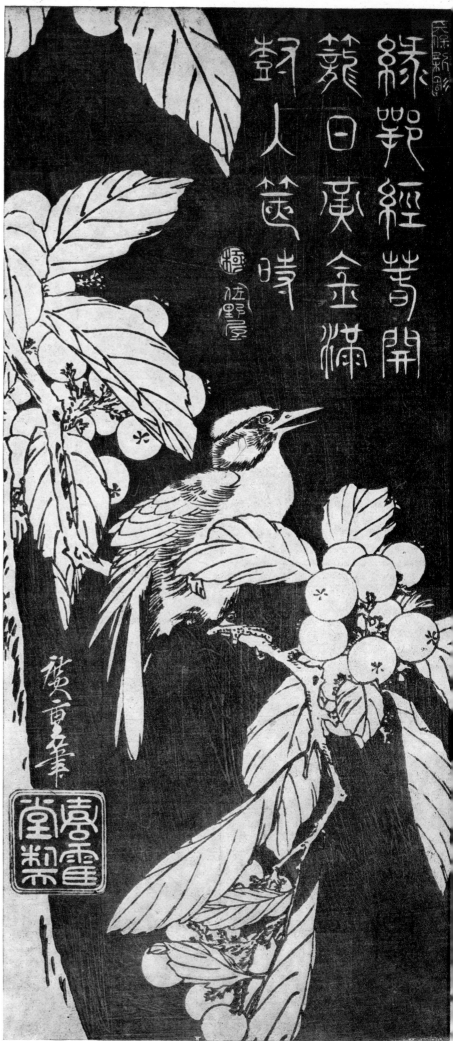

Kyōsai
c.1870

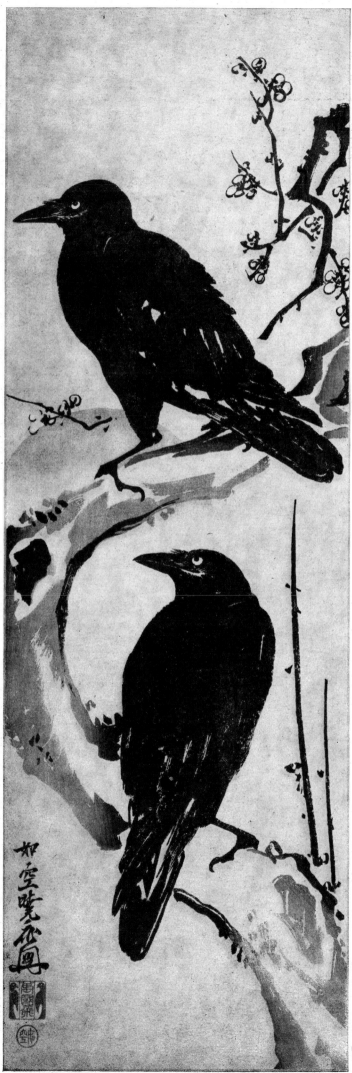

Two crows on a branch of flowering plum in winter, against the sun's disk. Kakemono-e. Signed: *Joku Gyōsai zu* Artist's seals: *Bankoku hi (Flying over every country)* and *Joku (Like the void).*
74·9 × 25·7 (29½ × 10) E.1148–1912

IV 12
Shinsai
c.1820

A Tai fish (seabream), with a diminutive
Ebisu, one of the seven gods of good fortune.
Surimono.
Signed: *Shinsai*.
20·9 × 17·8 (8¼ × 7) E.144–1898

The tai is more usually shown being caught or
carried by Ebisu. Because of its hunchbacked
appearance it is an emblem of longevity. Here,
in association with the plant shoots it
symbolizes the New Year. Ebisu's own
festival was held during this period.

IV 13
Taitō
1848

Carp swimming upwards.
Signed: *Katsushika Taitō* Artist's seals:
(*undeciphered*) and *Bumbutsu*.
35·6 × 16·5 (14 × 6½) E.2128–1899

The carp is a symbol of perseverance against
obstacles. The story of the carp which climbed
the waterfall of Lung Men (Dragon Gate),
and was transformed into a dragon was used
by the Chinese as a model of the student
successfully running the gamut of the
examinations and being transformed into an
official. This was adopted by the Japanese,
who used the carp as an especially appropriate
symbol for the boys' festival.

IV 14
Gakutei
c.1835

Three crabs at the edge of the water.
Surimono.
Signed: *Gakutei*.
21·2 × 18·7 (8⅜ × 7⅞) E.3806–1916

Given by the Misses Alexander

The crab has a general connotation of
shiftiness, by analogy with its characteristic
sidelong movements. Note the way in which
recession is suggested in the essentially flat
water pattern by the fading of the dark lines
into blind printing.

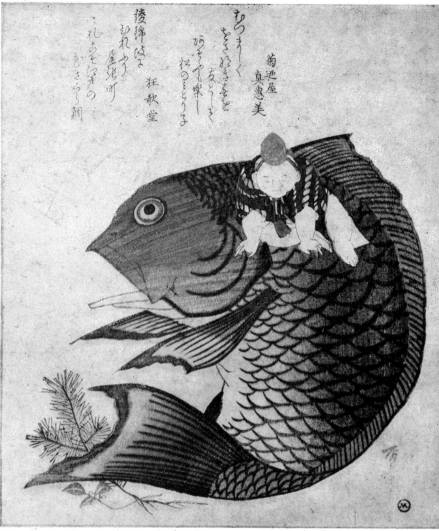

IV 12

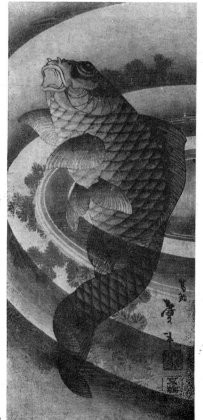

IV 13

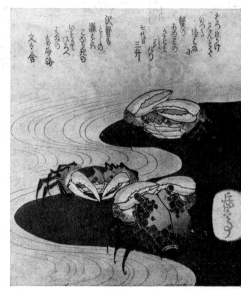

IV 14

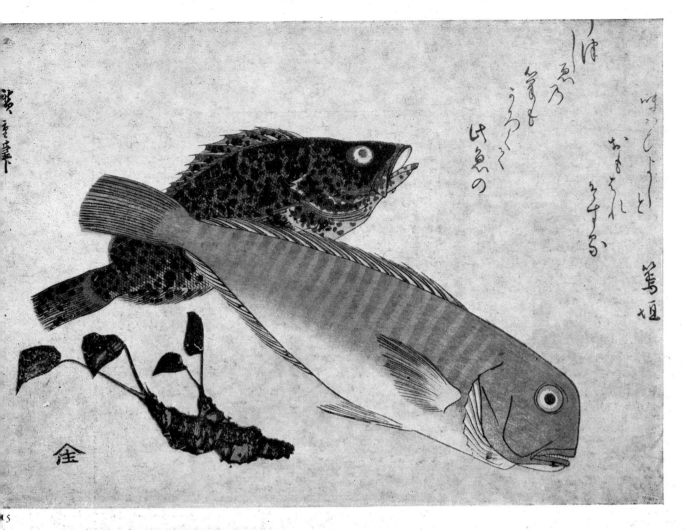

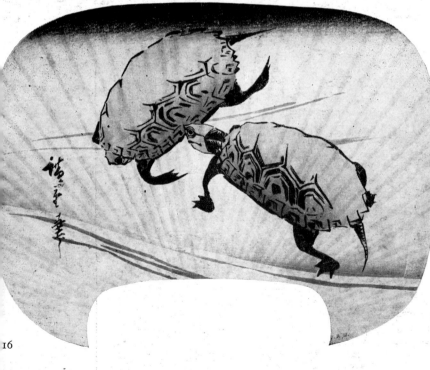

IV 15
Hiroshige
c.1840–42

Shiroamadai (Latilus argentaus) and
Omonhata (Epinephelus Craspedurus) with
roots, from *The large fishes* series. Published
by Yamada-ya Shohei (Kinkyōdō).
Signed: *Hiroshige fude* Publisher's mark.
24·1 × 34·9 (9½ × 13¾) E.1058–1963

Bequeathed by Lady Evelyn Malcolm

Fish, when alive the symbol of the untrammel-
led life, are symbolic of food in abundance,
and, because of their supposed medicinal
properties, of good health when dead.

IV 16
Hiroshige
c.1830

Two terrapins swimming underwater.
Signed: *Hiroshige fude*.
21·3 × 28·6 (8¾ × 11½) E.4836–1919

The tortoise family are all credited with
considerable numen in the Far East, a tortoise
in association with a snake being the tutelary
animals of the northern point of the compass.
They are symbols of longevity, and are
believed to reach the age of a thousand, at
which time they acquire a long feathery tail,
as well as considerable spiritual power. With
the crane the tortoise is an associate of Jurōjin
(see II 23 and IV 8) and is often depicted
alongside the treasure ship of the seven gods of
good fortune.

The rib marks of use on this fan emphasize
the superb positioning of the tortoises.

IV 17
Eisen
c.1820

Butterfly hovering above a peony plant.
Published by Maru-ya Kiyojirō (Jukakudō).
Kakemono-e.
Signed: *Keisai* Artist's seals: *Keisai* and *Eisen*
Publisher's mark. Censor seal: *kiwame*.
51·7 × 19·0 (20⅜ × 7½) E.672–1910

The butterfly is associated with young
women, with gaiety and freedom from care.
The geisha were often referred to as butter-
flies, and their elaborately winged hair-styles
recall these insects. The peony, which blooms
in July, also carries associations with the
gorgeous display which surrounds the geisha
and the courtesans.

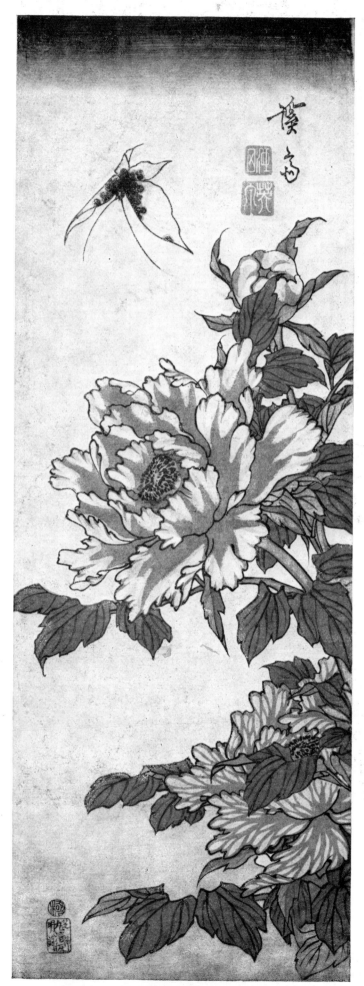

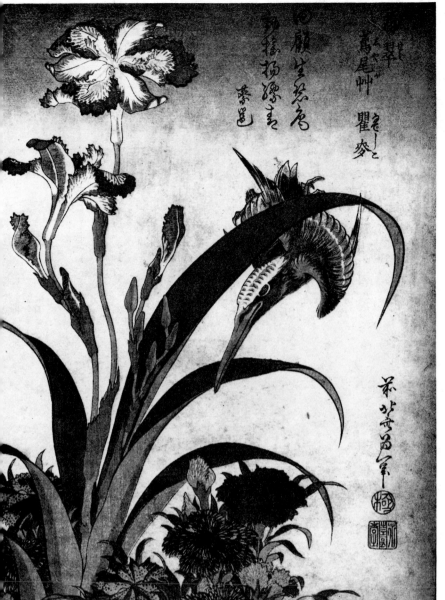

18

19

IV 18
Hokusai
c.1830

Irises, pinks, and a kingfisher. Published by Nishimura-ya Yohachi (Eijudō).
Signed: *Zen Hokusai I-itsu fude*
Publisher's seal. Censor seal: *kiwame*.
22·9 × 16·5 (9 × 6½) E.599–1899

The iris, associated with the boys' festival, sometimes also known as the iris festival, has strong overtones of youthfulness and was reputed to be efficacious as a longevity drug. The pink on the other hand is one of the seven plants of autumn, and would not bloom at the same time as the iris. Perhaps it is not too far-fetched to see the combination of these two flowers with the brilliant but only fleetingly seen kingfisher as a subtle 'gaudeamus igitur'.

IV 19
Shinsai
c.1820

Camellia in bloom. Two sheet surimono.
Signed: *Ryūryūkyo Shinsai* Artist's seal: *Ryūryūkyo*.
19·1 × 34·5 (7½ × 13½) E.1415–1898

The camellia blooms in January, and is therefore appropriate for a New Year's design.

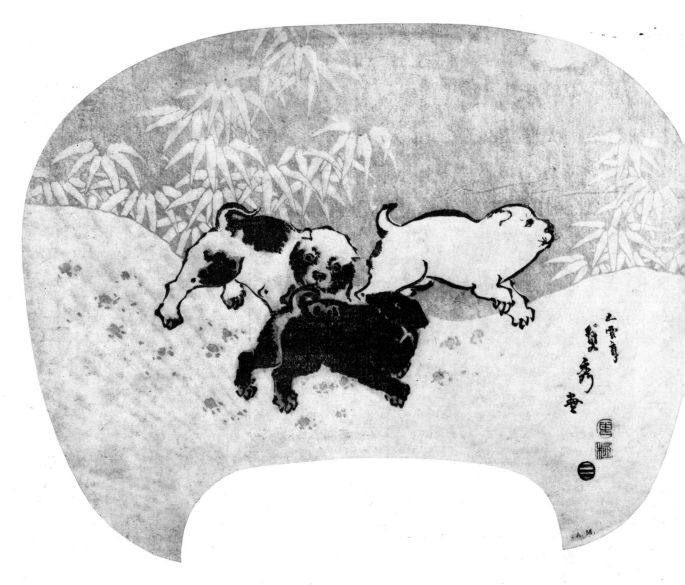

IV 20
Sadahide
1836

Three puppies running past a clump of
bamboo in the snow. Published by Iba-ya
Sensaburō (Dansendō). Fan print, in grey and
black.
Signed: *Gountei Sadahide ga* Publisher's
mark. Censor seals: *kiwame* and *Monkey*.
17·1 × 29·2 (8¾ × 11½) E.4931–1919

The monochrome severity helps in avoiding
the mere cuteness which is the trap lying in
wait for all who attempt such subjects.

The puppies, associated as they are with
children and childbirth, combine with the
resilient bamboos to suggest the birth of new
life in the midst of winter.

21

IV 22

23

IV 21
Joshu
1860

Picture of a wild tiger, brought from foreign lands, at Hiro no koji Street, Ryōgoku bridge. Published by Yamaguchi-ya Tōbei (Kinkyōdō).
Signed: *Joshu utstsu* Artist's seal: *Joshu*
Publisher's seal and mark combined.
Censor seal: *aratame* combined with *Monkey 6*.
35·6 × 25·1 (14 × 9⅞) E.5151–1886

For the mythological dimensions of the tiger see v 36. The three prints in this section show the interest in the foreign and the foreigners which characterized Japan after Perry.
The tigers in the new Tokyo zoo were commemorated in bronze a few years later than this.

IV 22
Kyōsai
1860

'True picture of a live wild tiger, never seen before from olden times until today.'
Published by Ebisu-ya Shōshichi.
Signed: *Motome ni ojite Kyōsai shasei* (Kyōsai drew from nature, by special request).
Publisher's seal. Censor seal: *aratame* combined with *Monkey 6*.
35·6 × 25·4 (14 × 10) E.11944–1886

It is possible that Kyōsai is here obliquely expressing fears about the effects of foreign influence in Japan. The cock, which is being torn apart by the tiger, is closely associated with Amaterasu, the solar goddess and founding deity of Japan. Perhaps the next print could be seen as his suggested solution.

IV 23
Kyōsai
c.1870

Kashiwade no Omi Hasui stalking a tiger in the snow. Published by Adachi.
Signed: *Shojo Gyōsai* Publisher's seal.
23·8 × 26·3 (9⅜ × 10⅜) E.745–1903

This warrior of the sixth century, also known as Hadesu, was sent on an embassy to Korea. A tiger was discovered to have seized and eaten one of his children. Hadesu hunted it down, and, seizing it by the tongue, despatched it with his sword.

Books associated with section IV (not reproduced)

IVa
Utamaro
1788

Ehon mushi erabi, Insects and plants, with
comic poems. 2 volumes.
E.2958, 2959–1925

IVb
Copy after **Utamaro**
1892

Meiji remake of IVa.
E.2928–1925

IVc
Shigemasa
1805

Shashin: Kachō zu-e, Birds and flowers,
drawn from life. 3 volumes.
E.6982–E.6984–1916

Given by the Misses Alexander

IVd
Hokkei
1814

Hokkei Manga, Hokkei's sketchbook.
E.14829–1886

IVe
Shigenobu
1855

Yanagawa gafu, ju no bu, Yanagawa
(Shigenobu)'s drawings, animal section. The
first volume of five.
E.7013–1916

Given by the Misses Alexander

IVf
Kyōsai
1881

Gyōsai rakuga, Drawings for pleasure by
Gyōsai (Kyōsai). 2 volumes.
E.2753, 2754–1925

民

俗

V Minzoku: *Heroes and heroines, battles and warriors, myths and legends, poetry and fiction*

This section is confessedly something of a catch-all. Minzoku means popular customs and superstitions, and under this head are included those prints which refer not to the concrete environment of the people, but to the contents of their imaginations. These are the images which could supply answers to questions which went beyond their experience.

An attempt has consequently been made, at the expense of the formal qualities, to elucidate the subject matter, and to contrast different versions of similar subjects.

The truly enormous quantity of prints with violent and bloody characteristics, a far higher proportion of the whole than is represented by this selection, calls for some comment: Edo was the centre of a system of military government, a government which maintained a large class of socially privileged but economically parasitic fighters, for excepting for occasional police action they were never called upon to fight. Further, their revenues, based on rice, were eroded by inflation so that the mercantile classes, with a money economy, were, despite their inferior status, their creditors. This did not lead to the samurai class being held in the high esteem which they felt was their due.

Government sumptuary edicts were promulgated with the aim of keeping the merchants in their place, and one of these, the Tempō reforms of 1842, prohibited the marketing of prints representing actors or courtesans. The battle subjects filled the gap, and the treatment of them became increasingly lurid, until the wars of the end of the century provided the real thing. It is therefore appropriate that the print tradition which had supplied a vicarious substitute for the stifling peace of the late Tokugawa period should make their last contribution to the popular imagination with reports on the wars with China and Russia.

V1
Moronobu
late 17th century

Koreans exhibiting their skill in horsemanship before their ambassador and Japanese dignitaries. From a set of eleven prints imitating the form of a handscroll.
26 × 36·8 (10¼ × 14½) E.2840–1913

These prints by Moronobu owe much of their strength to the strict subordination of design to the requirements of the block cutter. It is this appropriateness of message to medium which has led connoisseurs to prefer the early prints to the later, despite the greater suavity of cutting and large range of colours which slowly became available during the 18th century.

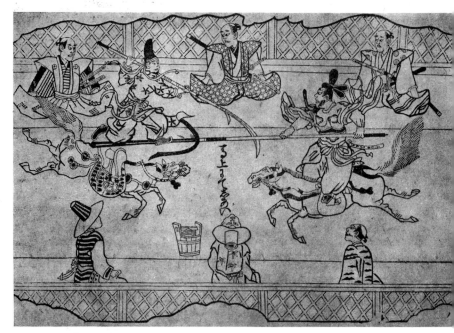

V1

V2
Sukenobu
c.1740

A horse race. Book illustration from Ehon Tsurezure Gusa, Picture book of grasses for idle moments, first published 1738.
21·3 × 30·5 (8⅜ × 12) E.1377–1922

T. H. Lee Bequest

Sukenobu was one of a group of Ukiyo-e artists, working in Kyōto the imperial capital, whose output was mainly in book form. The comic figures in the background here are a fine example of a type of figure taken over by the Edo mainstream of Ukiyo-e, and seen frequently in e.g. the landscape prints of Hiroshige and his followers (see III 23, III 52).

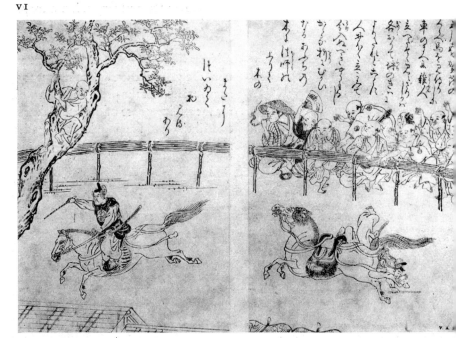

V2

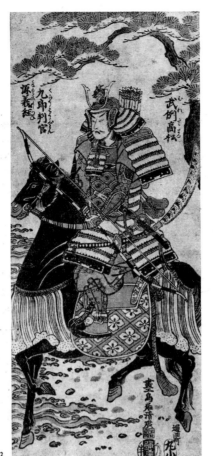

v 3

v 3

Kiyohiro

c.1750

Kurō Hangan Minamoto no Yoshitsune, from the series Mure takamatsu, Tall pines amongst the ranks of warriors. Published by Maru-ya Kohei.
Signed: *Gakō Torii Kiyohiro* Artist's seal: *Kiyohiro* Publisher's seal. Engraver's seal: *Tsusen*
39·1 × 17·1 (15⅝ × 6¾) E.364–1954

Given by Mrs Sidney D. Aris

For Yoshitsune's biography see v 18–v 22. This print will serve as an example of the celebration of the base of shogunal political power: the armoured mounted warrior, bound by oaths of feudal loyalty to his superior and whose power was certainly to be feared by the settled townsfolk who bought prints. The government, which took repeated action in attempts to curb the theatrical prints, always encouraged those which portrayed loyal heroism.

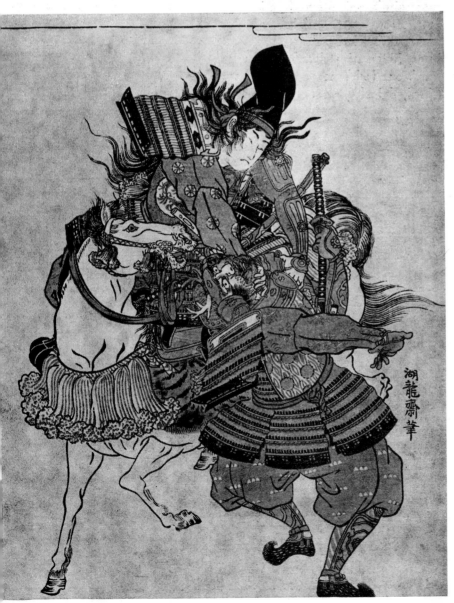

v 4

Koryūsai

c.1770

Tomoe Gozen killing Uchida Saburō Ieyoshi during the battle of Awazu no hara (1184).
Signed: *Koryūsai fude*
25·4 × 19·1 (10 × 7½) E.4361–1897

Tomoe Gozen is a famous Amazon warrior of the Japanese Middle Ages. Concubine to Minamoto Yoshinaka, cousin and rival for power to Yoritomo, she fought at his side until he was killed in this same battle of Awazu-ga-hara by the forces of Yoshitsune.

V5
Toyoharu
c.1800

Marubashi Chuya in an escape attempt.
Published by Omi-ya.
Signed: *Utagawa Toyoharu ga* Publisher's
seal.
32·4 × 22·5 (12¾ × 8⅞) E.650–1901

An example of the sort of heroism not
calculated to please the shōgunate: Marubashi
Chuya, determined to avenge the death of
his father, joined a plot against the shōgun in the
mid-17th century. The plot was uncovered,
and Chuya was arrested and crucified.

Chuya is depicted in a way which links him
to the guardian figures of a Buddhist temple,
the cage he escapes from resembling that in
which the guardians stand. The halberd and
lanterns are those of the police.

This print by the founder of the Utagawa
school, its forceful line uncomplicated by
elaborate colouring, is reminiscent of the
drawing manner used to depict the fierce
avenging forms of Buddhist deities. It is an
unusually explicit statement of revolution for
its date.

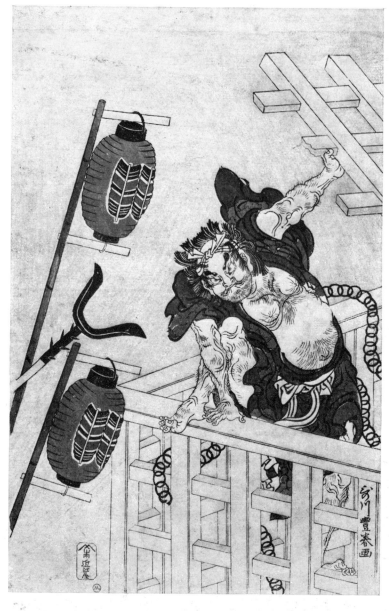

V6
Hiroshige
c.1820

Ushiwaka's fight with the brigand Kumasaka
Chōhan, on his way to Oshū. Published by
Iwato-ya Kisaburō (Eirindō). Diptych.
Signed: *Hiroshige ga* Publisher's seal.
Censor seal: *kiwame*.
35·6 × 74·3 (14 × 29¼) E.3437–1886

Ushiwaka is the boyhood name of Minamoto
Yoshitsune, a condensed history of whom is
given below (V18–V22). This episode shows
the first opportunity he had to try the
miraculous swordsmanship taught him by
the tengu. This early work of Hiroshige is
under the influence of early Kuniyoshi.

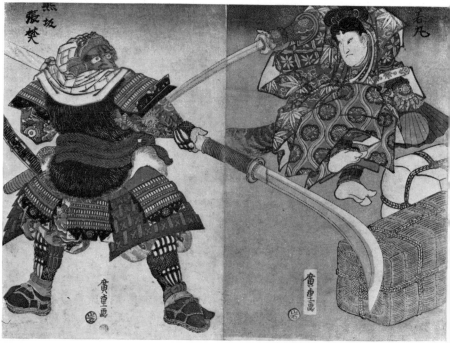

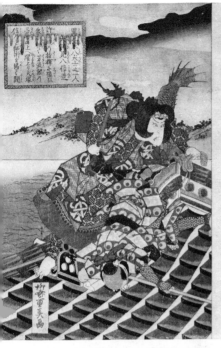
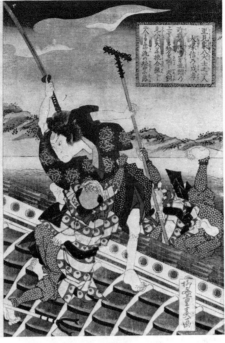

V7
Shigeharu
1834

Theatrical scene: Inuzuka Shino in fight with his brother Inugai Gempachi and his police on the roof of the Horyukaku. Diptych.
Signed: *Ryusai Shigeharu* Unidentified seal.
38·1 × 50·8 (15 × 20) E.12446–1886

These are two of the Hakken-shi, the 8 Dog Warriors, heroes of the novel Hakkenden by Kyokutei Bakin (1767–1848). This mammoth opus, comprising 106 Japanese volumes, recounts the unlikely but highly heroic adventures of eight warriors, representing the eight virtues, born of the unconsummated (!) union of Fuse Hime, the daughter of the Daimyō of Awa, and the Daimyō's dog, who received the girl as the stated reward for the head of the Daimyō's enemy.

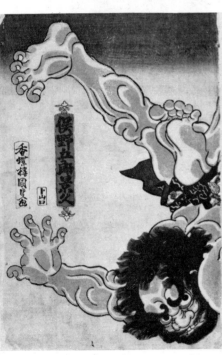
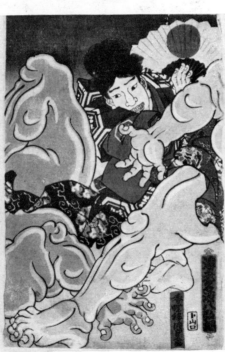
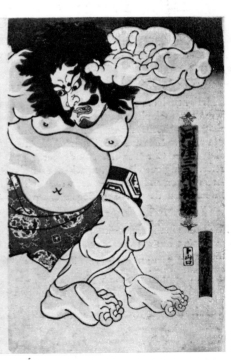

v8 and cover
Kunisada
c.1840

The great wrestling match at Mt Akazawa. Published by Yamaguchi-ya Tōbei, (Kinkyōdō). Triptych.
Signed: *Kōchōro Kunisada ga* Publisher's mark.
38·1 × 76·2 (15 × 30) E.5306–1886

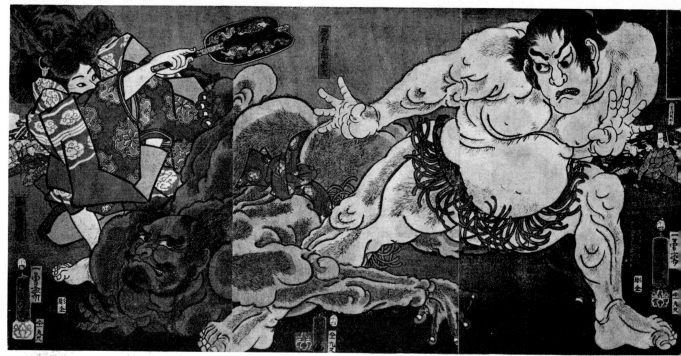

V9
Kuniyoshi
1858

Akazawayama Daisumō, the great wrestling match at Mt Akazawa. Published by Maru-ya Kyūshirō. Triptych.
Signed: *Ichiyūsai Kuniyoshi ga* and *Kuniyoshi ga* Artist's 'kiri' seal. Publisher's seal.
Engraver's seal: *Hori Kin* Censor seal: Horse 4.
38·1 × 76·2 (15 × 30) E.10542–1886

This fight, a locus classicus for Japanese wrestling, took place at the behest of the shōgun Yoritomo, shown in the background of V9, between Kawazu no Saburō Sukeyasu and Matano Goro Kagehisa, the dapper referee being one Ebina Gempachi. Kawazu's later murder, and the vengeance wrought by his sons form the plot of the Soga monogatari (see V43, 1 3).

Wrestling in the 12th century was not yet a pure sport, but was used as a means to obtain the verdict of the spirits in some pressing question.

V10
Yoshitoshi
1900

Rōrihakuchō Chō Jun (Chinese: Ch'ang Shun) and Kokusempū Ri Ki (Chinese: Li Chi) in an underwater fight: an episode from the novel Suikoden. Published by Hasegawa Tsunejirō. Diptych. Kakemono-e.
Signed: *Kaisai Yoshitoshi ga* Artist's seal: *Daiso* Publisher's inscription.
71·1 × 24·5 (28 × 9⅝) E.1028–1914

Given by Mr Yone Noguchi

For a note on the Suikoden see V53, V54. See also 157. The print is reproduced in an article by the donor: The Last Master of the Ukiyoye Art, *Transactions & Proceedings of the Japan Society*, XII, London, 1914, pp. 146–55.

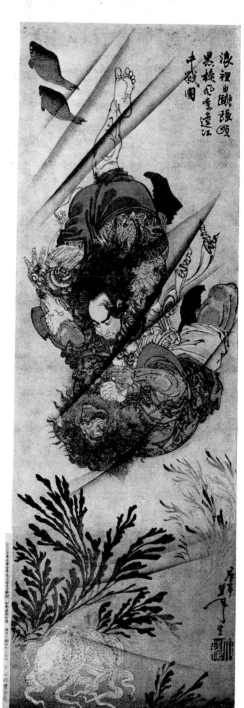

V10

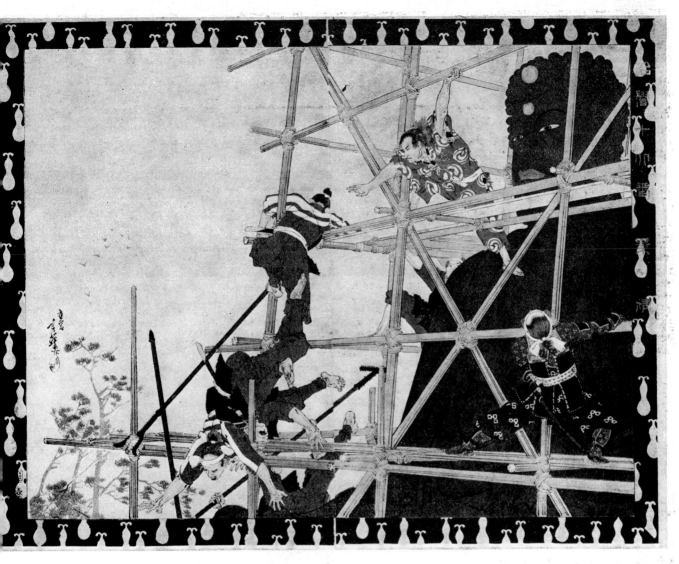

V 11
Toshihide
1893

Kagekiyo, from the series Kunyo jūhachi ban,
Eighteen examples of lordly behaviour.
Published by Akiyama Takeuemon. Diptych.
Signed: *Motome ni ōjite Toshihide* Artist's
seal: *Toshihide* Publisher's inscription.
37·2 × 50·8 (14⅝ × 20) E.365–1901

Fujiwara Kagekiyo was a warrior of the 12th
century noted for his great strength and
daring. He fought on the losing Taira side in
the Taira (Heike)/Minamoto (Genji) civil
wars. He was imprisoned following an
unsuccessful attempt on the life of Minamoto
Yoritomo in the Tōdaiji temple in Nara. He
died in prison after blinding himself to avoid
seeing his enemies' triumph, on this account
being regarded as the patron of the blind. He
is one of the many paragons of loyalty to a
defeated cause with which Japanese history is
studded.

The extent to which the woodcut medium
had become reproductive of mannerisms more
appropriate to brush drawings, and not as
previously a translation into its own terms of a
specially prepared design, is particularly
evident in this nonetheless attractive
composition. (Compare v 5.)

V12
Kuniyoshi
c.1840

Ukishima ga hara, the plain of Ukishima.
Fan print.
Signed: *Ichiyūsai Kuniyoshi ga*
21·6 × 28·3 (8½ × 11⅛) E.2905–1913

Given by Mr R. Leicester Harmsworth

This print shows the meeting between the troops of Yoshitsune (see under v 18–v 22) and those of his half brother Yoritomo in 1180, in the early stages of Yoritomo's revolt against the Taira. Yoshitsune's great ability as Commander-in-chief aroused his brother's jealousy and led to enforced exile (see next entry).

V13
Kuniyoshi
c.1840

Funa Benkei, Benkei in the boat. Fan print.
Signed: *Ichiyūsai Kuniyoshi ga*
21·6 × 28·6 (8½ × 11¼) E.2904–1913

Given by Mr R. Leicester Harmsworth

Benkei (see also v 35, 153) was Yoshitsune's most loyal henchman, an idealization of the type of the warrior monk. The heroic role in the latter part of the Yoshitsune legend falls on him as repeatedly he snatches his strangely weakened master from the jaws of a multitude of disasters.

The incident depicted here took place when the flight into exile involved a sea passage through the straits of Shimonoseki, the site of Yoshitsune's naval victory over the Taira at the battle of Dan no ura. The vengeful spirits of the drowned Taira warriors raised a storm which Benkei calmed, using his priest's rosary.

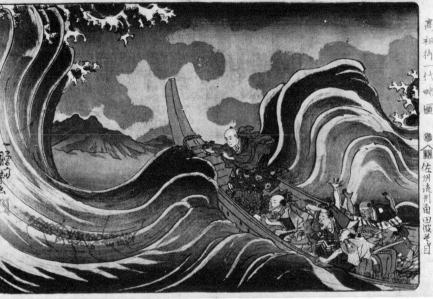

Kuniyoshi

c.1835

Sashū ryūkei kakuda nami o me, Nichiren calms the waves on the way to Sado, from Kōsō go-ichidai ryaku zu, Abridged biography of the Buddhist priest Nichiren, illustrated. Published by Ise-ya Rihei (Kinshūdō).

Signed: *Ichiyūsai Kuniyoshi ga* Utagawa seal. Publisher's seal.

22·2 × 35·9 (8¾ × 14⅛) E.1334–1922

T. H. Lee Bequest

See VI5.

4

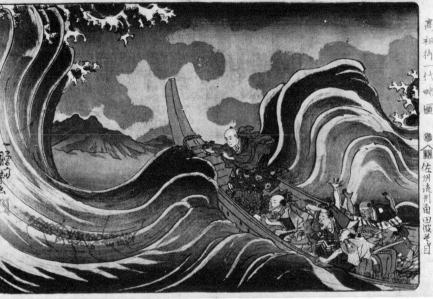

I5

Yoshimori

857

Nichiren shōnin nami daimoku no zu, Nichiren, the saintly one, putting an inscription on the wave. Published by Aito. Triptych.

Signed: *Ikkōsai Yoshimori ga* Publisher's seal. Censor seals: *aratame* and *snake* 7.

5·6 × 72·4 (14 × 28½) E.13853–1886

Nichiren (1222–1282), posthumous name Kōsō, is one of the saints of Japanese Buddhism. He laid claim to an understanding of the mysteries of Buddhism based on direct revelation, and founded a new sect, the Nichiren, or Sun Lotus sect, which was based on the Myōhō Renge Kyō (Sanscrit:

Saddharma Pundarika Sutra, the Sutra of the Lotus of the Wonderful Law). He sought to replace the usual salvation-bringing invocation to Amitabha Buddha, Namu Amida Butsu, with the opening line of his sutra, Namu Myōhō Renge Kyō. Believing, understandably in view of the century of vicious civil war which preceded him, that the world had entered the stage of decline, he inveighed so strongly, and for Buddhism untypically, against the other sects that he was twice exiled and once escaped execution only by divine intervention. He is also credited with predicting the Mongol attack on Japan.

The incident shown in these two prints by Kuniyoshi and his pupil took place during his second journey into exile in 1271. On the way to the island of Sado a storm blew up which was calmed only by the rosary and the recitation of the sacred phrase. The words of the chant appeared on the waves in a glittering magical script and the waves subsided.

V 16
Yoshitoshi
1867

Taiheiki Anegawa dai kassen, The Great Battle at Anegawa, from the Taiheiki. Published by Masuda-ya. Triptych.
Signed: *Ikkaisai Yoshitoshi* Artist's paulownia seal. Publisher's seal.
Censor seal: *aratame* combined with *hare* 12.
36·2 × 72 (14¼ × 28¼) E.14207–1886

The Taiheiki, Chronicle of the Great Peace, is an anonymous record of the battles of the 12th–14th centuries, the period of civil wars which led to the establishment of the Ashikaga shogunate.

This print, with its flagrantly anachronistic uniforms and weapons, was issued during the brief period of fighting which accompanied the overthrow of the shogunal system and the restoration of real power to the emperor. The Muromachi period title, consequently, may be seen as a cover for more direct reportage than had been usual, and also as a warning of the possible repetition of the disastrous civil wars of the Middle Ages.

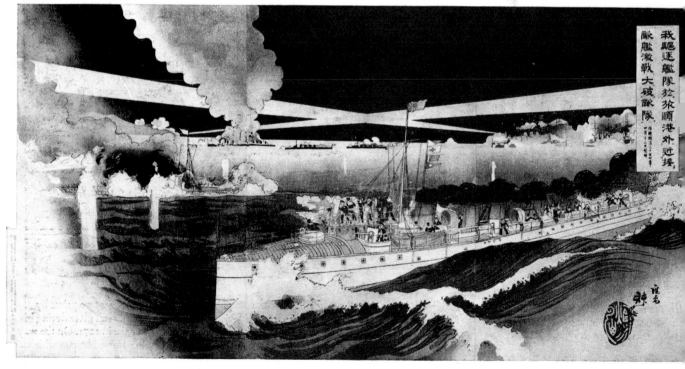

V 17
Kōkyo
1903

Japanese destroyer squadron outside Port Arthur on the occasion when the Russian flagship was blown up, 13 April 1903. Published by Matsumoto Kiyojirō. Triptych.
Signed: [?] *sai Kōkyo ga* Publisher's inscription.
38·1 × 76·2 (15 × 30) E.3410–1905

It is this class of print, covering the Sino-Japanese and Russo-Japanese wars which constitutes an epitaph to the ukiyo-e print tradition. From providing the medium of expression of a section of urban society, the woodblock publishers were called on to service the new and bellicose nation state with a speedy propaganda instrument. This print is dated only seven days later than the engagement it depicts. For this propaganda role the woodblock was quickly superseded by photographic processes, and subsided into a medium of reproduction for publishers of fine art.

Yoshitsune was a real historical figure whose
generalship played a major part in the
overthrow of the Taira government during
the civil wars of the twelfth century (see v3).
Around the historical core of his life grew a
series of legends, of which an abbreviated
résumé follows:

He is the ninth and last son of Minamoto (also
known as Genji) Yoshitomo, who is murdered
by a treacherous retainer following an
unsuccessful plot against his erstwhile ally,
the villainous Taira Kiyomori (1118–1181)
(see v64). Yoshitsune, who is known in
childhood as Ushiwaka and Shanaō, is spared
from death as an infant because of Kiyomori's
desire for his mother, and is kept in ignorance
of his antecedents. At the age of seven he is
packed off as a page to a temple on Mt
Kurama to receive training as a monk. At the
age of eleven he discovers his lineage and
resolves to restore the Genji fortunes by
toppling the Taira. He has the good fortune
to fall in with Sōjōbō, the king of the local
tengu, mythical spirits related to the crow,
and receives instruction in the martial arts
from him, until he attains to a magical
proficiency with the sword, belying his
effeminate beautiful page appearance.

To avoid taking the tonsure of a monk he
leaves Kurama secretly in the company of a
gold merchant who takes him to a refuge in
Ōshū. En route he has a series of adventures,
including the slaughter of the brigands (see
v6), and the assumption of his adult name.
He also encounters his faithful retainer-to-be,
Benkei (see v13, v35), winning his loyalty by
defeating him in a fight on Gojō bridge in
Kyoto (see I55, and compare the encounter
of Robin Hood with Little John).

In Ōshū he hears of the revolt against the
Taira led by his half brother Yoritomo, joins
him (see v12), and is entrusted with the
command of the forces. His successes against
the Taira, most notably in the sea battle at
Dan no ura, incur his brother's jealousy. He
is constrained into an ill-conceived rebellion
against his brother, which fails. He goes into
exile, protected by his faithful Benkei (see
v13), but is eventually forced to commit
suicide.

Some legends say that the tengu saved him at
the last moment, and carried him across the
sea to become either Genghis Khan, or the
first emperor of the Ch'ing dynasty in
China(!), or the ruler of Hokkaidō.

 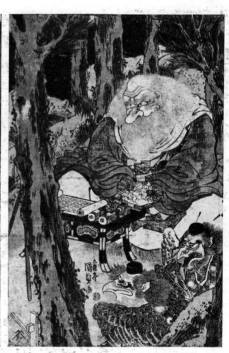

VI8
Kunisada
c.1815–1820

Ushiwaka Kurama hyōe rai, Ushiwaka
encouraged in the martial arts at Kurama.
Published by Yamamoto-ya Heikichi
(Eikyudō). Triptych.
Signed: *Gototei Kunisada ga* Publisher's
seal. Censor seal: *kiwame*.
36·8 × 76·2 (14½ × 30) E.5557–1886

There are two sorts of tengu. One, bird-like,
is exemplified by Yoshitsune's sparring
partners. The other, bald with a long nose,
by the old king with his scrolls of secret lore.
The small hats worn by some of the tengu are
those of the warrior monks, the yamabushi,
of whom Benkei was one, and with whom the
tengu are often linked.

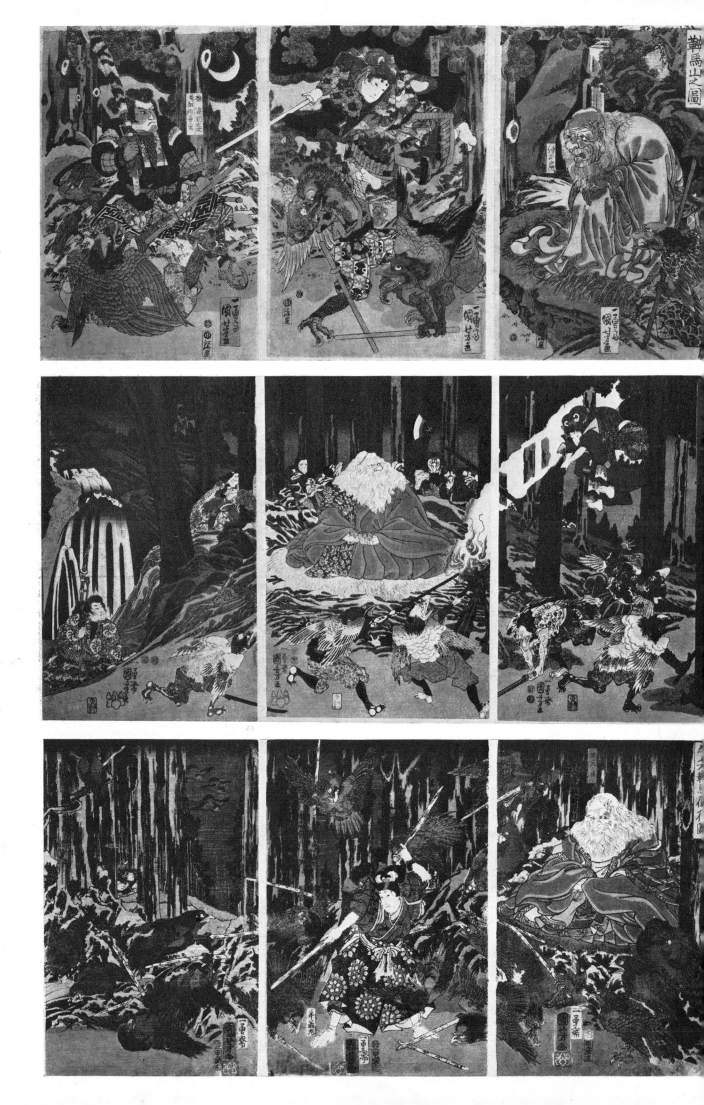

19

uniyoshi
1832

uramayama no zu, Picture of Mt Kurama.
ublished by Ezaki-ya Tatsuzō. Triptych.
gned: *Ichiyūsai Kuniyoshi ga* Publisher's
ark and seal. Censor seal: *kiwame.*
·1 × 77·8 (15 × 30⅝)

ent by Mr B. W. Robinson

he figure on the right, in this and all the
rints in this group except the last, is Kisanda,
oshitsune's servant, whom according to the
ory he acquired after leaving Kurama. He
olds Yoshitsune's sword with its fur-
overed scabbard.

20

uniyoshi
851–1852

Minamoto no Ushiwakamaru Sōjōbō ni zui
agi o kaku no zu, Illustration of Ushiwaka
arning the martial arts from Sōjōbō.
ublished by Enshū-ya Hikobei. Triptych.
gned: *Ichiyūsai Kuniyoshi ga* Artist's
aulownia seal. Publisher's mark and seal.
ensor seals: *Mera* and *Watanabe.*
·2 × 73·7 (14⅝ × 29)

ent by Mr B. W. Robinson

he tengu have reverted to their more usual
ybrid reptile/birdman form. Sōjōbō's power
indicated by the vajra, Buddhist
underbolt, he holds, and by the mysterious
ngi growing nearby.

21

uniyoshi
861 (reprint of 1858)

shiwakamaru Kurama shu gyō no zu,
icture of Ushiwaka training at Kurama.
ublished by Kagi-ya shō. Triptych.
gned: *Ichiyūsai Kuniyoshi ga* Artist's
aulownia seal. Publisher's seal.
ensor seal: *aratame* combined with *cock.*
·2 × 74·3 (14¼ × 29¼)

ent by Mr B. W. Robinson

ere the tengu are given more crow-like
haracteristics, with some marvellous
dividual expressions.

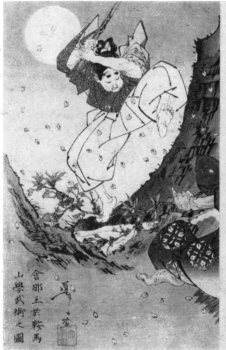

V 22

V 22
Yoshitoshi
1897

Shanao learning fencing from Sōjōbō.
Published by Hasegawa Tsunejiro. Diptych.
Signed: *Yoshitoshi* Publisher's inscription.
35·6 × 46·4 (14 × 18¼) E.1029–1914

Given by Mr Yone Noguchi

Along with the change of relationship
between design and medium which
characterizes late Meiji prints (see V I, V II)
there was a change to a softer more pastel-like
palette, which in minor hands can have a
saccharine effect. Here the contrast between
the colour scheme and the ingenious
substitution of flowering branches for swords,
provide a nice ironical contrast with the
violent action, and with Yoshitsune's later
bloody career.

V23–V25 Daruma

V23
Tsukimaro, also known as **Kikumaro**
c.1810

Daruma, with a little man wearing a giant
sword, balancing on his fly-whisk.
Signed: *Tsukimaro fude*
30·5 × 20·3 (12 × 8) E.1322–1922

T. H. Lee Bequest

Daruma (Sanscrit: Bodhidharma), is the semi-
legendary founder of the sect of Buddhism
known in China as Ch'an and in Japan as Zen.
The humorous side of the rigours of his nine
year wordless meditation session have proved
popular with Japanese artists in all media. His
staring appearance is the result of his cutting
off his eyelids to prevent himself from falling
asleep while meditating.

The apparently irrational combination here
with the diminutive sword-bearer is almost
certainly based on a pun which has so far
eluded elucidation.

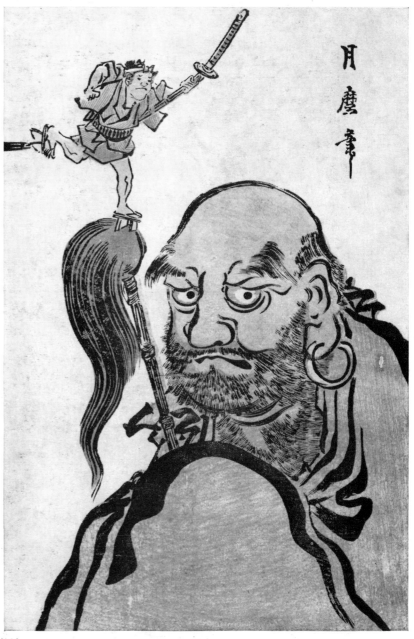

V23

V24
Kunimaru
c.1820

Courtesan as Daruma. Published by Iba-ya
Sensaburō (Dansendō). Fan print.
Signed: *Ichiensai Kunimaru fude* Artist's
seal. Publisher's mark. Censor seal:
kiwame.
16·5 × 22·5 (6½ × 8⅞) E.4946–1919

The frequent representations of women as
Daruma seem to be based on the ungallant
sentiment that no woman was capable either
of meditation or of holding her tongue.

V24

V 25

Kunisada

1852

An actor of the Iwai family as a woman Daruma, with a scene on the Tokaidō between Yoshiwara and Kambara. Published by Tama-sō.
Signed: *Toyokuni ga* Publisher's seal.
Censor seals: *Murata, Kinugasa* and *Rat* 8.
34·3 × 24·1 $(13\frac{1}{2} × 9\frac{1}{2})$ E.8595–1886

The inset scene shows a tea merchant's shop. Legend has it that Daruma's amputated eyelids took root and became the tea-plant, a most excellent remedy for fatigue.

V 26–V 28 Shōki

V 26

Utamaro

c.1810

Shōki delivers a love letter. Published by Mori-ya Jihei.
Signed: *Utamaro fude* Publisher's seal.
34·6 × 22·9 $(13\frac{7}{8} × 9)$ E.1424–1898

Shōki is an import from China, where his name is Chung K'uei. He is said to have been a failed scholar during the Han dynasty, who committed suicide rather than live without rank or office. The emperor, hearing of this, ordered a state funeral for him. So grateful was Shōki that he devoted the rest of his spirit existence to the extirpation of demons. Pictures of him are all supposed to descend from one painted by the T'ang dynasty painter Wu Tao-tzu on the order of the emperor Hsuan Tsung, who had seen a vision of him. Certainly he is always shown in the garb of a T'ang official. He proved immensely popular in Japan, being particularly associated with the boy's festival.

In this print he is avoiding the mistake of the sennin, or immortal, Kume, who fell from paradise after being entranced by the reflection of a woman in a stream, by using a demon to declare his love to the washerwoman below.

V 26

Kuniyoshi
1849–1853

Shōki deals with a demon. Published by
Ebisu-ya Shōshichi (Kinshōdō).
Signed: *Kuniyoshi ga* Artist's seal:
Kuniyoshi. Publisher's seal. Censor
seals: *Hama* and *Magome*.
36·8 × 25·4 (14½ × 10) 24709

An exercise in the Kanō style.

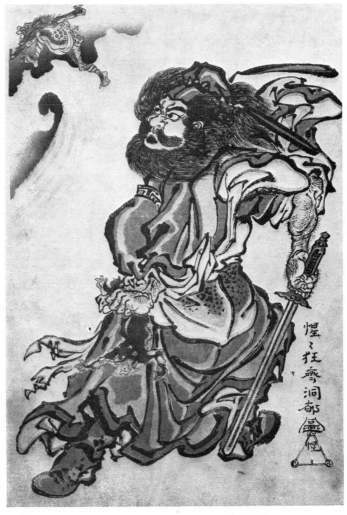

v 27

v 28
Kyōsai
c.1865

Shōki and the one that got away.
Signed: *Shōjō Kyōsai tōtō zu* Artist's seal:
Shōjō.
37·2 × 26 (14⅝ × 10¼) E.11944–1886

Kyōsai's signature here means: Pictured by
Kyōsai the drunken sprite in the cave city.
Cave city, tōtō, is punning on tōto, Eastern
Capital, one of the many circumlocutions for
Edo, and is a characteristically belittling
touch from this spirited artist. Another
exercise in Kanō style.

v 28

29

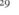

31

V 30

V29
Anonymous (Torii School)
c.1715

Young woman with the attributes of Kanzan and Jittoku. Coloured by hand.
28·9 × 13·7 (11⅜ × 5⅜) E.598–1899

Kanzan (Chinese: Han Shan) and Jittoku (Chinese: Shih-te) are eccentric figures taken, like Daruma, q.v., from Zen iconography. They performed menial functions around a temple, and treated the serious with giggling disdain. This print, therefore, may be taken as conferring a somewhat spurious sanctity on the hedonistic habits of the habitués of the Edo demimonde.

V30
Masanobu
c.1720

Sugawara no Michizane in court costume. Kakemono-e, printed in black and red.
Signed: *Hōgetsudō Tanchōsai Okumura Shimmyo Bunkaku Masanobu Kinzu* Artist's seal: *Tanchōsai.*
66·5 × 24·6 (26¼ × 9⅞) 1945–10–13–01

Lent by the Trustees of the British Museum

See V 31

V31
Masanobu, attributed to
c.1720

Sugawara no Michizane in his deified form of Tenjin Sama. Coloured by hand.
31·3 × 14·9 (12¼ × 5⅞) E.1341–1922

T. H. Lee Bequest

Michizane was a 9th-century courtier, and minister to the emperor Go-Daigo. He was exiled to the island of Kyūshū as a result of political chicanery, though Tokihira, the enemy who engineered the banishment, was later struck by lighning.

He was a poet and calligrapher of such merit that he was deified as the god of poetry, and was much worshipped as such. The branch of plum refers to the legend that his favourite plum tree uprooted itself and flew to him in Kyūshū.

V 32
Shunsen
c.1810

Jō and Uba, the spirits of the pine trees.
Published by Izumi-ya Ichibei (Kansendō).
Signed: *Kashōsai Shunsen ga* Publisher's
seal.
38·1 × 26 (15 × 10¼) E.370F–1890

Jō and Uba are the Philemon and Baucis of
Japan: the man was a son of Izanagi, one of
the spirit creators of the islands of Japan. He
went from Sumiyoshi, Settsu province, to
Takasago, in Harima province, where he
met and fell in love with a local maid. The
two lived to a great age in perfect union and
happiness, and after death inhabited the pine
trees, one in Sumiyoshi and the other in
Takasago. On moonlit nights they are seen in
one or other place gathering pine needles.
They are symbols of longevity, here
emphasized by the tortoises (see IV 16), and of
happy marriages.

V 32

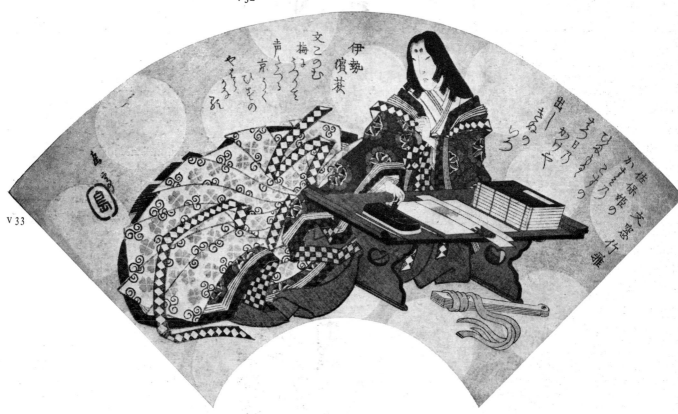

V 33

V 33
Gakutei
c.1830

Woman in the court costume of the Heian
period (8th–12th centuries). Surimono. Fan
print.
Signed: *Gakutei* Artist's seal: *Yashima*.
16·2 × 28·3 (6⅜ × 11⅛) E.323–1914

Given by Mr R. Leicester Harmsworth

This print evokes a comparison between the
extremely refined female dominated literary
scene of the pre-civil war imperial court, and
the new culture of the accomplished
courtesans of the Yoshiwara.

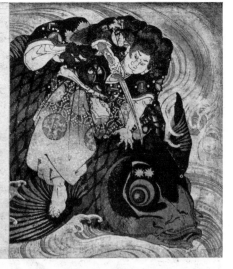

34

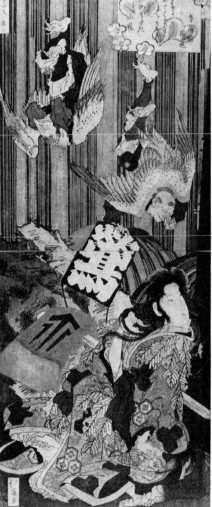

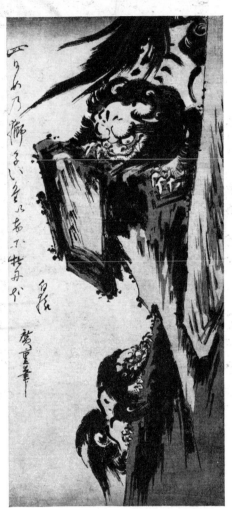

v36

v35

v34
Hokkei
c.1830

Oniwaka killing the giant carp. Diptych.
Surimono.
Signed: *Hokkei ga.*
21 × 36·8 (8¼ × 14½) E.3826–1916

Given by the Misses Alexander

Oniwaka (little demon) is the boyhood name
of Benkei (see v13, 153), whose story slowly
acquired exploits to match those of
Yoshitsune.

These two prints by Hokkei are fine examples
of elaborate surimono printing, the finely
wrought drawing being complemented by
the rich yet subdued harmony of colour with
gold and silver.

v35
Hokkei
c.1830

Yama-uba, Kintoki's axe, and two tengu
flying down a waterfall. Diptych. Surimono.
Signed: *Hokkei ga.*
41·3 × 17·8 (16¼ × 7) E.3825–1916

Given by the Misses Alexander

Yama-uba is a wild mountain-woman,
characterized by her extremely long hair and
her garment of leaves, who was foster-mother
to Kintoki (see v39), a sort of child Tarzan
figure of great strength, who is still a great
favourite with Japanese children. It is possible
that this composition is completed by another
two sheets on the right showing Kintoki
doing something which would account for
the extraordinary expressions on the faces of
the tengu.

v36
Hiroshige
c.1830

The shishis and the precipice.
Signed: *Hiroshige fude.*
47·3 × 16·8 (14⅝ × 6⅝) E.4795–1916

The shishi is a highly modified lion, adopted
through Buddhism, where it is the mount of
Manjusri, Boddhisattva of Wisdom. Its
appearance is close to that of a fierce pekinese
dog, which seems indeed to have been bred to
resemble the shishi.

Those shown here are a mother and cub: the
cub is climbing back up the cliff after being
pushed off by mother to improve his
endurance and perseverance.

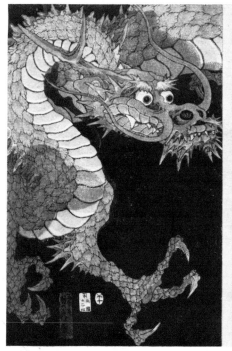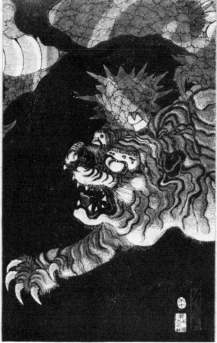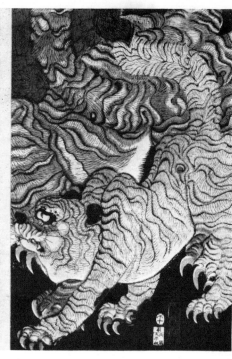

V 37
Sadahide
1858

Dragon confronting two tigers. Published by Daikoku-ya Heikichi (Shōjudō). Triptych. Signed: *Gountei Sadahide ga* Publisher's seal. Censor seal: *aratame* and *Horse 10*. 36·5 × 71·8 (14⅜ × 28¼) E.12136–1886

The tiger and the dragon represent, inter alia, wind and water. When balanced these forces have a beneficial effect, for the breath of the tiger is the wind, and that of the dragon the clouds: together they make the rain, which fructifies the earth. Where there is too much wind, the rain will be blown away and the beneficial effects will be cut off. One can only suppose, for an ill-omened print is hardly a selling proposition, that the dragon is of greater than usual strength, or the tigers weaker.

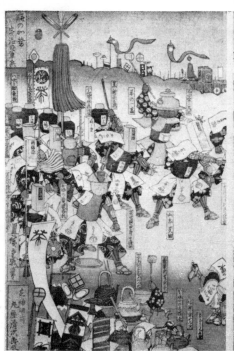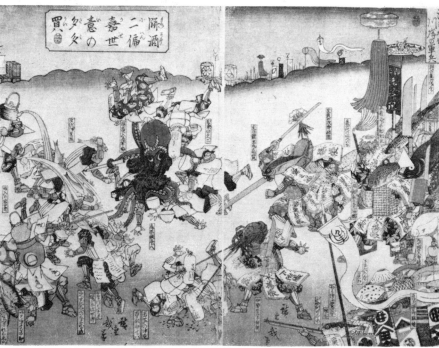

V 38
Hiroshige
1843–1845

The second war between the mochi and the sake. Published by Maru-ya Seijirō (Jukakudō). Triptych. Signed: *Hiroshige ki fude* Publisher's seal. Censor seal: *Fu*. 36·8 × 73·3 (14½ × 28⅞) E.3151–1886

This is an example of a widespread genre of humorous pseudo-history, and is signed 'drawn for fun'.

Mochi are a kind of rice paste cake, traditionally eaten at the New Year and taken with tea. Sake is a distilled rice wine, often drunk hot, and with a bland taste that is sharpened by accompanying it with seafood. Hiroshige is here suggesting that there is an irreducible difference in character between the mochi lovers and the sake lovers.

V39 V40

v39 and v40
Kuniyoshi
c.1840

Two prints from the series Buyū mitate juni shi, Heroes compared with the twelve branches (zodiacal signs). Published by Minato-ya Kohei.
Signed: *Ichiyūsai Kuniyoshi ga* Artist's Utagawa seal. Publisher's seal.
Each 36·8 × 12·4 (14½ × 4⅞) E.727 & E.2729–1952

v39 shows Kuan Yu, one of the heroes of the Chinese novel San Kuo Chih Yen-i, the Romance of the Three Kingdoms, compared with the sign of the goat.

v40 shows Kintoki (see v34) compared with the sign of the cock.

The animal characters associated with the twelve signs are Rat, Ox, Tiger, Hare, Dragon, Snake, Horse, Goat, Monkey, Cock, Dog and Pig. The equivalent zodiac signs are Aries, Taurus, Gemini, Cancer, Leo, Virgo, Libra, Scorpio, Sagittarius, Capricorn, Aquarius and Pisces. Every year, month, day and hour can be assigned to one of the twelve, making for a very complicated horoscope system.

V41
Toyohiro
c.1800

The poet Ariwara Narihira crossing the Ide
no Tamagawa river, from a set of the six
Tamagawa rivers.
Signed: *Toyohiro ga.*
36·8 × 25·4 (14½ × 10) E.12636–1886

V42
Kuniyoshi
c.1840

Ariwara Narihira composing his poem on the
maple leaves floating on the Tatsuta river,
No. 17 of the series Hyaku nin Isshu. The
hundred poets. Published by Ebi-ne.
Signed: *Chōrō Kuniyoshi ga* Artist's seal, the
Utagawa seal, tripled. Publisher's seal.
35·9 × 24·1 (14⅛ × 9½) E.11411–1886

Ariwara Narihira (825–880) was a poet and
statesman of the Heian period, and reputedly
the hero of a series of romantic poems called
the Ise monogatari. His reputation as a poet
is such that he is included not only among the
anthology of 100 poets, but is also one of the
Rokkasen, the six sages of poetry.

He is also celebrated for his beauty and for his
romantic adventures, particularly with the
poetess Komachi (see II 58).

The two prints here are associated with
poems of his. The first was the reflection that
it was impossible to cross the Tamagawa
without reining one's horse to admire the
flowering shrubs, and the second stating that,
even when the spirits reigned, the Tatsuta
was never turned to Korean gold as it is when
the maple drops its leaves.

V41

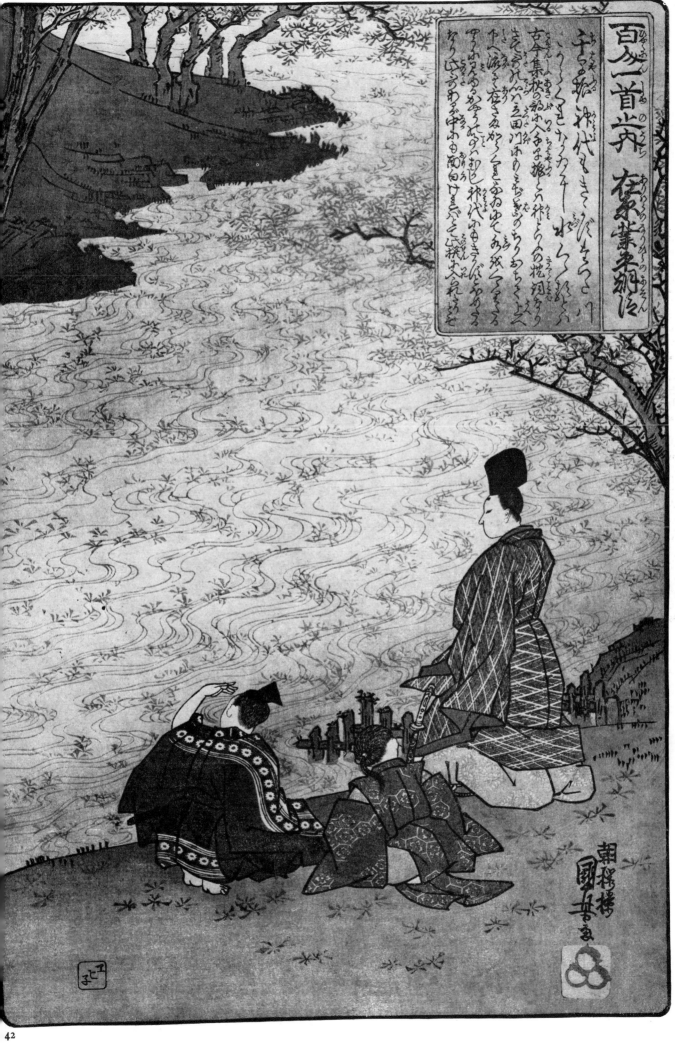

V 43
Hiroshige
1843–1845

The shrine called Soga no Yashiro, one of the
series Soga Monogatari Zu-e, Illustrations to
the story of the Soga brothers. Published by
Iba-ya Sensabūro (Dansendō).
Signed: *Hiroshige ga* Publisher's mark and
seal combined. Censor seal: *Watari*.
37·5 × 25·4 (14¾ × 10) E.3172–1886

The story of the revenge of the Soga brothers
has already been referred to (see v 8, v 9). They
succeeded in killing their father's assassin in
Yoritomo's camp, but themselves perished.
The shrine to commemorate their loyalty was
erected by Yoritomo, an apparently
inconsistent gesture for the man who had had
their grandfather assassinated, who had Gorō,
the younger Soga brother, beheaded with a
blunt sword, and who would surely have been
their next victim had they survived.

V 43

V 44
Yoshitoshi
1866

Mitsutoshi and the fox fires, from Wakan
hyaku monogatari, One Hundred Japanese
and Chinese ghost stories. Published by
Tsukiji Daikin.
Signed: *Ikkaisai Yoshitoshi ga* Publisher's
seal. Censor seal: *aratame*, combined with
Ox 2.
36·8 × 25·4 (14½ × 10) E.14180–1886

Anthologies of this sort, usually of tales
involving ghosts and the weird, were
extremely popular. This one concerns the
encounter whilst fishing of the rōnin (see
v 48–v 52) Mitsutoshi, formerly a retainer of
the Akechi family during the civil wars of the
late 16th century, with the fox spirits, and his
bravery in extricating himself from their
power.

V 44

45

Masanobu
c.1710

Suetsumu Hana, The saffron flower, Chap. VI
of the Genji Monogatari, No. 6 of a series of
12 parallels to the chapters of the Tale of
Genji.
$25.7 \times 5.9 (10\frac{1}{8} \times 14\frac{1}{8})$ E.1347–1922

T. H. Lee Bequest

The tale of the Genji is a long romance,
written in the 10th century by Lady Murasaki
Shikibu, concerning the romantic and
amorous adventures of Prince Genji.
This series by Masanobu translates the locale
to his contemporary Edo and offers the rising
urban mercantile class the opportunity to
compare itself with the old high culture. The
allusion in this print is provided by the folded
kimono, and refers to Genji being sent the
robe of a neglected lover as a reminder of his
failure to visit her.

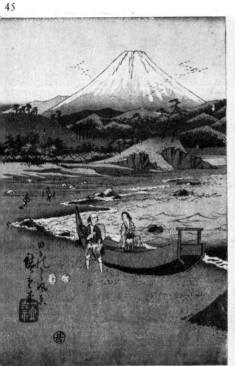

V 46

V46
Hiroshige and Kunisada
1857

Tago no ura fūkei, View of Tago bay: Genji
and a lady companion composing a poem on
the view. Published by Maru-ya Jimpachi
(Enjudō). Triptych.
Signed, right: *Toyokuni ga*, left: *Hiroshige
fude* Hiroshige's seal: *Ichiryūsai*
Publisher's seal. Censor seals: *aratame* and
Snake II.
$36.2 \times 71.8 (14\frac{1}{4} \times 28\frac{1}{4})$ E.1420–1898

This joint venture, combining Hiroshige's
landscape and Kunisada's figures, extends the
charisma of Genji to the favoured places in the
countryside around Edo.

V 47
Hiroshige
1845–1846

Zaigo Chūjō Minamoto no Hikaru, from the
series Kodai monogatari zu-e, Illustrations
to stories of olden times. Published by
Tsuji-ya Masubei. Fan print.
Signed: *Hiroshige ga* Publisher's seal.
Censor's seal: *Kinugasa*.
22·9 × 30·2 (9 × 11⅞) E.541–1911

Here Genji, given the full version of his name,
seems to have degenerated into an overposed
model for luxury textiles. The diagonally
thrusting composition, and the economically
evoked moonlit scene combine with him to
produce a disturbingly bitter-sweet feeling.

V 47

V 48–V 52 Chūshingura

V 48
Toyokuni
c.1790

Rikiya and Konami in Act II of Chūshingura.
Signed: *Toyokuni ga*
30·5 × 13·7 (12 × 5⅜) E.53–1955

Chūshingura, A treasury of loyal retainers,
was originally written as a play for the puppet
theatre, and was first performed in Edo in
1748. It is based on historical events which
took place in 1701, although it is set in the
Ashikaga period because of a regulation
forbidding the real names being used in
portrayals of recent events. The Lord of Akō,
Enya in the play, is goaded by the greedy
lecherous Kōtsuke no Suke, Moronao in the
play, into attacking him in the precincts of
the shōgun's castle. Despite the provocation,
Enya is ordered to commit seppuku for
drawing a weapon in the castle. His retainers
are dismissed to become rōnin, literally 'wave
men', or masterless warriors.

Forty-seven of them resolve to avenge their
master's death, under the leadership of
Kuranosuke, in the play Yuranosuke. After
waiting for Moronao's suspicions to die down,
they attack his mansion, kill him, and place
his head on their master's grave. They in turn
are ordered to commit seppuku, and are
buried around their master. Their graves
become a place of pilgrimage.

The Toyokuni print shows part of a sub-plot.
Rikiya, son of Yuranosuke, is in love with
Konami, daughter of Honzō, counsellor to
Wakasa no Suke, who along with Enya had
been insulted by Moronao. Honzō bribed
Moronao to treat him better and violence was
thereby averted. However, he also stayed
Enya's hand when he attacked Moronao,
thereby rendering his family unsuitable for
alliance with the avengers of Enya. (See also
V 51).

The style of this print is most unusual for
Toyokuni, recalling in drawing, colouring
and format the work of the Katsukawa school
(see 140), and is presumably an early work.

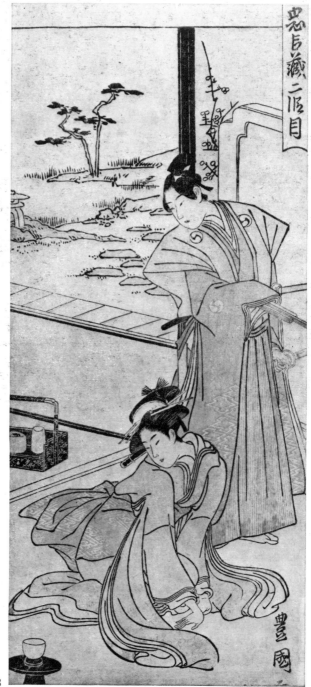

V 48

忠臣藏銕炮

五段目

V 49

Eisen

c.1830

Sadakurō robbing Yoichibei in Act v of Chūshingura. Published by Sōshū-ya Yohei. Signed: *Eisen ga* Publisher's seal.
23·5 × 35·6 (9¼ × 14) E.12917–1886

Yoichibei, returning from selling his daughter, fiancée of Kampei, one of the forty-seven, to a brothel to provide funds for the rōnins' attack, is killed and robbed of the funds by the robber Sadakurō. Sadakurō is in turn shot by Kampei, who mistakes him in the dusk for the wild pig he is hunting, and the money is saved.

The unusual format, with the large title, results in a very flat perspective, which, with the green red colour harmony, lends a great clarity to the figures.

V 50

Hiroshige

c.1840

Konami and her mother on the bridal journey in Act VIII of Chūshingura. Published by Iba-ya Sensaburō (Dansendō).
Signed: *Hiroshige ga* Publisher's seal.
Censor seal: *kiwame*.
24·1 × 35·6 (9½ × 14) E.3448–1886

The bridal journey provides some relief to the general slaughter which characterizes this drama. The glowing clarity of colour in this simple landscape masterpiece is beautifully calculated to convey this lyrical feeling. The mood does not last: the marriage only takes place after the mothers-in-law have attacked one another, and the bridegroom has speared his father-in-law with the latter's help!

V 51
Hiroshige
c.1840

Toritsuga no banshō "Vesper bell: handing
over the letter". Rikiya and Konami, from
Chūshingura Hakkei, Eight Chūshingura
views. Published by Iba-ya Sensaburō
(Dansendō). Fan print.
Signed: *Hiroshige ga* Publisher's mark.
23·2 × 29·8 (9⅛ × 11¾) E.2913–1913

Given by Mr R. Leicester Harmsworth, MP.

V 52
Kunisada
1854

Honzō prevents his wife from killing Konami,
their daughter, in Act IX of Chūshingura.
Published by Tsuta-ya Kichizō (Kōeidō).
Signed: *Toyokuni ga* Publisher's mark.
Engraver's seal: *Hori take.* Censor seals:
aratame and *Tiger* 5.
24·1 × 34·9 (9½ × 13¾) E.5913–1886

This is the first part of the follow-up to V 50.
Konami had just been told that she could not
marry and asked her mother to kill her, when
her father appeared to confess his fault in
restraining Enya in the first place, and
prevented the killing.

The prominent woodgrain pattern in the
brooding grey sky contrasts with the white of
the snow to give this print a weirdly
menacing quality.

V 51

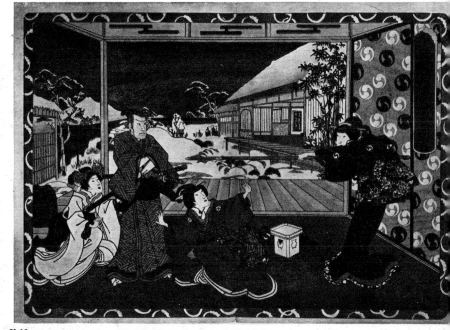

V 52

V 53–V 54 Suikoden

V 53 and V 54
Kuniyoshi
c.1828–1830

Daitō Kanshō and Gyokukirin Roshungi, two
sheets from the series Tsūzoku Suikoden
gōketsu hyakuhachi nin, The 108 popular
heroes of the Shui Hu Chüan. Published by
Kaga-ya Kichibei.
Each: signed *Ichiyūsai Kuniyoshi ga*
Publisher's seal. Censor seal: *kiwame.*

Lent by Mr B. W. Robinson

Suikoden is the title of Bakin's (see V 7)
translation of the Chinese novel of brigandry,
devilry and heroics Shui Hu Chüan, an
English version of which has been produced
by Pearl S. Buck under the title *All Men are
Brothers.*

The opportunities for exotic costume and
props, note the geomancer's compass hanging
from the belt in V 54, for weapons of
unfamiliar patterns and for violent and
dramatic postures were not lost on
Kuniyoshi, who made his reputation with
this series. A subject from the same novel by
Kuniyoshi's pupil Yoshitoshi is in V 10.

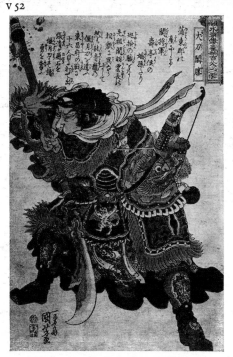

V 53

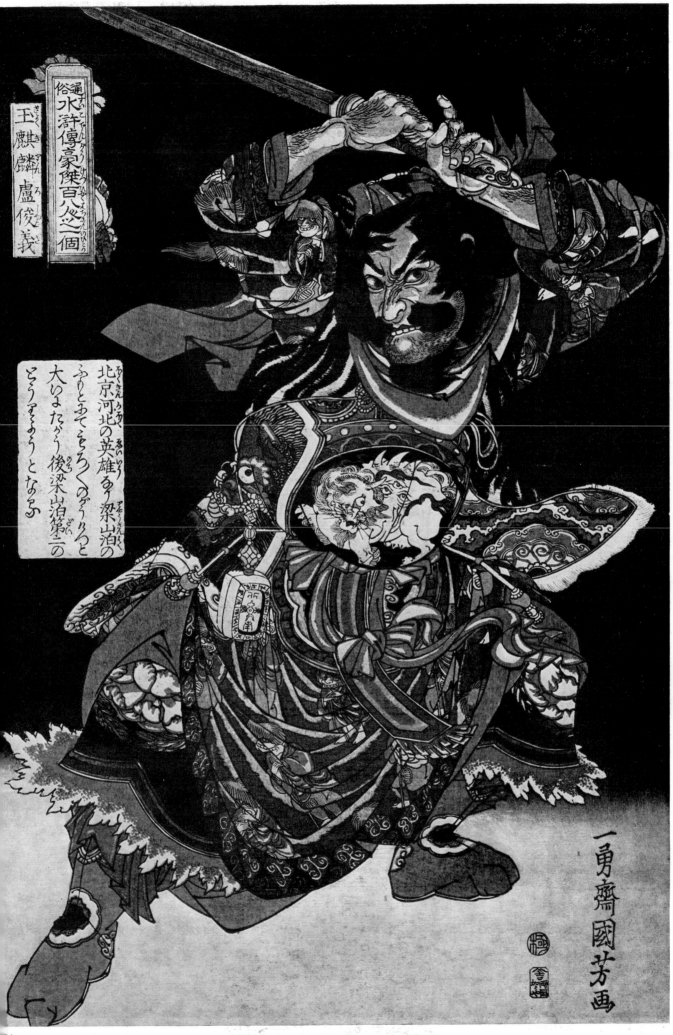

v 55–v 57 Monkey

v 55, v 56 and v 57
Yoshitoshi
1866 and 1865

Three sheets from the series Tsūzoku Sai Yū ki, Popular Shi Yu Chi. Published by Fukudaishi.
Signed: *Ikkaisai Yoshitoshi ga*
Publisher's seal. Censor seal: *aratame* combined with *Ox 2* or (v 57) *Rat 11*.
35·6 × 25·4 (14 × 10) E.14167, E.14175 & E.14177–1886

Shi yu chi is a Chinese novel, probably finalized in the 14th century, and is a heavily mythologized version of the journey to India of the T'ang monk Hsüan Tsang, accompanied by a monkey spirit and a pig spirit. It is available in English in a translation by Arthur Waley, entitled *Monkey*. With the exception of v 55, itself an unusual treatment of the human form for Ukiyo-e, these prints are crowded in structure and oppressive in colour. Fortunately this treatment suits the subject matter. Yoshitoshi must himself have felt that he was unduly limited by this manner, for his style changed by the 1870s to the less cluttered drawing and more limpid colours exemplified by v 10 and v 67. This was carried on by his pupils, e.g. v 11.

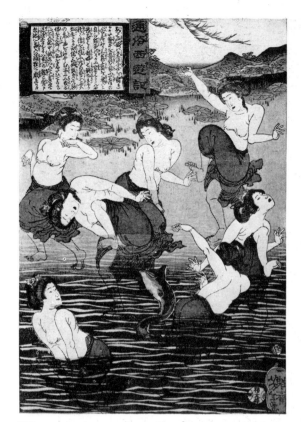

v 55

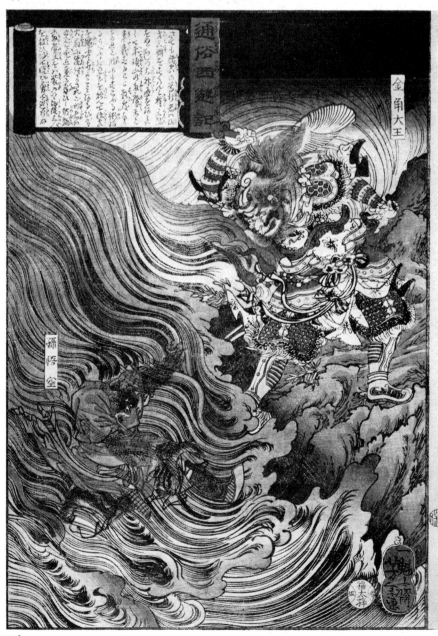

v 56

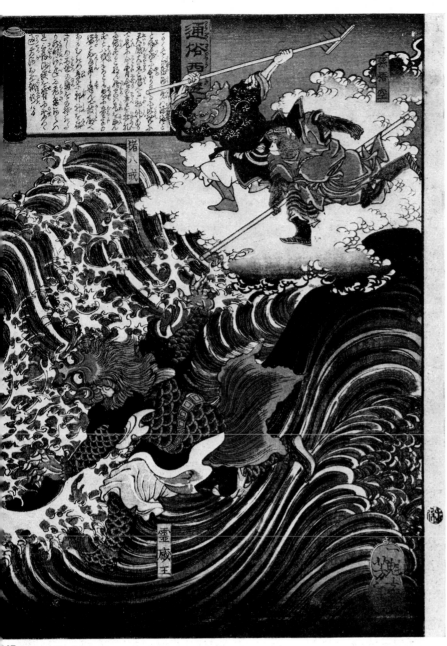

57

v 58
Moronobu
c.1680

Watanabe no Tsuna visited by the demon of Rashōmon disguised as a nurse. Coloured by hand.
25·1 × 34·6 (9⅞ × 13⅝) E.1346–1922

T. H. Lee Bequest

Watanabe no Tsuna was a henchman of the at least semi-legendary Raikō (see v 59). Once he encountered the demon of the Rashōmon gate in Kyoto, and succeeded in cutting off its arm. This he kept in a box and showed to nobody, until one day an apparently harmless old nurse praised him for his daring exploit and asked to see the trophy. Reluctantly he agreed: the old woman snatched it and flew off into the air. The demon had regained its arm.

The device of leaving the roof off a building to show interior and exterior simultaneously is taken over from the earlier Yamato-e scrolls, and emphasizes the continuity between the older Japanese style and early Ukiyo-e, as distinct from the heavily Sinified Kano school patronized by the upper classes.

V 59

V 59
Moronobu
c.1680

Raikō presents the head of the Shutendōji.
Published by [?] Sabakata-ya. Coloured by
hand.
Publisher's mark.
27·5 × 36·5 (10⅞ × 14⅜)　　1919–10–14–02

Lent by permission of the Trustees of the
British Museum

Raikō, otherwise known as Minamoto
Yorimitsu (944–1021), is the hero of numerous
legendary exploits involving demons and
ogres in the Kyoto area. The Shutendōji was
an enormous boy ogre, which turned into a
demon at night. With divine aid, Raikō
managed to drug its wine and decapitate it,
while his followers hacked its still struggling
body to pieces. This probably reflects the
breaking up of a gang of brigands.

The masterful use of the diagonal viewpoint in
this and the preceding print, and the
counterpoint provided by the architectural
details show well why Moronobu's reputation
has never declined.

v60–v63

Hokusai, Copies after
Originals c.1830, Copies c.1875

Four from the series Hyaku monogatari, of
which five were published.

v60 24·7 × 18·6 $(9\frac{3}{4} × 7\frac{3}{8})$	1921–5–11–14	
v61 24·5 × 18·5 $(9\frac{5}{8} × 7\frac{3}{8})$	1921–5–11–15	
v62 25·5 × 18·8 $(10 × 7\frac{3}{8})$	1921–5–11–16	
v63 24·7 × 17·9 $(9\frac{3}{4} × 7)$	1921–5–11–18	

Lent by permission of the Trustees of the
British Museum

These prints, whose ghostly qualities need no
commentary, have only recently been
diagnosed as Meiji period copies. They have
been included as a dreadful warning of the
skill with which the works of some of the
major Ukiyo-e artists have been forged.

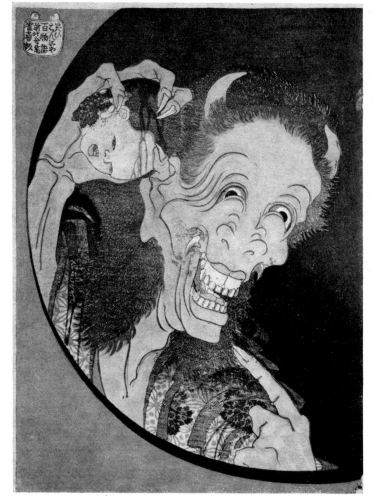

v60

v64

Hiroshige
1843–1845

Taira Kiyomori sees strange sights. Published
by Iba-ya Kyūbei. Triptych.
Signed: *Ichiryūsai Hiroshige ga* and *Hiroshige ga*
Artist's seal: *Hiro.* Publisher's seal.
Censor seal: *Watari.*
36·8 × 76·2 $(14\frac{1}{2} × 30)$ E.3390–1886

Kiyomori, the enemy of Yoshitsune and
Yoritomo, shortly before he died, was under
the impression that his palace was haunted by
the ghosts of all the Genji he had caused to die.
Hiroshige has marvellously captured the
delirium of the ageing tyrant, as the snow
laden garden reveals itself as composed of
more and more skulls. Kiyomori is here
recognizable as the actor Nakamura
Utaemon IV, who took the part in the play
Gempei Soga in the first month of 1845.

v64

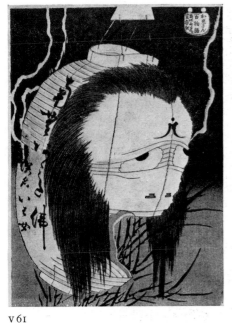

v 61

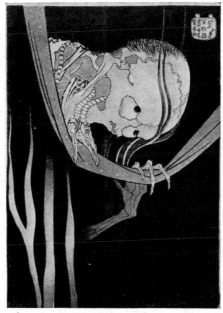

v 62

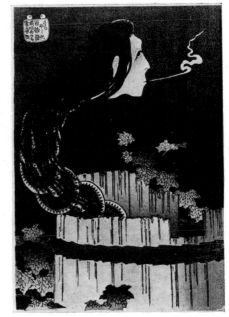

v 63

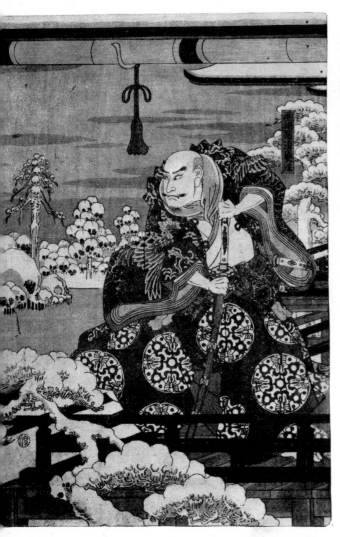

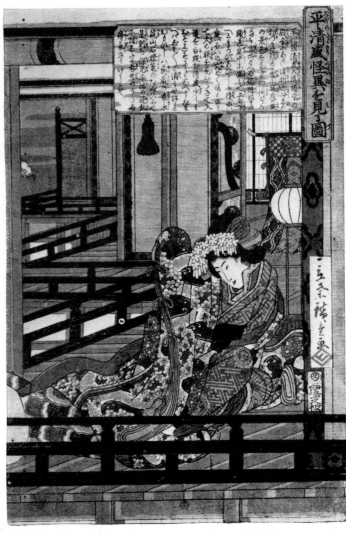

v65
Kuniyoshi
1843–1845

Mitsukuni and the skeleton spectre. Triptych.
Signed: *Ichiyūsai Kuniyoshi ga* Artist's
paulownia seal. Censor seal: *Watari*.
34·9 × 70·5 (13¾ × 27¾) E.1333–1922

T. H. Lee Bequest

I have been unable to locate this story but the
print is evidently inspired by a theatrical
production. The woman with the scroll is
Takiyasha, sorceress daughter of Taira
Masakado (d.940). He attempted in the 10th
century to set himself up as emperor, and after
he was killed his castle was believed to be
haunted.

This and similar monster-killing stories may
be seen as a dramatization of the position of
the reformer in a traditional society. Needless
to say the spectre was overcome.

v66
Yoshikatsu
c.1850

Ōmori Hikoshichi and the disguised demon.
Published by Kato-ya.
Signed: *Isseisai Yoshikatsu ga* Publisher's
seal. Engraver's seal. Unidentified
censor seal: *aratame* combined with *ten*.
37·2 × 25·1 (14⅝ × 9⅞) E.13644–1886

Hikoshichi was a 14th century warrior who
agreed to carry a pretty girl he had met across
a river. Half-way across he looked down and
saw the reflection of a hideous hag. Since
demons have the power to alter their
appearance, but not its reflection, he drew his
sword and killed it. One sequel says that the
experience drove him mad and that he
attacked his own troops and was killed.

This is one of the rare subjects that calls for the
representation of reflections in water, which
are otherwise omitted (see section III).

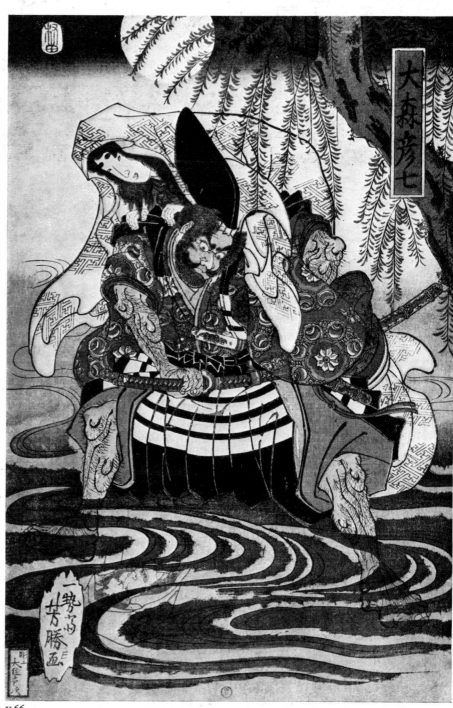

v 66

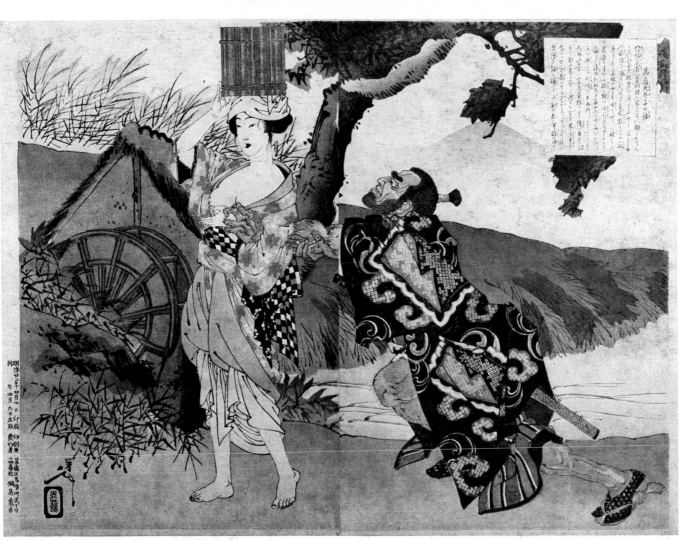

V 67

v67
Yoshitoshi
1889

Ōiko the strong woman and Saeki the wrestler. Published by Ajima Kamekichi. Diptych.
Signed: *Yoshitoshi*　　Artist's seal: *Daiso*.
Publisher's inscription.
37·5 × 50·8 (14¾ × 20)　　E.359–1901

Oiko was a woman of herculean strength whose outward appearance was that of any pretty girl. She must have been an attractive fantasy figure to a class that was subject to the arrogant whims of the samurai. One day the wrestler Saeki, on his way to Kyoto for a contest, seeing her by the river Takashima, slipped his arm in hers in an over-familiar way. She gripped tight, and dragged him home, where she fed him on rice balls she had compressed into the hardness of stones. It took all his strength just to feed himself. When, however, she released him he found that this regime had so strengthened him that he was able to overcome all his adversaries with the greatest of ease.

Books associated with section v (not illustrated)

v a
Moroshige
c.1686

Kōshoku Edo Murasaki, Love story of Murasaki of Edo. A novel by Ishikawa Ryusen.

Lent by Mr & Mrs Jack Hillier

v b
Hambei
1688

Nippon etai gura, Japan's treasury for the ages. A novel by Saikaku. 2 volumes.

Lent by Mr & Mrs Jack Hillier

v c
Shunshō
1775

Nishiki hyakunin isshu, Illustrated One hundred Poets.

E.2895–1925

v d
Utamaro
1789

Kyōgetsubō, Crazy moon-gazing. Comic poems about the moon.

E.3529–1897

v e
Shigemasa
1802

Ehon Komagadake, Illustrations of famous horses and horsemen of China and Japan. 3 volumes.

E.2361, 2362, 2363–1925

v f
Shinsai
1803

Ehon kyōka gojūnin isshu, Fifty illustrated comic poems.

E.7007–1916

Given by the Misses Alexander

v g
Hokusai
(1819) 1835

Manga Volume 10.

E.14866–1886

v h
Hokusai
1835

Ehon Sakikage, Illustrations of forceful personalities. Volume 1 of 4.

E.14879–1886

v i
Gakutei
c.1820

Gakutei Ehon. Humorous portraits of the poets.

E.3041–1925

v j
Eisen
c.1835

Buyū sakikage zue, Illustrations of forceful heroism. Volumes 1 and 2 from 3.

E.10572, 10573–1886

v k
Yoshitoshi
1866

Ikkai manga, Sketches by Ikkai (sai Yoshitoshi). Volume 1 from 15.

E.14901–1886

List of Japanese era names and their starting dates

(Within the period covered by the exhibition).

Genroku	1688
Hoei	1704
Shotoku	1711
Kyoho	1716
Gembun	1736
Kampo	1741
Enkyo	1744
Kan-en	1748
Horeki	1751
Meiwa	1764
An-ei	1772
Temmei	1781
Kansei	1789
Kyowa	1801
Bunka	1804
Bunsei	1818
Tempo	1830
Koka	1844
Kaei	1848
Ansei	1854
Man-en	1860
Bunkyu	1861
Genji	1864
Keio	1865
Meiji	1868
Taisho	1912

All artists worked primarily in Edo unless the contrary is stated.

1 Harukawa **Ashihiro** (fl.c.1820)

Osaka. Pupil of Ashikuni (d.1820). Mainly Kabuki subjects.
I 9

2 Kigadō **Ashiyuki** (fl.c.1804–c.1830)

Osaka. Pupil of Ashikuni. Before 1814 used the name Nagakuni. Prolific output of Kabuki subjects.
I 33; I 55.

Chikamaro; See Kyōsai.

3 *Eishosai **Choki** (fl.c.1785–c.1805)

Earlier name Shiko, changed to Chōki in Kansei. Studied under Toriyama Sekien (1712–1788), also a teacher of Utamaro. Uneven output ranging from the banal to the brilliant.
II 2.

4 *Keisai **Eisen** (1790–1848) (old spelling: Yeisen)

Writer and artist, becoming fully productive c.1820. Pupil of, or at least associated with, Eiji and Eiji's son Eizan (q.v.). Also studied the Kano style of painting. Mainly produced pictures of beauties, but also some distinctive and original landscape work. Something of a reputation for a debauched Bohemian lifestyle.
II 29; II 30. III 30; III 33; III 49. IV 17. V 49.

5 Hosoda **Eishi** (fl.c.1756–c.1829) (old spelling: Yeishi)

Member of a samurai family. Studied the Kano style under Kano Sukenobu (Eisen II), (1730–1790), while carrying out an administrative job. Forced by ill-health to resign, he devoted himself full-time to painting, and took up Ukiyo-e style. Designed for prints c.1780–c.1800, thereafter devoting himself entirely to more prestigious scroll-painting. Best noted for his beauties.
II 18.

6 Chōkōsai **Eisho** (Shōeidō) (fl.1789–1801) (old spelling Yeishō)

Pupil of Eishi, specialising in beauties, particularly large heads. Some erotica in an Utamaro manner.
II 4; II 5: II 45.

7 *Ichirakutei **Eisui** (Ichirakusai) (fl.1789–1801) (old spelling Yeisui)

Pupil of Eishi. Beauties, especially large heads. Here represented by a rare hashira-e.
II 66.

8 Kikugawa **Eizan** (1787–1867) (old spelling Yeizan)

Worked c.1804–c.1860. Son of Kikugawa Eiji, a maker of fans and Kano style painter. Followed the style, and market, of Utamaro, although he specialised in a much harder kind of beauty.
II 7; II 26; II 28; II 29; II 68.

No signature reproduced

9 Fusatane (fl. mid 19th century)

Unrecorded. Follows the style of Hiroshige. Mostly mediocre, but a few pieces of merit.
II 11. III 38; III 39; III 40.

10 Yashima **Gakutei** (Gogaku, etc.) (fl. 1804–1844; d. 1868).

Better known in Japan as a writer. Pupil of Hokkei (q.v.) and Hokusai (q.v.). Particularly noted for his meticulously printed surimono, and best known for his series of views of Osaka, where he spent part of his working life.
II 73. III 54; III 55; III 56. IV 14. V 33.

Gyosai; See Kyōsai.

11 Suzuki **Harunobu** (1725–1770)

Possibly a pupil of Nishimura Shigenaga (q.v.). Long credited with the invention of full colour printing, he was certainly the first to develop its full potential, using blind printing and subtle overprinting to obtain his unique quiet colour harmonies. His mature work includes no Kabuki subjects, for he specialised in a demure type of courtesan. He also produced kachō-e and some amusing erotica.
II 38; II 39; II 40; II 51; II 52; II 53.

12 Hirokage (fl. mid 19th century)

Unrecorded. Presumably a pupil of Hiroshige, whose style he stiffens without utterly destroying it.
III 52.

13 Utagawa **Hirosada** (1800–1867)

Osaka. Pupil of Kunisada (q.v.). A distinctive smooth style. A curious reverse slope on his signature may indicate left-handedness.
I 15; I 16; I 60.

14 Utagawa **Hiroshige** (Andō, Ichiryūsai, etc.) (1797–1858)

Pupil of Toyohiro (q.v.) whose pioneer landscape interests he was to develop. With Hokusai the best known of Ukiyo-e landscape artists. He was directly inspired by natural landscapes, taking sketchbooks with him on his journeys across Japan. Nevertheless, his finished prints diverge from the real scene, in the interests of compositional coherence. Immensely popular in his own time, his prints have suffered from overproduction, worn blocks, careless printing and poor quality pigments. The basic strength of most of his work can, however, survive all but the harshest of such indignities.
Towards the end of his career some of the work was done by his pupil Utagawa Shigenobu (1826–1869), who married his master's daughter and succeeded to his name on his death. His work is usually poorer than that of his master, but not so uniformly abysmal as some critics have suggested.
II 13; II 14; II 16; II 17–III; III 13 20–III 25; III 29; III 31; III 32; III 36; III 37; III 50; III 51; III 60. IV 6; IV 9; IV 15; IV 16. V 6; V 36; V 38; V 43; V 46; V 47; V 50; V 51; V 64.

15 Toto-ya **Hokkei** (Kikō etc.) (1780–1850)

Originally a fishmonger, which is the meaning of the name Toto-ya. He studied the Kano style before becoming a pupil of Hokusa (q.v.). He is reckoned the best of Hokusai's pupils, producing especially fine surimono characterised by great clarity of design combined with superb printing.
III 1. V 34; V 35.

16 Shunshōsai **Hokucho** (fl. c. 1820)

Osaka. Possibly a pupil of Hokushū (q.v.).
I 31.

17 Shunkōsai **Hokuei** (fl. 1st half 19th century) (old spelling: Hokuyei)

Osaka. Possibly a pupil of Hokushū (q.v.), and one of the many Osaka artists who claimed allegiance to Hokusai by the use of the character Hoku in their names. Many also claimed a connection with the Katsukawa school, Hokusai's repudiated lineage, by the use of the character Shun in their studio names (see Shunshō). Hokuei's debt to Hokusai is particularly clear in the landscape backgrounds in many of his prints.
In his early years he also used the name Shunkō, and was prodigal with studio names a few of which are: Shumbaisai, Sekkaro, and Shumbaitei.
I 10; I 32; I 56–I 58.

18 Shotei **Hokuju** (?1763–after 1818)

Worked in Edo and Osaka. Pupil of Hokusai. He had a penchant for the tricks of representation which characterised western art for the Japanese of his period, and with which Hokusai had experimented. His work is consequently distinguished by the representation of shadows, peculiar perspective effects and by strange hybrid cloud formations.
III 27.

19 Katsushika **Hokusai** (1760–1849)

Probably the son of a mirror maker. First worked for a bookseller, then as a wood engraver until 1777 when he was accepted as a pupil by Katsukawa Shunshō (q.v.). He produced Kabuki prints in his master's manner using the name Shunrō. There was a rupture with Shunshō in 1785, perhaps caused by a conflict between Hokusai's penchant for experiment, and his master's conservatism, and he was forbidden to use the Katsukawa name, although he continued to be called Shunrō until 1796. There followed a period of straitened circumstances, changes of name and changes of residence. At one time he is said to have been reduced to hawking red peppers and calendars in the streets. He learned Kano style during the restoration of a temple, and Rimpa style by imitating the work of Hyakunin Sōri III (fl. c.1750–c.1780). He adopted the name Sōri, using it in conjunction with Hokusai from about 1797. Sōri was passed on to one of the pupils he seems to have begun acquiring c.1799, as were later names such as Shinsai (q.v.) and Taitō (q.v.). Other important names he used were I-itsu, from 1817, and Manji, as a main name from 1822. These continual changes of name, usually accompanying a change of residence, reflect his volatile temperament.
His constant striving for novelty and originality, which have perhaps aided his reputation in the West, were held against him in his own time, when loyalty to tradition was the norm, nevertheless his influence on other artists was important particularly in Osaka.
Incredibly prolific in all subjects, he is best known for his magnificent landscape prints in which all the diverse influences he underwent are synthesised. (Because he is so well known he is under-represented in the exhibition).
III 14–III 16; III 18; III 19. IV 5; IV 18. V 60–V 63.

20 Shunkōsai **Hokushu** (fl.c.1810–after 1830)

Osaka. Until 1818 used the name Shunkō. Thereafter came under the influence of Hokusai and changed his name to Hokushū. He seems to have been the link between Hokusai and the Osaka artists with the Hoku character in their names.
I 11.

21 *****Joshu** (fl. second half of the 19th century)

Nothing known.
IV 22.

* *No signature reproduced*

22 Kitagawa **Kikumaro** (fl.1789–1818; d.1830)

Follower of Utamaro (q.v.), whose style he follows quite closely, until 1804, when he was attracted to Hokusai. He changed his name twice: to a different version of Kikumaro in 1801, and, in 1804 to Tsukimaro. His work consisted mainly of beauties.
II 70. V 23.

23 Torii **Kiyohiro** (d.1776)

Pupil of Torii Kiyomitsu I (q.v.). Produced theatrical work in the family tradition, and beauties of a liveliness to rival Harunobu.
I 39. II 13–II 15. V 3.

24 *Torii **Kiyomasu I** (fl. ?1697–?1720; d.?1730)

The relationship between the early members of the Torii school is confused, both by the comparative scarcity of surviving works and by the sketchy and inconclusive nature of the biographical evidence. Tradition has it that Kiyomasu I was the son of Kiyonobu (q.v.), who was credited with the founding of the tradition. Recent research tends to indicate that Kiyonobu had precursors in the family and that Kiyomasu may have been his elder brother. The work of the two men is sufficiently similar for the theory that they were one individual to have been propounded. It is characterized by bold clear line, and by striking mise en page. The Torii family held the monopoly of theatre poster painting until the nineteenth century, and dominated the theatrical print market until the livelier full-colour works of Shunshō threatened to, and eventually did, take over their public.
I 35.

25 *Torii **Kiyomasu II** (1706–1763)

This one is also problematical. One theory calls him the son of Kiyonobu I, and states that he succeeded to the Kiyonobu name on the retirement of his father in 1727. The other that he was the son-in-law of Kiyonobu I, and that he succeeded to the leadership of the school over the head of Kiyonobu II, who, by this account a separate individual, was not sufficiently able. There is a record of the death of a Kiyonobu in 1752, this requiring a third Kiyonobu to account for works bearing the signature after that date.
Kiyomasu II produced mainly Kabuki prints in the family tradition, but is here represented by one of his charmingly naive landscapes.
III 34.

26 Torii **Kiyomine** (Kiyomitsu II) (1788–1868)

A pupil of Kiyonaga (q.v.), who changed his name to Kiyomitsu after the death of his teacher. While he did produce theatrical work in the family tradition, he is best known for his beauties.
II 20.

27 Torii **Kiyomitsu I** (1735–1783)

Son of Kiyomasu II. Prolific, and did much in the way of advancing printing technique, although his work never seems to have exploited it as fully as that of Harunobu.
I 19–I 21; I 37; I 38.

Kiyomitsu II; See Kiyomine.

No signature reproduced

28 Torii **Kiyonaga** (1752–1815)

Son of a bookseller. Became a pupil of Kiyomitsu, and was adopted into the Torii line. He went on to absorb influences from such artists as Shigemasa (q.v.), Koryūsai (q.v.) and Bunchō (fl.c.1765–1780; d.1792). He was influential in the creation of the unnaturally tall and cool type of beauty which was fashionable at the end of the 18th century, and was influenced by, as well as influencing, Utamaro.
II 44. III 59.

29 Torii **Kiyonobu** (1664–1729)

Traditionally the leader of the first generation of the Torii clan, who long maintained a near monopoly on theatrical work. The problems regarding identities and priorities amongst early Torii men are outlined under Kiyomasu I.
I 36.

30 **Kokyo* (late 19th–early 20th centuries)

A pupil of Ogata Gekkō (1859–1920).
V 17.

31 Isoda **Koryusai** (c.1766–c.1788)

Studied under Shigenaga (q.v.), as perhaps did Harunobu. Koryūsai's oeuvre covers much the same area as Harunobu's, both having a particular penchant for the difficult hashira-e format. He often limits the palette in his prints to an attractive rust-red contrasting with a dark mossy green.
II 22–II 24; II 54–II 57; II 65. IV 1; IV 2; IV 2; IV 8. V 4.

32 Utagawa **Kuniaki** (1835–1868)

Pupil of Kunisada (q.v.). There seem to have been two Kunisada pupils of this name, both functioning at about the same time, and brothers. It seems likely that two slightly differing sets of records have been interpreted as referring to separate individuals where only one existed.
I 17; I 67.

33 Toyohara **Kunichika** (1835–1905)

Pupil of Kunisada. Himself spawned numerous pupils, chief amongst whom is Chikanobu (1838–1912). Kunichika was prolific and his work is repetitive en masse, although individual examples have a garish vitality.
I 18; I 68.

34 Utagawa **Kunihiro** (fl.c.1818–c.1844)

Osaka. Pupil of Toyokuni.
I 59.

35 Utagawa **Kunikazu** (fl.c.1848–c.1861)

Pupil of Kunisada. Theatrical and landscape.
II 153.

36 Utagawa **Kunimaro** (fl. mid 19th century)

There were three Kunimaros in the 19th century. This seems to be the one who was a follower of one Toyomaru, a co-pupil with Toyokuni of Toyoharu (q.v.). The other two were pupils of Kunisada and worked at the end of the 19th century.
I 61.

** No signature reproduced*

37 Utagawa **Kunimaru** (?–1830)

Pupil of Toyokuni, of the same era as Kunisada and Kuniyoshi. Mainly beauties and picture books.

v 24.

38 Utagawa **Kunimasa** (1773–1810)

Pupil of Toyokuni. Especially noted for his large heads of actors, in which he bears comparison with his master and with Sharaku.

I 6; I 7; I 43.

39 Utagawa **Kunimasu** (fl. c. 1830–c. 1848)

Osaka. Pupil of Kunisada. First used the name Sadamasu.

I 14; I 53.

40 *Utagawa **Kuninaga** (fl. c. 1818–c. 1830)

Pupil of Toyokuni. Spent most of his time as a decorator of lanterns, but also produced some good Kabuki and perspective prints.

I 52.

41 Utagawa **Kunisada** (1786–1864)

Pupil of Toyokuni. On the death of the latter the name Toyokuni was passed on to another pupil, Toyoshige (q.v. sub Toyokuni II), who married the widow of his master. Kunisada never recognized this assumption, and in 1844, on the 25th anniversary of the master's death, when Toyoshige had himself been dead for ten years, he assumed the name "2nd generation Toyokuni", thus throwing several generations of Japanese print lovers into a state of confusion. He is recognized as having a legitimate right to the name "3rd generation Toyokuni", and is sometimes listed as Toyokuni III.

His output was incredibly prolific, especially in theatrical subjects and beauties, and much of his work is consequently repetitive. Much is also fascinating. The sheer variety of subjects he illustrated is in itself amazing. He had an enormous number of pupils and followers, both in Edo and Osaka.

I 8; I 62–I 66. II 8; II 3 I–II 33; II 74. V 80 V I 8; V 25; V 46; V 52.

42 Utagawa **Kuniteru** (1830–1874)

Pupil of Kunisada. Before 1844 used the name Sadashige. Best known for his representations of the changing scene at the beginning of Meiji.

III 63.

43 Utagawa **Kunitsuna** (fl. 2nd half 19th century)

There were two artists of this name: one, a pupil of Toyokuni, worked around 1830. The only reference I can find to the other, presumably this one, identifies him with Kuniteru without explaining the identification. I have preferred to leave him as a separate entity.

III 61.

44 Utagawa **Kuniyoshi** (1797–1861)

Pupil of Toyokuni. Was open to all sorts of influences: Kano, Hokusai, Hiroshige, and European prints. Produced a vast quantity of work, covering the entire range of ukiyo-e subject matter. His best work is excellent, and even his run-of-the-mill pieces are seldom utterly tedious. Had a large number of pupils, the most interesting of whom is Yoshitoshi (q.v.).

II 9; II 10; II 21; II 75. III 26; III 28; V 9; V 12–V 14; V 19–V 21; V 27; V 39; V 40; V 42; V 53; V 54; V 65.

* No signature reproduced

45 Kawanabe **Kyosai** (Gyōsai) (1831–1889)

Originally a pupil of Kuniyoshi. Used the name Chikamaro until 1863. He abandoned pure ukiyo-e style, and after studying Kano evolved his own blend of manners. He is best known for his birds, pictures of Meiji manners and customs and for his lively ghosts and demons. He drank heavily and often used the sobriquet Shōjō, which is the name of a sort of sprite with long red hair and an inordinate fondness for *sake*.

II 12. IV 11; IV 22; IV 23. V 28.

46 Okumura **Masanobu** (1686–1764)

Apparently self-taught, following the best in Torii style, in Moronobu, Sukenobu and the Kaigetsudo group of artists. He is credited with pioneer work in new methods of hand colouring and in the introduction of colour printing. He is also credited with the promulgation of the perspective print, *uki-e*, and the white line print imitating stone rubbings, *ishizuri-e*. He was also a publisher. One of the most influential figures in early 18th century ukiyo-e.

II 48; II 50; II 64. V 30; V 31; V 45.

47 *Hasegawa **Mitsunobu** (fl.1742–1758)

Osaka. Studied under Sukenobu (q.v.). Nearly all his work seems to be landscape in format, and to have been issued in albums. He was also influenced by Moronobu (q.v.).

II 36.

48 Hishikawa **Moronobu** (1618–1695)

The father of the ukiyo-e print. First studied design with his father, an embroiderer in Awa province. Moved to Edo where he studied Tosa style, and the new ukiyo-e style of Iwasa Matahei. His Tosa origins are reflected in the fact that many of his print series imitate handscrolls, a favourite format for that school. His book illustration is also superb.

III 57. V 1; V 58; V 59.

49 Gyokuransai **Sadahide** (1807–?1873)

Pupil of Kunisada. Worked in all subjects. Some co-operative work with his master.

II 63. III 5. IV 20. V 37.

50 Hasegawa **Sadanobu** (1809–1879)

Osaka. Pupil of Kunimasu. As well as theatrical work produced landscapes in the Hiroshige idiom. He had a son who carried on the name after his death.

I 34. III 41–III 48.

51 *Toshusai **Sharaku** (worked 1794–1795)

Sharaku is the most famous of Ukiyo-e mysteries: his work appeared, startling and new, apparently from nowhere, despite an obvious general debt to Shunsho. It is characterized by a grotesque realism of a sort which can hardly have endeared him to the actors of female parts he portrays in so uncompromising a fashion. His real identity remains obscure. There is tenuous evidence to encourage belief that he may have been an actor in the aristocratic No theatre, in the service of the Lord of Awa, called Saito Jurobei. Despite the undoubted influence he had on contemporaries like Toyokuni and Kunimasa, he does not seem to have gained a popular following, and he disappeared as suddenly as he had appeared.

I 2; I 41.

** No signature reproduced*

52 Ryūsai **Shigeharu** (1803–1853)

Osaka. Pupil of Kunihiro (q.v.), a pupil of Toyokuni, and then of Yanagawa Shigenobu, a pupil of Hokusai. He used other studio names, chief amongst which was Gyokuryusai.

I 54. V 7.

53 Kitao **Shigemasa** (1739–1820)

Son of a bookseller. Self-taught, his work shows the influence of the Torii school, of Masanobu, Harunobu, Koryusai and Kiyonaga at various stages in his career.

IV 3.

54 *Nishimura **Shigenaga** (1697–1756)

Self-taught, showing influences of Kiyonobu, Masanobu and Sukenobu. Apparently taught Harunobu.

II 37.

55 *Shimposai**

There was a Kyoto artist called Yoshiashi who used this name, and who died at the end of the eighteenth century.

II 47.

56 Ryūryūko **Shinsai** (c.1764–c.1820)

Pupil of Hokusai, from whom he received the name Shinsai in 1800. His work seems to consist almost entirely of surimono.

IV 12; IV 19.

57 Katsukawa **Shuncho** (worked c.1772–c.1800)

Pupil first of Shunshō and then of Shunman (q.v.). His work, however, reflects the influence of Kiyonaga more than any other. He produced good theatrical and beauty prints.

I 44. II 6; II 46. III 58.

58 Katsukawa **Shunko** (1743–1812)

Younger brother and close stylistic relative of Shunshō. Mainly theatrical work, with a penchant for triptychs.

I 26–I 28; I 40; I 47; I 48.

59 Kubo **Shunman** (1757–1820)

Studied Nanga style painting under one Katori Nahiko (1723–1782). At first he used a character for the Shun part of his name that was the same as that in Shunshō, but he changed it to another to avoid being associated with the Katsukawa school. He went on to study under Shigemasa, but his mature work is more influenced by Kiyonaga than by any other. He produced excellent prints of beauties in landscapes, and fine surimono.

IV 4.

* *No signature reproduced*

60 Katsukawa **Shunsen** (1762–after 1830)

Pupil of Katsukawa Shunei (1762–1812). Originally called Shūrin, he changed to Shunsen in 1806. In 1820 he changed again and became the second Shunkō. Shortly thereafter he gave up designing for prints and took up ceramic decoration. He specialized in beauties, particularly in the *kakemono-e* format, and also produced good landscapes.

II 25; II 67. V 32.

61 Katsukawa **Shunsho** (1726–1792)

Founder of the Katsukawa school. Studied under one Miyagawa Shunsui (fl.c.1716–c.1764). He developed the possibilities of the Kabuki print, basing himself on the work of Ippitsusai Bunchō (worked c.1765–c.1780). Bunchō had developed the realism of the drawing style, in contrast to the stiff formal poses typical of many of the Torii school works, and had brought into play the full palette of Harunobu. One of Shunshō's innovations was to depict actors in their offstage activities. Once formed, his style changed very little, making the suggested clash with the volatile Hokusai quite credible.

I 22–I 25; I 45; I 46.

62 *Nishikawa **Sukenobu** (1670–1751)

Worked in Kyoto, almost exclusively as a book illustrator. He combined Kano, Tosa and Edo Ukiyo-e styles. His way of drawing beauties was influential, particularly on Harunobu.

V 2.

63 Katsushika **Taito** (fl.c.1804–c.1848)

Pupil of Hokusai, from whom he acquired the name. Earlier known as Hokusen, changing in 1819. Also worked in Osaka, where he forged Hokusai's signature on his own pieces, whence his nickname of Dog Hokusai.

IV 13.

64 Rokkatei **Tomiyuki** (fl. mid 19th century)

Osaka.

I 13.

65 Gosai **Toshihide** (1862–1925)

Pupil of Yoshitoshi (q.v.). One of the more consistently competent Meiji print artists, although his beauties have a tendency to the saccharine so fashionable at the time.

VII.

66 Okumura **Toshinobu** (fl.c.1716–c.1748)

Pupil of Masanobu. Kabuki and beauties, almost always found with elaborate hand colouring.

III 17.

67 Utagawa **Toyoharu** (1735–1814)

Founder of the Utagawa school, teacher of Toyokuni, and of Toyohiro, Hiroshige's master. He is best known for his perspective views, and his beauties. He also pioneered views of foreign lands, including one of the forum in Rome.

V 5.

68 Utagawa **Toyohiro** (d.1828)

Pupil of Toyoharu, at the same time as Toyokuni, with whom he produced joint works. Beauties and landscapes. Teacher of Hiroshige.

II 19. V 41.

** No signature reproduced*

69

69

70

71

73

74

75

69 Utagawa **Toyokuni** (1769–1825)

Pupil of Toyoharu, and probably the most influential member of the Utagawa school. An enormous number of pupils, amongst whom the chief were Kunimasa, Kunisada and Kuniyoshi. His own work was at all times open to influence, often to the point of plagiarism, and the enormous volume of prints he produced was responsible for a loss of vigour in many of them. His best work is very fine indeed, blending influences from his master, the Katsukawa school, Kiyonaga, Utamaro, Sharaku and others.
I 3–I 5; I 29; I 42; I 49–I 51. II72; II72. V48.

70 Gosotei **Toyokuni II** (1802–1835)

Pupil of Toyokuni, originally called Toyoshige, changing to Toyokuni on his master's death (see Kunisada). His theatrical prints are weaker versions of his master's work, but he did produce some striking and original landscapes.
III 35.

Utagawa **Toyokuni III**: See Kunisada

Tsukimaro: See Kikumaro

71 Kitagawa **Utamaro** (1735–1806)

The facts about Utamaro's early life are obscure, but it is known that as a youth he became a pupil, and entered the household of Toriyama Sekien, who also taught Choki. His early work was produced under the name of Toyoaki, and consisted mainly of theatre handouts and cheap books. He moved into the circle of the publisher Tsuta-ya Jūsaburō, from whom he took the name Kitagawa, and developed his passion for life in the Yoshiwara, the beauties of which were to dominate his subject matter until his death. His superbly controlled line manages to suggest volume in a way which is unique to him. His last years were clouded by his imprisonment for contravening censorship laws, probably in 1805.
I 1. II1; II3; II16; II34; II41–II43; II49; II58–II62; II69.

72 *Kitagawa **Utamaro II** (fl.c.1804–c.1818)

Pupil of Utamaro I, who, on his master's death, married his widow and assumed his name. His work is very much like the late pieces by Utamaro, although they often lack the feeling for volume one expects from the master. His designs are nonetheless pleasing. It is not clear what share he may have had in the production of the numerous prints of a lower than perfect standard which were published in the years immediately preceding Utamaro's death.
II 17; II 35. V 26.

73 Utagawa **Yoshikatsu** (fl. mid 19th century)

Pupil of Kuniyoshi (named Ishiwatari Shōsuke)
V 66.

74 Utagawa **Yoshimori** (fl. mid 19th century)

Pupil of Kuniyoshi (lived at Ikenohata)
V 15.

75 Ichimōsai **Yoshitora** (fl. mid 19th century)

Pupil of Kuniyoshi. Pleasing bird pieces, and largely mythical views of foreign cities. Warriors.
III 62; IV 7.

* *No signature reproduced*

76

76 Ikkaisai **Yoshitoshi** (1839–1892)

Pupil of Kuniyoshi, living in Kuniyoshi's house and having access to his store of exotic western pictures. His early work is conventional Utagawa style, but in the late 1860s a change of manner takes place, blending Shijo school and western techniques. He worked as a newspaper illustrator, and achieved tremendous popularity, this explaining the posthumous publication dates on some of his prints. He had a morbid fascination for scenes of sadism and ghastliness. He died in a mental hospital in 1892.

II 12. V 10; V 16; V 22; V 67.

Suggestions for further reading

Edward F. Strange, *Japanese Colour Prints*, London (Victoria & Albert Museum), 1904 and subsequent editions to 1931.
An invaluable beginner's handbook, stressing the later periods, and with a good range of signature-reproductions.

W. von Seidlitz, *A History of Japanese Colour Prints*, London, 1910 and subsequent editions to 1920.
Sound and scholarly (originally written in German).

Laurence Binyon, *Catalogue of the Japanese and Chinese Wood-cuts in the British Museum*, London (British Museum), 1916.
A rich mine of information on titles and subject-matter.

Arthur Davison Ficke, *Chats on Japanese Colour Prints*, New York, 1917 (reprint, 1958).
Excellent for aesthetic appreciation and as enshrining the outlook of one of the foremost collectors of the golden age.

Basil Stewart, *Subjects portrayed in Japanese Colour Prints*, London, 1922.
Discursive and lavishly illustrated. Especially good on the *Chushingura* and other dramatic subjects.

Laurence Binyon and J. J. O'Brien Sexton, *Japanese Colour Prints*, London, 1923. Reprint, 1960.
A magnificent combination of Binyon's artistic insight and Sexton's painstaking scholarship and knowledge of the Japanese sources. Still the best general treatment of the subject.

James A. Michener, *The Floating World*, London, 1954.
Highly personal and sometimes wayward, but always stimulating and often informative.

J. Hillier, *The Japanese Print: A New Approach*, London, 1960.
Rich and varied diet; lives up to its title.

Richard D. Lane, *Masters of the Japanese Print*, New York, 1962.
An authoritative work by a leading Japanese language scholar, resident in Japan.

Harold P. Stern, *Master Prints of Japan*, New York, 1969.
163 masterpieces excellently reproduced with full description and scholarly commentary. Lively and readable.

HER MAJESTY'S STATIONERY OFFICE

Government Bookshops

49 High Holborn, London WC1V 6HB
13a Castle Street, Edinburgh EH2 3AR
109 St Mary Street, Cardiff CF1 1JW
Brazennose Street, Manchester M60 8AS
50 Fairfax Street, Bristol BS1 3DE
258 Broad Street, Birmingham B1 2HE
80 Chichester Street, Belfast BT1 4JY

Government publications are also available
through booksellers

The full range of Museum publications
is displayed and sold at the
Victoria and Albert Museum

Obtainable in the United States of America
from Pendragon House Inc.
899 Broadway Avenue
Redwood City
California 94063

£2.75

Printed in England for
Her Majesty's Stationery Office
Text by Sir Joseph Causton & Sons Limited,
London
Colour section by
Product Support (Graphics) Ltd, Derby
Cover by Balding & Mansell Ltd, Wisbech

Dd 133607 K40

SBN 11 290190 5 *